CLEBURNE BASEBALL

CLEBURNE BASEBALL

· A Railroader History ·

SCOTT CAIN

Foreword by Iván "Pudge" Rodríguez

THE
History
PRESS

Published by The History Press
Charleston, SC
www.historypress.net

Front cover, top left: courtesy of Layland Museum; *top center*: courtesy of Sonny Burt; *top right*: courtesy of Jim Swan; *bottom*: courtesy of Layland Museum.
Back cover, top: courtesy of Layland Museum; *bottom*: courtesy of author.

First published 2017

Manufactured in the United States

ISBN 9781467137010

Library of Congress Control Number: 2016953502

CONTENTS

FOREWORD

Baseball is more than just a game. It is a way of life. The game has impacted players and fans for generations. In the largest cities and the smallest villages, a sandlot game can be found on any spring or summer day. Baseball offers the chance for a boy to go from a Little League game to the World Series. That is what happened to me.

I grew up in Barrio Algarrobo, a small village near San Juan, Puerto Rico. From as far back as I can remember, my dad and I would play catch in an open field near our house. For hours my dad would teach me how to throw and catch while we talked about life. From the time I could hold a baseball, the game was part of my life.

When I began playing Little League games, I started on the mound. When my father thought I was throwing too hard, he moved me to catcher so I wouldn't scare the other players. I played games against Juan González. Little did either one of us know that we would one day become teammates for the Texas Rangers. Back then, we were just kids enjoying the game under the unrelenting heat of a Puerto Rico summer.

When I left the mound and took my place behind home plate, I had no idea that I would remain a catcher for the rest of my career, but it just felt natural to crouch behind the plate. I loved the position. I could call the game. I could talk up batters and umpires. I could help lead my team. And the best part was the view. There's no better view than from behind a catcher's mask.

Beginning in my early days in baseball, I learned that there were no free rides. Respect was earned, not given. Baseball could give a lot, but it also

required a lot. One day when I was sixteen years old, a man by the name of Luis Rosa wanted to talk to me. Like my friends, I knew who he was. He was a major-league scout who discovered players like Sandy Alomar Jr. and Juan Gonzáles. On this day, he wanted to talk to me. I was nervous and excited at the same time. We talked for a while. When it was all said and done, I was under contract with the Texas Rangers and might get a chance to become a major-league player.

When I arrived in the United States, I was a sixteen-year-old kid. Being in America was both thrilling and a nervous experience for me. I was a long way from home, and I didn't know what the future had in store for me. One day, one of my coaches started calling me "Pudge," because he said I was short and stocky. Little did I know that when I made it to the major leagues, everyone would still be calling me Pudge.

On June 20, 1991, I was called up to the big leagues. At nineteen, I was the youngest player on a major-league roster at the time. When I arrived in Arlington, Texas, I was a long way from my playing days in Barrio Algarrobo. I didn't feel like I had arrived. I felt like I had something to prove.

Much like the game in its early days, playing catcher is not for the faint of heart. You have to be tough. You have to make quick decisions. And, at times, you have to take control of a game. When a runner decided to steal a base, well, I took that personally. Those were my bases to protect. My team was counting on me to let the runners know that those were our bases.

It was an honor to play professional baseball for several major-league teams over twenty-one years. As much as I enjoyed playing, one of the greatest joys I experienced in baseball was teaching my son, Iván Dereck, the game, just as my father taught me. Growing up the son of a major-league catcher was not easy for him. We had little time, but we threw the ball whenever we could. In 2011, I watched with pride as he was drafted by the Minnesota Twins. He was carrying on his father's business!

The stories of the players and the fans are what make baseball unique. The game can give, but in the end, what you do with the gift of baseball makes all the difference. Baseball has given me a platform to help others, and I am grateful for that. When I visit places like Cook Children's Hospital, the smiles of children fighting for their lives gives me more joy than I could ever give them. They are the real heroes.

Whether the stories come from Cleburne, Texas, or Barrio Algarrobo, Puerto Rico, baseball has been and will continue to be a timeless part of communities and families. As you read about my story and about Cleburne's story, I hope it brings back fond memories from your own experience with

baseball. And when those memories give you a smile, remember to make new memories for others.

—IVÁN "PUDGE" RODRÍGUEZ
Fourteen-time Major League Baseball All-Star, American League MVP (1999) and member of the Texas Rangers Hall of Fame

PREGAME

As the opportunity to bring professional baseball back to Cleburne unfolded with the initial development of the Depot in 2015, my love of the sport was re-ignited. In the process, I uncovered baseball's rich history in Cleburne. I was deeply moved by the newspaper accounts and personal anecdotes of the struggles and triumphs of the players, the fans and the city itself.

As I recounted Cleburne's baseball story, I recalled a simpler time, when I was a young boy. Through the years, I had somehow forgotten the impact baseball had on my life. Jack Guthrie, my Little League coach, looked past my dismal batting average and taught me the meaning of teamwork and leadership when he made me the 1979 Most Valuable Player for the Dragons. Years later, family memories were made watching the Texas Rangers and playing softball with friends. Like many others, baseball was a part of my family and was often the backdrop for memorable moments.

I want to dedicate this book to my family. They endured my "discoveries" and countless retelling of the stories I found. Thank you Chris for loving me, flaws and all. Thank you Marcus for your patience when I hovered over stacks of articles. And a special thank-you to Matthew, who waited patiently for years for our first game of catch in the backyard. I look forward to our next talk about cars, girls and solving world problems while we throw a ball—and I'm sorry about overthrowing you all those times!

A special thank-you to Karen Rippel for smoothing out the grammar in the manuscripts. I also want to thank Mollie Mimms and John Warren for helping chase rabbits down the paths of broken history and Morgan Ritcher

for the countless hours digging through old newspapers. Thank you to my history teacher, Eddie Sewell, who instilled in me a love of history. Thank you Donnie Nelson, Jamie Adams and Robbie Fenyes for your leadership and enthusiasm in honoring Cleburne's history by resurrecting the Railroaders.

It has been a privilege to dust off the pages of Cleburne's baseball history and read the stories of the players, the fans and town. As I read the accounts, I laughed, I cried and I was overcome with a sense of pride for my hometown. I hope these stories resonate with you in the same way.

This is Cleburne's baseball story.

First Inning

COME AND TAKE IT

The one constant through all the years, Ray, has been baseball. America has rolled by like an army of steamrollers. It has been erased like a blackboard, rebuilt and erased again. But baseball has marked the time. This field, this game: it's a part of our past, Ray. It reminds us of all that once was good, and it could be again.
—Field of Dreams

There is just something about Texas. And when it comes to baseball in Texas, that something becomes legendary. Baseball was a natural sport for Texas railroad towns. And for one small North Texas town in particular, railroads and baseball merged at just the right time to make some magic. Railroad towns had to be tough in order to overcome their inherent and persistent challenges, but their toughness was considerably tame compared to the rawness of early professional baseball. Put the two together, and the sparks were sure to fly.

In the early days of Texas, settlers traveled from across the globe to start a new life on the rugged prairies. Towns popped up overnight in the middle of nowhere, bringing with them an abundance of opportunities. When the railroads made their appearance across the plains of Texas, things really got interesting. In the mid-1800s, a small stop on the Chisholm Trail changed virtually overnight when the town landed the largest railroad shops west of the Mississippi River. Cleburne, Texas, would soon come to be known as one of the strongest and most vibrant railroad towns in America.

Downtown Cleburne at the turn of the century. *Courtesy of Layland Museum.*

Meanwhile, in baseball's formative years, the sport that would become America's pastime was not for the fainthearted. The players themselves were rugged and tough. Their interactions with the fans included jawing back and forth and, more than once, concluded in fistfights. Despite these conflicts, or perhaps because of them, Americans quickly recognized that baseball was indeed the nation's sport. Baseball offered something for everyone. It was ideally suited for the young and the young at heart. In time, it would weave itself into the lives of almost every American.

In a fitting twist of fate, the town of Cleburne was incorporated in the same year that baseball was recognized as the nation's sport. The year was 1867.[1] The town and the sport that shared a birth year would soon cross paths, eventually producing an amazing collection of stories reflecting the city's rich heritage of tenacity and victory in the face of adversity.

Pistols and Panthers

Legend has it that the rugged Texas spirit was on full display in an early game between Fort Worth and Cleburne. Fans packed the rickety wooden bleachers of Cleburne's ballpark, known simply as Gorman Park. It was mid-afternoon, and the spring sun was warming the players and fans. The park was packed to capacity for one of Cleburne's first professional baseball games.

The Fort Worth Panthers were used to playing in tough pioneering towns. But this was their first experience in the small railroad community just to the south of their home city. As the innings rolled by, Fort Worth amassed a couple of runs while shutting out the Cleburne Railroaders. The fans were growing visibly restless; they knew that when the bottom of the ninth inning arrived, the game was likely over.

The Railroaders rallied and scored one run and then another. Suddenly, with the game tied, the excitement grew. In the bottom of the ninth inning, Cleburne got a runner on first, then used two outs to advance him to third base. When an unknown batter stepped into the box, the game was tied, 2–2. The Railroaders, with a runner on third, were down to their last out. The batter swung, got under the pitch and hit a soft, shallow pop fly into center field. The Panther center fielder moved slightly forward to position himself directly under the ball. On a normal day, it was an easy out. But this was no normal day.

Along the outfield fence line, sitting on horseback, were between three hundred and four hundred cowboys, most of them wearing six-shooters on each hip. As the ball began its descent, five of the cowboys drew their pistols, took aim at the ball and began blasting away. When the dust settled, all that remained of the baseball was a cloud of twine. The umpire was visibly shaken and worried. Since the ball had not been caught, he reasoned that there was no out, so he made the only ruling he could. He pointed at the runner at third and motioned for him to advance across home plate. As the baserunner stepped on the plate, the umpire called the game over. Cleburne won, 3–2, in the most bizarre walk-off fashion. The umpire and the Panthers quickly, and wisely, made their way to the train station and left town.[2]

Baseball was a natural byproduct of the most important thing to happen to Cleburne: the railroad. As the nineteenth century was winding down, the railroad was taking transportation and commerce to new heights. In 1881, the Gulf, Colorado & Santa Fe Railroad completed laying track from Fort Worth through Cleburne and on to Temple. A secondary line connected

Fans often rode on horseback to baseball games. This unknown Cleburne game was likely finished without cowboys shooting the ball out of the air. *Courtesy of Layland Museum.*

Weatherford to Cleburne in 1887. With the rails quickly taking root, there was an increased need for railroad shops to keep the locomotives running. This need would transform Cleburne seemingly overnight.[3]

In 1867, Cleburne was a watering hole along the Chisholm Trail when several Civil War veterans settled in the north Texas community. It wasn't long until the decision was made to rename the town after the Civil War general Patrick Cleburne. Before General Cleburne was killed in battle, he stood up against racism by calling for the Confederate army to allow black men to fight alongside white men. His views ended his meteoric rise through the ranks, but his name lived on to reflect the spirit and tenacity of a growing north Texas town.[4]

It is likely, though not definitively proven, that soldiers passed the time between battles during the Civil War playing a game called baseball. After the war, many of these soldiers brought the game to Cleburne. Over the next few years, the game would offer a diversion from the harsh reality of daily life in a frontier town. This diversion would later assume a more prominent role in a town that was struggling to find its identity, a struggle that ended in 1898.

In the 1870 census, Cleburne's population was listed as 683. In 1898, city leaders discussed economic incentives in a meeting with Santa Fe Railroad executives. An agreement was reached to build the largest railroad machine shops west of the Mississippi River. The impact on the city's growth was evident almost immediately. By 1920, the population had skyrocketed to 12,820.[5] Additional rail lines would soon arrive, including the interurban that connected the downtowns of Cleburne and Fort Worth. A local

Architectural drawing of the 1905 expansion of the Santa Fe Railroad shops. *Courtesy of Sonny Burt.*

streetcar was built to provide public transportation throughout the city. The Santa Fe shops were the central part of daily life for most of the city until they were unceremoniously closed in 1988.

With the shops providing jobs and creating economic opportunity, Cleburne's leadership shifted its attention to helping the city become one of the greatest in the nation. They studied and analyzed what other prosperous cities were doing to promote growth and looked for opportunities to emulate those practices. They wanted Cleburne to be recognized as a progressive city and as an example of leadership for other growing towns. Under the guidance of Emmett Brown, the school system was improved and soon became a model for other schools throughout the state. Utilizing the "house" system of educational organization, camaraderie and pride became prevalent throughout the town. Leaders applied for funding to build a Carnegie library, and numerous clubs and organizations were established.[6]

At the same time that Cleburne was finding its identity, baseball was being established as America's pastime. While the origins of baseball are

Legends of the game. *From left to right, bottom row*: Honus Wagner, Al Simmons, Babe Ruth, Walter Johnson and Tris Speaker. *Top row*: Eddie Collins, Gabby Hartnett, Connie Mack, Bill Klem, unknown and George Sisler. *Courtesy of Tris Speaker's great-nephew, Jim Swan.*

clouded in mystery and controversy, things were clearing up in the mid-1800s. By 1823, the game was frequently being played on a field near the outskirts of New York. The first organized baseball club, the New York Knickerbockers, was formed on September 23, 1845. By 1867, the same year that the thriving railroad town in north Texas was officially named Cleburne, the Washington Nationals embarked on a tour across the nation. That year, over four hundred clubs were recognized, and twenty-three of the nation's thirty-seven states had professional teams. Some baseball scholars recognize 1867 as the year baseball became the nation's sport.[7]

Cleburne's ties to professional baseball in Texas today are strong yet mostly unknown. Following the 1906 season, the Cleburne Railroaders moved to Houston to become the Buffalos. Many years later, the Buffalos became the Houston Colt .45s, a team later renamed the Astros.[8] A couple of players on the Railroaders' 1906 team went on to play professionally for the Washington Senators.[9] The Senators relocated to Arlington, Texas,

in 1972, becoming the Texas Rangers. Through the years, Cleburne has maintained its ties to professional baseball. Several minor-league teams evolved, and a few local boys achieved major-league success. It could be said that professional baseball and Cleburne fit each other like a hand and a well-oiled glove.

Despite the fact that professional baseball was absent from Cleburne for almost one hundred years, the stories continued to unfold. In baseball's formative years, the "dead-ball era" of baseball was about as tough and unyielding as life in small Texas communities at the time. The chapters that follow recount many of the stories of players, seasons and fans of Cleburne. While not intended to be a treatise of facts and figures, this book highlights the impact that baseball had on a small, growing community and how that community in turn influenced America's pastime. Though profound, that impact has almost been lost under the dust of history. The time has come to blow off the dust so that these stories can again be enjoyed.

Second Inning

ARRIVAL OF PROFESSIONAL BASEBALL

The way a team plays as a whole determines its success. You may have the greatest bunch of individual stars in the world, but if they don't play together, the club won't be worth a dime.

—*Babe Ruth*

Cleburne was poised for growth when it landed the Santa Fe Railroad shops at the turn of the century. Trains were driving commerce and connecting cities like never before. With the arrival of the shops, businessmen came from all parts of the state and the country to establish a career and raise their families.

One such businessman was Charles Thacker. Born in Kentucky, he and his family loaded a wagon and traveled to Texas when Charles was ten years old. The Thacker family landed in Waco for a period, then made their way to Cleburne in the 1890s. Like many other children, Charles went to school. Though good with numbers, he was no doubt caught daydreaming as he gazed out the schoolhouse window. Charles couldn't wait to gather with friends for a game of sandlot baseball. Between chores and homework, Charles would meet his friends at a makeshift diamond, most likely located in someone's front yard. They would take turns batting and fielding for hours on end until frustrated mothers located the young boys. The sandlot games never ended. They were just called on account of chores by the umpire (one of the mothers).

Charles excelled in mathematics. After his schooling, he trained to become a bookkeeper. He was a student of details. In fact, he was fanatical

about details. As a young adult, he hung a shingle on Chambers Street for a sporting goods store. His small business thrived, and he accumulated a fair amount of wealth. He soon got married; not long after the wedding, he and his wife, Kate, found themselves holding a baby girl. Charles looked at his new daughter, Lois, and thought his life was good. He had built a growing business, his house was filled with the sounds (and smells) that only a baby can provide and his hometown was growing with the railroad. He was living the American dream, yet something was missing.

Several important projects that shaped Cleburne can be credited to Thacker. He was the driving force behind the creation of the Cleburne Country Club, which remained in existence for over a century. He and Jink Lee raised the funds to build Blue Hole Road, the first gravel road in Johnson County.[10] Today, the thoroughfare is known as Country Club Road. He was an advocate for environmentally clean sports like bicycling and golf. But his biggest contribution to Cleburne was born from his love of baseball.

Before moving to Cleburne, Thacker pursued his love of baseball. In 1888, he helped secure Waco's place as a charter member of the newly formed Texas League for professional baseball. He served as the secretary for the league and worked alongside some of his friends. One of those friends was Doak Roberts. He and Roberts learned firsthand how difficult organizing and operating professional baseball in Texas was in the early years. The two friends ran the league, managed teams, traveled between cities, paid salaries and bills and promoted the teams. True to form, Thacker meticulously compiled a list of details and kept an accurate account of the league's records.

Ironically, the first year of professional baseball in Texas was filled with mistakes, and the endeavor almost met its demise before it even gained a foothold. However, Thacker's love of details, coupled with Roberts's salesmanship, led the way to future seasons for the league. Today, few know about Thacker's contribution to Texas baseball. Without him, the league may have died after the first season.

It was Thacker's experience with professional baseball and his close friendship with Doak Roberts that put an idea into his head that would soon become an obsession. In the early 1900s, baseball could put a city on the map and was a sign of a growing community. Large cities like Fort Worth, Dallas, San Antonio, Austin, Galveston and Houston were home to clubs. But the distance between cities posed a problem. The turnaround time required for travel between cities significantly increased a team's operating costs. Southern cities competed against one another, but Fort Worth and

Dallas were too far away to participate in the Southern League. For a league to survive, it needed teams. And for a team to survive, it needed fans in the bleachers as often as possible.

Roberts, Thacker and others engaged in an experiment. They brought in teams from smaller towns that were connected to the larger ones by railroad. The shorter distances between towns resulted in lower train fares and less expense. This seemed like a good idea. However, one problem became evident. Smaller towns meant smaller crowds. Life at the turn of the century was hard. Men worked long hours in the fields or shops, six days a week. A constant battle with Texas weather, coupled with the time invested in raising families, left little time for entertainment and indulging in games.

When Thacker left Waco for Cleburne, he also left behind his involvement with baseball. But his love of the game never went away. It remained on the back burner until he met up with his old friend Doak Roberts in 1905. While Thacker had been building his business and raising his family, Roberts had carried on the Texas baseball project. He landed in Corsicana, where he owned a team. He later moved the team to Temple.[11] The two men reminisced about their days forming the Texas League. Roberts shared his struggles in Temple and no doubt told Thacker that he was thinking about hanging it up and giving up on baseball.

The wheels in Thacker's meticulous mind began turning. He loved Cleburne. He loved baseball. Cleburne was his home, and he could never again engage in an adventure like the Texas League circuit. Or could he? As Roberts droned on about his life, Thacker was far removed from the conversation. He started doing the math in his head. He thought about the details. Could it work? Then he began to smile, and there was a twinkle in his eye that had been absent for some time. He waited for his friend to take a breath.

"What about Cleburne?" he blurted out.

Roberts's eyebrows raised in confusion. "What do you mean, what about Cleburne?"

Thacker told his friend about his hometown and why he believed professional baseball would work there. It was close to Fort Worth and Dallas. It had several railroads connecting it to area cities. It was progressive and growing. And its people wanted to put Cleburne on the map. Roberts said he would think about it.

On his way home, Thacker sat in his seat on the train and thought about the birth of a baseball club in Cleburne. He had no idea what 1906 would come to mean for him and his city.

Rail transportation between league cities offered players and fans a chance to relax, catch up on reading or engage in a card game. *Courtesy of Sonny Burt.*

While Thacker was dreaming of baseball in Cleburne, the city council was taking steps to create a modern city. In a controversial move, the council approved an ordinance banning the raising of hogs within the city limits.[12] It was believed that the move would improve the health and safety of the residents while making the city cleaner. Soon, roads were paved and plumbing and electricity were added to homes. And in the spring of 1906, Cleburne was home to a professional baseball team.

With increased sightings of Doak Roberts and rumors of baseball, the talk of the town quickly shifted from hogs to ballplayers. Roberts made several visits to Cleburne to discuss the team. Once he announced his choice of Cleburne, discussions shifted to the details. Questions circulated throughout the community. Where would the team play? It was determined that the diamond needed to be located near downtown, close to local businesses (valuable sources of support for the team) and accessible by foot for residents.

Who would lead the team? The locals began following the movements of players and managers in the Texas League. In particular, Roberts was questioned about the prospects of hiring the legendary Ben Shelton as the

team's captain. He had a reputation for swift play and firm leadership. In 1905, he played for Temple, where he led the league in hits, doubles, runs and on-base percentage. He played across Texas and in Oregon, where he learned to adapt to the ever-changing nuances of the game. He knew how to adapt, and he knew how to build chemistry among the members of a team. It was this leadership that made him the first pick for Roberts's team. Although he never reached the big leagues, Shelton helped shape several players into major-league talent and even helped form a few legends along the way.

Ben Shelton was a great choice to lead the team, but it still needed a place to play. There was a plot of land just south of downtown that was owned by the Trinity & Brazos Valley Railroad. The railroad's superintendent, Pat A. Gorman, executed a lease for the property to the Cleburne Athletic Club for a term of three years. The location was staked off, and the plans were drawn. The park would be state-of-the-art and multifunctional. While its primary use would be for professional baseball, other teams would play there. There would be picnics for the community, and the park would eventually be used by shooting clubs. It would feature a large grandstand, bleachers along the outfield base lines and a fence surrounding the spacious outfield. The park was initially called Cleburne Athletic Park, but the name was soon changed to Gorman Park, in honor of the superintendent who made it possible.

Roberts and Thacker supervised the construction. Lumber arrived to erect the grandstands. When completed, the stands would accommodate between eighteen hundred and two thousand fans. Gates were installed, and a clubhouse with showers and a gym was raised. Plows and rollers worked the fields, which needed to be as level as possible. More important, they needed sanding, to avoid the accumulation of muddy mire that could slow down the games. While the field was taking shape, the two business leaders worked on raising money to support a professional team.

Funding a club in the early days of Texas baseball presented unique challenges. It required gate receipts and community investment. Thacker owned a sporting goods store, and he used his resources to help the cause. He offered a new bat to the first player to score a run. When the season arrived, other business owners followed Thacker's example. Hats, suits, shoes, bags of coins and, occasionally, cigars were given to players who achieved various milestones. While the pay was scant, a good player could finish a season with a new wardrobe and other finery that he would otherwise only see in a storefront window.

While Gorman Park was taking shape, the league finalized its plans. The schedule was laid out, and the rules were adopted. Albert Spalding's ball

was approved as the official ball of the Texas League. The ball was quite different from today's baseball, giving rise to the term "dead-ball era." In its early years, baseball was a pitcher's game. Out-of-the-park home runs were rare. Gorman Park's outfield was so deep that it was nearly impossible to hit a ball out of the park.

One of the early controversies involved Sunday play. Across the nation, cities struggled with the issue of playing games on Sundays. Laws in several states prohibited amusements on Sundays. In some cities, players were arrested at the start of a Sunday game. In fact, many teams playing on a Sunday afternoon would send their worst player to the mound or batter's box to be arrested; the better players would then play the remainder of the game.[13] Cleburne decided to prohibit Sunday play, although most cities in the league allowed it.

By the end of January 1906, Roberts announced that would-be players would arrive in Cleburne and report for duty on March 15. On that date, ballplayers from around north Texas and beyond swarmed into Cleburne as tryouts commenced. The players would have a month to play exhibition games and practice before the roster was set and the season opened.

As the players began arriving, Roberts seized an opportunity to unite the team and the town. As is the case today, preseason games at the turn of the century meant virtually nothing in competitive terms. But they did offer the team a chance to raise money—if the seats could be filled. What would bring fans with pockets full of change to a throwaway game?

Doak Roberts had a keen eye for baseball talent, but he was also a master of promotion. In February, he put down his scouting reports and began to think about how he could bring the town together and get fans interested in preseason games. As he removed his glasses from his face and lowered them to his lap, he closed his eyes and thought about what had worked in the past. He thought about his last season in Corsicana. He recalled that wonderful season and relived a particularly great moment, when his team was the victor in the battle for a cup. Corsicana was situated on the Cotton Belt Railroad line, and several cities had competed for a beautiful trophy known as the Cotton Belt Cup. In 1904, Roberts and his partner, J.E. Edens, had put together a solid team in Corsicana, where they won the cup together. However, the partners split after that season. In 1906, Roberts started the Cleburne club, and Edens went to Temple.

Roberts remembered the trophy and the joy surrounding its capture. Technically, it belonged to both him and Edens. The question after the split was who would get to keep the coveted cup. Then a smile filled Roberts's

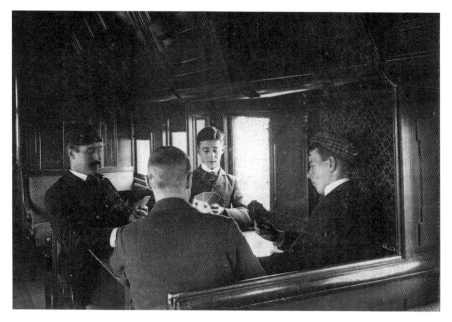

Unknown fans playing cards. *Courtesy of Sonny Burt.*

face as his eyes opened. That was it! Cleburne and Temple could compete during the preseason for the Cotton Belt Cup. The winner of the series would get the cup, which was valued at $300. The two cities would no doubt rally around their respective teams. The event would solicit good press, and the players would actually be playing for something—bragging rights and a silver cup.

Roberts wasn't the only one planning for the season. The city formed a fan club called the Rootorial Society. The society would coordinate supporting the local team while heckling the visitors. (However, when the local team played poorly, they themselves were heckled.) The fan base grew when word came that a number of fans from Alvarado, Grandview, Midlothian and other communities planned on attending games.[14]

As the fans readied for the season, the players were also gearing up. One tradition in baseball, the art of the prank, has nothing to do with action on the field. During the course of the Cotton Belt Cup series with Temple, Cleburne captain Ben Shelton planned an elaborate prank against his team's manager. Shelton heard that Temple's manager had secured the very best liniment to rub out soreness in his players. Shelton took the news to Roberts, and the two discussed how using the liniment would give players

an advantage by removing soreness and giving them fresh legs and arms. Shelton argued that unless Roberts secured the liniment for his team from a local pharmacy, they would be at a disadvantage. Roberts agreed and promised to put in an order for the very best.

Before Roberts could make his way to the pharmacy, Shelton paid the local druggist a visit, urging him to raise the price of liniment as high as possible. He explained that Roberts would soon be placing an order for the team. Not one to turn down a good prank, the druggist agreed. A few hours later, Roberts walked into the drugstore. When asked the price, the druggist replied that it was $9.50 a bottle. Roberts couldn't believe it, so he went to another drugstore. Unfortunately for the manager, Shelton had already called on that druggist as well.

"How much?" asked Roberts.

"Thirteen dollars," came the reply. When Roberts made it back to the clubhouse, the players and Shelton burst out with laughter as Roberts relayed his story.[15]

As the season approached, Roberts continued to sign players to fill the roster. One of those players was Charlie Moran. "Uncle Charlie," as he was known, was a great athlete and quite a character. Before landing on the Railroaders' roster, Moran pitched in the major leagues. After his stint with the Railroaders, he would return to the majors as a catcher before coaching football at Texas A&M for six years. During his tenure at A&M, a professor once asked Moran how he taught his players to be good losers. He replied, "I didn't come here to lose!" After a few more football stints, Moran returned to baseball, this time as an umpire.

Toward the end of his career, Moran's hobby was raising hunting dogs. During a game between the New York Giants and the Chicago Cubs, Uncle Charlie was the game's umpire. Hughie Critz stepped into the batter's box, and the following conversation ensued.

> "Charlie, they tell me you have some good dogs. What are you asking for
> a good one?"
> "A hundred and fifty dollars. Ball one."
> "That's a lot of money."
> "Best dog in America! Strike one."
> "Is he fast?"
> "Fast? He can outrun a train! Ball two."
> "What color?"
> "Liver and white. Real handsome animal. Strike two."

"Can he retrieve?"
"Through hell and high water! Ball three."
"Okay, I'll take him."
"That's fine. Ball four. Take your base."

While Critz was walking to first, smiling and thinking about his new dog, the catcher, Gabby Barnett, pulled his mask off and looked at Moran. "If it's the same to you, Charlie, don't be selling no more bird dogs to .200 hitters while they're up here at the plate!"[16]

By early April, the team was taking shape. The team's uniforms arrived and were put on display in the window of the Bradford Bros. Company store. New features were continually added to Gorman Park. One of the largest scoreboards in the state was installed along the outfield fence. A press box was added for Charles Thacker. His attention to detail made Thacker the ideal scorekeeper. The only problem was that everyone in town knew it. During the preseason games, Thacker was constantly interrupted by fans wanting to know game-time stats. Therefore, the only solution was to put Thacker high above in a perch where no one could bother him. He would spend the entire season in solitude, above the fray. The only interruption Thacker would encounter was the sound of his own gong, which he used to signal the start or finish of the game. In the perch, he could attend to recording the game's statistics. Those were the only things in which he found joy, as he lost his wife before the season began.

As the preseason marched toward Opening Day, the race for the Cotton Belt Cup remained tight. Cleburne and Temple battled back and forth, and it looked like it would come down to the last game of the series. Cleburne fans boarded trains bound for Temple.

While the team was gearing up to take a shot at making baseball history, the city was making preparations to add streetcar service. Several years later, Cleburne would be connected to Fort Worth with the laying of track for the interurban rail system. The progress in transportation not only improved daily life for Cleburne's residents but also made baseball more accessible.

The Cotton Belt Cup proved to be a source of drama. In early April 1906, the *Dallas News* reported that W.E. Green, the superintendent of the Cotton Belt Railway, said the cup was only for cities on the Cotton Belt line. Therefore, he argued, since Cleburne was not on the line, it could not win or keep the trophy. Roberts fired back, stating that since the cup was the joint property of Temple's manager, Edens, and himself, they had to play a

The interurban ran between Cleburne and Fort Worth for many years. *Courtesy of Layland Museum.*

series for the cup. Essentially, Roberts told Green to butt out. Roberts won the argument.

As the Cotton Belt series neared its end, a tiebreaker game was required. The series made news across Texas unlike any other preseason event in baseball. Hearing about the tie, the city of Lampasas offered to host the tie-breaker game, which provided a neutral site. In some ways, the preseason series had become as big as a league championship. So, off to Lampasas the two teams went. When the final out was made, Cleburne won the game, the series and the $300 trophy. During the train ride home, the players passed the cup back and forth and basked in the glory of the meaningless title of Cotton Belt Cup champions. Fighting for the right to the cup was a symbol of pride for the two communities. However, at the conclusion of the 1906 season, the cup and the series disappeared into a dark corner of history. To this day, no one knows the cup's location or if it still exists.

The euphoria of winning the Cotton Belt title was short-lived. On April 12, 1906, just days before the season opened, Cleburne was playing at Gorman Park. The weather was typical for springtime in north Texas. As the game started, the wind increased, and the skies grew ominous. Many fans

left the park and went home. Those who remained moved under the cover of the grandstand. The rains increased, turning the field into a mud pit, and lightning filled the sky. At the end of the sixth inning, the umpire sounded the gong and ordered the players off the field.

As the players were leaving the field and the fans were seeking cover under the grandstand, a gust of wind exceeding ninety miles per hour struck. A small tornado tore through Gorman Park. The roof was ripped off, leaving the fans in the raw grasp of Mother Nature. Lumber was peeled away and thrown about like tinker toys. Some lumber landed in the middle of Buffalo Street, hundreds of yards away. The roundhouse at the railroad shops sustained damage, as did many homes throughout the community. At the park, the scene was chaotic.

As quickly as the tornado landed, it lifted, and the storm passed. Fans milled about, assessing the damage. The grandstand was in shambles. People picked up hats and umbrellas. A few of the fans had cuts and bruises. As the damage was assessed, someone noticed a young boy lying helpless on the ground.

William G. Dalton had heard about the new professional baseball team coming to Cleburne some time before the April contest. He saved his money and finished his chores so he could go to a game. On April 12, he no doubt had to convince his mother that going to the game at Gorman Park was not a waste of time. It was his first professional baseball game. And, as misfortune would have it, it was also his last.

Dalton lay on the ground unconscious. He never knew what hit him. Someone picked up his limp body and took him to his home at the corner of Buffalo and College, just a few blocks away (there was no hospital in Cleburne in 1906). He lay in his bed until 2:00 a.m. the following Monday, when "death came to relieve him from suffering."[17]

While there is no placing a value on a life lost, there was an assessment to the damage done to the park. Estimated at $500, the destruction amounted to 40 percent of the total cost of construction. The Texas League season was a little more than a week away, and the Railroaders needed a new home. The team could have folded, and the city could have given up. But that was not the Cleburne way. With a spirit that personified the attitude of all Texans, the residents rallied together. A local roller rink donated half of its sales to rebuilding the stadium. The citizens of Cleburne immediately got busy cutting lumber and framing a new grandstand. Fifty men were assigned to work around the clock. The team itself put together a pro-am benefit baseball game to raise needed funds.

By the time Opening Day arrived, Doak Roberts had assembled one of the most talented teams in the history of the Texas League. All told, nine of the 1906 Cleburne Railroaders went on to play major-league baseball.[18] Two years later, Doak Roberts wrote his good friend Charles Thacker.

Dec. 27, 1908
To: Charles H. Thacker:

I was thinking of the Cleburne bunch, and can tell you that nearly all of whom have gone to faster company. I think Cleburne holds the record for promotion. These are the players that were on that team and where they are today:

Dode Criss— St. Louis Browns
Tris Speaker—Boston Americans
George Whiteman—Boston Americans
Roy Akin—Boston Americans
Charles Moran—St. Louis Cardinals
Rick Adams—Denver of the Western League
Parker Arbogast—Vancouver of the Pacific Coast League
Walter Dickson—Atlanta of the Southern League
Bobby Wright—Charleston, South Atlantic League
Dee Poindexter—Married out of the game

Advise me of the address of Fred Colquitt. I have written two letters to him at Rio Vista, but have not received a reply.
What do you think of Louis Drucke as a pitcher?
Regards to all the gang.
Sincerely,

J. Doak Roberts.[19]

During the dead-ball era, pitching was the name of the game. Cleburne assembled a stout pitching staff for the 1906 season. During the Cotton Belt series, Roberts signed Rick Adams, who had been an ace on the mound for Temple. In 1905, he had been sold to the Washington Senators. After a miserable start in the big leagues, he was released. Roberts wasted no time getting Adams under contract for the Railroaders. By the time the season ended, the Paris, Texas native won twenty-four games and led the league in strikeouts.

Joining Adams for the pitching rotation were rookie Dode Criss and veteran Walter "Hickory" Dickson. Criss immediately achieved local stardom. He was one of those rare pitchers who could also hit (in 1906, he batted .396). The best description of Criss was given by Ed Remley in 1912: "Dode Criss is a baseball freak."[20] He pitched in the major leagues after the St. Louis Browns signed him in 1908. Joining Criss and Adams in the starting rotation was "Hickory" Dickson. Early in life, Dickson had a broken bone that healed extremely fast. As a result, his friends gave him the nickname he carried into adulthood. In 1905, he played for Temple. In 1906, he went 15-6 against the mighty Fort Worth and Dallas teams and was on the mound for some of the most remarkable feats ever performed by a pitcher. He later struggled in the major leagues during stints with New York and Boston. Just twelve years before his death in 1918, he often carried the Railroaders on his arm.

Not all Cleburne pitchers amassed large numbers while contributing to the pennant race. "Wingo" Charlie Anderson grew up in the nearby Johnson County town of Lillian. It had a total population of fewer than fifty, including dogs, cats and cattle. Charlie started the season on the mound for the Railroaders, was cut and then was re-signed at the end of the season. During the pennant race, he pitched two games in three days, giving the exhausted pitching staff some much-needed rest. He won both games. In 1906, his record was 2-1. He never pitched at home, but he made home-field advantage count because of his contribution. In 1910, he played briefly for the Cincinnati Reds.

The Railroaders were stocked with great fielders. Years later, Roberts stated that his 1906 Railroaders sported the best outfield he had ever seen at any level in baseball. The outfield included Cecil "Dee" Poindexter, who, at thirty, was the old man of the outfield.

He was joined by George "Lucky" Whiteman and then, later in the season, Tris Speaker. Whiteman was the ironman of his day. He played in 1,432 Texas League games during his career and went on to play in the major leagues for the New York Yankees and the Boston Red Sox. But as great as Poindexter and Whiteman were, history would one day declare that the youngest player of the team, Speaker, was the most important.

The First Half Season

With the roster set, it was time to start playing games that counted. In a tradition that would last through the five seasons of professional baseball in Cleburne, the city threw a parade to kick things off. The procession started downtown and made its way to Gorman Park. Newly elected mayor Phil Allin was the grand marshal. He was followed by wagons filled with members of the city council, the Gaskill's Hungarian Military Band, the Dallas Giants and the Cleburne Railroaders. The crowd was large, and the mood was festive. After all, it was time to play baseball. And for the first time in history, Opening Day included Cleburne, Texas!

When the final out of the opening game was made, the Giants from Dallas looked like, well, Giants. The Railroaders were unceremoniously defeated 4–0 before a very large crowd. The Dallas club was in town for a three-game series in the same Gorman Park that just days before had been decimated by a tornado. The resiliency of Cleburne's citizens was on display in the newly rebuilt grandstand. Unfortunately, the craftsmanship of the builders was not matched by the quality of play on the field. Dallas swept Cleburne.

Captain Ben Shelton was serious about winning, but one thing he didn't take too seriously was himself. After the horrible opening series, he wrote to Bill Ward, the manager of the Fort Worth Panthers. "I hereby challenge you for the cellar championship. Please notify all fans. Ben Shelton."[21] The cellar was not what the Railroaders' players or fans had in mind as their destination, but that is where they started. Despite losing the first six games, the fans were supportive. Anywhere from three hundred to four hundred devoted fans would ride the train to Fort Worth to catch a game. Cleburne fans were famous for their volume. Even the local paper reported that the rooters were practicing. "The bends in Buffalo creek, down in Cleburne, are good spots for the fellows to test their lungs."[22]

As the team started clawing its way out of last place, the fans wanted a part in boosting morale. For one series, more than 350 Cleburnites boarded a train bound for Fort Worth. During the game, they supported their Railroaders and made life miserable for the Panthers by out-yelling the Fort Worth fans. This hardy band of fans created a club for the purpose of making sure that the whole world knew that Cleburne supported its baseball team, and they studied what other cities did to support their teams. They learned that Houston fans went on the road wearing loud, obnoxious attire while showing their unwavering support. The Cleburne Rootorial Society, not to be outdone, decided on uniforms of flowing kimonos in loud,

ostentatious colors. This would certainly let a city know that Cleburne fans were in the house. And it might just distract the other team enough to give the Railroaders some advantage.

The Rootorial Society no doubt claimed responsibility for the club's change of fortune when it began winning games. The society consisted mostly of Cleburne residents, but some of its participants were from other cities. One rooter was said to have the voice of a foghorn. During a late-season game in Fort Worth, the foghorn warmed up before the first pitch and kept the Cleburne fans going through the end of the ninth inning. When he was told to knock it off or be shot like a buzzard, he found more volume as he marched up and down behind the bench.

Were the Rooters responsible for the team's success? They undoubtedly contributed to the players' confidence. But, more realistically, the team simply settled down and got into a rhythm. Whatever was responsible, the Railroaders began winning games and slowly pulled themselves out of the huge hole they had unwittingly dug. On the field, things were looking up. But off the field, distractions and problems surfaced.

Rumors surfaced that Roberts would transfer the team to Corsicana. From Roberts's perspective, the home attendance was not reflective of the support he had expected. There was little room for error, as Cleburne had joined other cities in prohibiting Sunday games. Cities like Corsicana, where Sunday play was allowed, provided huge numbers that made up for lighter attendance on weekdays. And Corsicana had a history of supporting baseball. Similar support in Cleburne remained to be seen.

In response, Cleburne's business leaders, led by Mayor Allin, argued that the team's low attendance was largely due to competition for entertainment during those first weeks of the season. The rivals for attention included a street carnival, a newly opened roller rink and, most distracting of all, a dog-and-pony show. (Yes, in 1906, there was such a thing as a dog-and-pony show.) Additionally, rainouts were unavoidable. But the city leaders reminded Roberts that, in spite of those obstacles, Cleburne had invested $1,500 in building a ballpark with a grandstand. And when a tornado destroyed the grandstand, Cleburne showed its true colors by raising money and pitching in to rebuild it in a matter of days. Also, the leaders pointed out that the team wasn't exactly leading the league in wins; more wins would encourage the greater attendance Roberts wanted to see. Cleburne considered its options, including an injunction to prohibit the team from leaving. They were intent on keeping their team.

Finally, the debate over the team's moving was settled. The city put up a guarantee to Roberts to keep the team through the end of the season. When

the Santa Fe Railroad required incentives to build the largest shops west of the Mississippi, Cleburne stepped up to the plate, so to speak. The town put its money where its mouth was for the sake of the Railroaders' success. The city guaranteed more than $6,000 to Roberts if the gate receipts fell short, and a contract was drafted that guaranteed Roberts would not suffer a loss. The contract also guaranteed that the Railroaders would remain in Cleburne to finish the season. The newspaper summed up the reasoning behind the assurance: "We are entitled to the best of everything and why not have the best baseball team?"[23]

As the Railroaders improved, the crowds grew. Cleburne was gaining recognition as a baseball town. And as long as the team played solid baseball, the town loved them. However, when the team played poorly, the fans let the players know how they felt. The local paper summed it up best: "There is not a town on the face of the earth that hates poor playing worse than Cleburne."[24] Just having a seat at the table was not enough: Cleburne wanted a championship.

Early baseball in Cleburne had its hazards. During one game, twelve fans were so mesmerized by the game that they forgot they were sitting on bleachers ten feet above the ground. Although the "wave" was still a century away, the fans were waving their arms, yelling robustly and jumping up and down in the bleachers. At almost the same time, twelve fans jumped up, and then they came down. And down. And down—all the way through the bleachers and ten feet to the ground below. "They were looking at the finish of the ninth and thought they were on level ground. When they hit the ground and looked for the diamond they could only see the heels of hundreds of shoes, swinging from benches."[25]

There was much for the fans to be excited about. The players were putting on quite a show. The pitching staff threw a few shutouts, the bats were coming alive and the fielding was excellent. The fans often rewarded solid play with gifts of hats, vests, clothes and, occasionally, cash, collected by the fans by passing around a purse or hat. Things were looking up, yet there remained one missing piece of the puzzle.

Tris Speaker

Doak Roberts was always looking for baseball talent. On Sunday, May 20, while the team was enjoying a well-deserved day off, he rode over to

Corsicana to scout a semipro team. Knowing that his pitching staff had suffered injuries, he was particularly interested in signing a pitcher. Finding one who could also hit would be a bonus. That day, Roberts watched an eighteen-year-old boy from Hubbard take the mound. His pitching was fine, but what caught Roberts's eye was what the player did at the plate. This boy could bat. After the game, Roberts went to the young man and introduced himself. "I am Doak Roberts, the manager for the Cleburne Railroaders," he said. "What's your name, young man?"

"Tris Speaker," came the reply. "What can I do for you?"

Born on April 4, 1888, in Hubbard, Texas, Tristram Speaker was a Texan's Texan—a cowboy and a ballplayer. Raised on a farm, he learned the value of hard work from an early age. Throughout his life, he was given several nicknames. In baseball circles, he was known as the "Grey Eagle" for his ability to swoop in from center field and scoop a shallow fly from the air just before it hit the ground. After he arrived in Boston, he was given the name "Spoke," because when Speaker spoke, that was it. He was direct and plain. By whatever name, his contributions to baseball and to the communities in which he played remain the stuff of legends.

When Tris was ten years old, he was thrown from a bronco. As he stared up at the horse that threw him, he realized that he couldn't push himself back up with his right arm. His arm and his collarbone were broken. Little boys across America are experts in breaking bones, and this particular break was responsible for converting a right-handed boy into one who threw left-handed and batted from the left side. Speaker later said, "I was a right-handed batter, but found my left arm the stronger, so I changed to batting from the left side."[26]

After high school, Speaker played for the 1906 Polytechnic Parrots, known today as the Texas Wesleyan University Rams. In one game, he was credited with playing shortstop, which is unheard of for a left-handed player. As Doak Roberts continued to talk with Speaker, he determined that he wanted the young man on his team.

Roberts invited Speaker into his buggy, where the two talked baseball. Although his mother didn't want him to play baseball for a living, that is all Speaker could think about. He loved the game. When Roberts offered him a chance to become a professional baseball player, there was no way he could turn down the offer.

The two worked out the details. Roberts penciled in the terms. Fifty dollars a month was the compensation. The two agreed, and a contract was signed right there. Roberts gave Speaker a dollar for train fare so he could

immediately travel to Waco, where the team was playing. He was to report to captain Ben Shelton.

Speaker hopped off the buggy and headed toward the train tracks. Roberts noticed that Speaker's cleats had scratched his buggy fender. When

Tris Speaker's first professional baseball contract. He was paid fifty dollars per month. *Courtesy of Jim Swan.*

Speaker received his first paycheck, it was minus the ten dollars needed to repair the fender.[27]

Speaker took the silver dollar and placed it in his pocket. Although he went against his mother's wishes where baseball was concerned, her lessons

Tris Speaker. *Courtesy of Jim Swan.*

of frugality were well received. Instead of paying for fare, he ran alongside a passing freight train and hopped aboard for the ride to Waco.

After Speaker left the buggy, Roberts put the contract into his pocket. Speaker would later follow Doak Roberts to the Houston Buffaloes in 1907. He did not finish the season for the Buffalos, as he was called to play for the Boston Red Sox. During his major-league career, Speaker maintained a batting average of .344 and continually battled with Babe Ruth for the batting title. He won three World Series titles. He made between six and ten unassisted double plays from center field, an unheard-of feat. Speaker still holds the major-league records for career doubles, followed distantly by Pete Rose, Stan Musial and Ty Cobb.[28] The mother who did not want him to play baseball in 1906 was there for the 1920 World Series, watching her little boy finish his career on top of the world.

Roberts had no way of knowing that his chance encounter was one of the greatest discoveries in baseball history. When his career was over, Tris Speaker was inducted into the very first class of baseball's hall of fame, along with Ty Cobb and Babe Ruth. The greatness of Speaker is often forgotten, in part because he shared the stage with those two legendary players and in part because of his humility.

Tris Speaker stands with an unknown teammate preparing a meal while on the road. *Courtesy of Jim Swan.*

Spoke was a no-nonsense, straight-shooting Texan who never lost contact with his roots. During his major-league career, he put on roping demonstrations before taking the field and cooked his own meals while on the road. And his word was his bond. After his career was over, he returned to Hubbard and lived on the family ranch, where he tended cattle, served as a volunteer fireman and fished nearby Lake Whitney.[29]

In 1958, Speaker pulled his fishing boat to Lake Whitney for a day of casting into the green waters. He was surrounded by the open Texas skies when he took his last breath. Athletes can learn much from this humble giant of baseball: Stay true to your roots. Never take yourself too seriously. And let your actions speak louder than your words. It's the Texas way. And it was Tris Speaker's way—a little less speaking and a lot more Spoke.

With Speaker on the roster, the team had all the ingredients of a pennant-contending team. There was just one problem. The team had dug such a deep hole to start the season, it would be difficult to catch the Fort Worth and Dallas teams, who had been playing more consistently. By this time, the rumor of the team moving had quieted. That was likely a result of Roberts's pronouncement on May 23: "As to Cleburne, I will say that no more enthusiastic city is in Texas and that she is able and willing to support her club to the finish and that the patronage is better than in any other week-day city in Texas. As the owner of the Cleburne club I want to say that I am more than pleased with the patronage and that there is no possible chance for Cleburne to be shaky or have any notion of quitting. Signed J.D. Roberts."[30]

On May 23, the team was in Waco for a game against the Navigators at Katy Park. Approximately three hundred fans, a relatively small crowd, filled the stands to watch the game. In the third inning, Dude Ransom stepped up to the plate for Cleburne. Lindy Hiett was on the mound for Waco. He checked the signs, then wound up and hurtled the ball toward the plate. The pitch was high and inside. The cloth baseball hat Ransom was wearing offered no protection from the leather ball. Ransom ducked, but it was too late. The thud heard throughout the park was the crush of the ball against his skull, which sent Ransom to the dirt. Both benches cleared, and players from both teams rushed to the plate, where Ransom was motionless. He lay there unconscious as the players watched in horror.

When he came to, it was clear that he was seriously injured. Ransom was rushed to a local hospital as his teammates helplessly watched. They were stunned, not sure how to react or what to do next. The umpire ordered the players to return to their positions to finish the game. However, the

Railroaders were now minus their right fielder. Shelton needed a player. The newly signed Tris Speaker was eager to play. "Put me in!" he yelled. His teammates, still in shock, were less than thrilled with Speaker's enthusiasm. One of their teammates was in grave danger, and this young guy who had just joined the team was gung-ho to take their dear friend's place.

One of Ransom's closest friends was second baseman Mickey Coyle. An Irishman known for his quick temper, Coyle was furious at Speaker's conduct. He felt that the rookie's eagerness showed disrespect for his friend and teammate. After the game, Coyle berated Speaker and then took the matter up with Ben Shelton. At first, he asked that Shelton trade Speaker. Then he demanded that Shelton cut him from the team. Coyle took up his case in the clubhouse with his teammates as he relentlessly berated Speaker.

After the last game in Waco, the team showered and proceeded to the train station for the ride to Temple. Speaker was one of the first players to board the Pullman car. As he sat by an open window, he noticed Coyle walking beside the car toward the stairs. Speaker leaned out the window just as Coyle passed by and cold-cocked him square on the jaw. That was the end of the discussion. The Irishman had met his match.

Funny thing about winning: It was fun. The whole town got into the spirit, and celebratory parties often commenced after the games. Since Charles Thatcher was instrumental in getting the new country club built, it was only natural that the club would throw a party for the baseball boys. After each game, both teams traveled south of town, where they were entertained. The popular event, called a smoker, included refreshments, beer and cigars. The party lasted into the wee hours of the night and only broke up when the visiting team had to make its way to the depot to catch a train out of town. The visitors no doubt extolled the merits of Cleburne's hospitality while traveling to the next city.

Despite the growth of baseball in Cleburne and the increased fan support, the city continued its refusal to host Sunday games. City leaders objected to the games and the irreverent noise that would accompany them. As a result, Sunday games were transferred to Waco. City leaders there were anxious for the games because Sunday contests meant big crowds, and big crowds meant large gate receipts. All this translated into greater financial stability for their city. In virtually every American city where professional baseball was played, Sunday revenue made up for slower weekday gate receipts. Indeed, Sunday play was often the determining factor in whether a team would stay or leave a city. Within a few short months, Cleburne would come to regret its Sunday stance.

Between early June downpours, the Railroaders were quietly amassing victories behind solid pitching. On June 3, Rick Adams pitched a fourteen-inning two-hitter en route to a 5–0 victory over Waco. There were occasional forfeits, such as a June 7 game, when Greenville failed to show up. It was rumored that the team members stopped by a stream to stretch their legs and missed the train when it moved out. Regardless of how it happened, they were fined fifty dollars, and Cleburne was awarded an easy victory. With this "win," Cleburne found itself in third place, just behind Fort Worth and Dallas.

With the excitement of a pennant race, Cleburne's residents could not get enough Railroader baseball. The size of the contingent of traveling fans grew. The noise in the grandstands got louder. And when the team was on the road, the fans could not wait for the newspaper to report the scores. Although radio coverage was still years away, the fans wanted more news of their favorite team. And when you cannot get the news quick enough, what do you do? You go to the nearest source. When the team was on the road, the office of the local newspaper would receive over one thousand calls inquiring about the score and whether the Railroaders had won. When Charles Thacker learned that the paper could not report the news because it was too busy fielding calls about the team, he had a scoreboard installed in the window of his sporting goods store downtown. From there, the locals could see the box score of the game. The crowd moved from the doorstep of the newspaper to Thacker's window.

When the team was home, the black-and-white box scores came to life. A fan could catch a game at Gorman Park and watch Tris Speaker take off on a dead run, plucking a shallow fly from the air just inches from the ground. In one game, Whiteman sprinted toward the infield and made a somersault catch. He bounced up without missing a beat and threw the runner out. The fans went nuts. Later that night, several fans presented him with a Panama straw hat for his gymnastic prowess. In another game, old Hickory Dickson was on the mound. He took a line drive square off his arm that necessitated his leaving the game, but not before the injured player picked up the ball and threw the runner out at first. The fans rewarded him, and they continued to award players with suits, hats and scarves.

Success in the minor leagues inevitably means losing valuable players to the big league clubs. With the way the Railroaders were playing, several major-league clubs took notice. Texas was not yet known as a breeding ground for talent, but that was quickly changing. Rumors circulated that Dode Chriss and Hickory Dickson had caught the eyes of some major-league

teams. Would they finish the season in a Railroader jersey? This question prompted many in Cleburne to wonder if the team's wildfire success would also be their downfall.

When the team was away, Gorman Park continued to see action. In addition to expected activities, such as picnics, a most unlikely event also took place. The Cleburne gun club held a shooting meet at the park. From home plate, shooters would take aim on the outfield. The difference in the sound of shot leaving a shotgun and the crack of a ball leaving a bat was unmistakable. It is unknown whether the six-shooter event at the game against the Panthers helped to originate the idea, but it is known that trap shooting was thenceforth conducted in the park. It is unimaginable today for a ballpark to host such an event. But during the early days of baseball in Texas, guns and gloves were natural pairings.

Another natural in baseball is superstition. For over a century, ballplayers have refused to wash a pair of lucky socks, replace a soiled hat or deviate from a routine. And in a game where every detail is recorded, it stood to reason that the Railroaders would find a reason why one particular pitcher had their number. Cleburne struggled with a Dallas pitcher by the name of Pruitt. In trying to understand why, the team, fans and local newspaper surmised that it was the unlucky number thirteen that Pruitt wore on the back of his jersey. Even his shoe size was thirteen. In one game, Cleburne finally appeared poised to win against Pruitt. Toward the end of the game, the Railroaders led 11–1 and had two runners in scoring position. But Cleburne refused to score the last two runs in order to avoid winning 13–1. It worked. The next time the Railroaders faced Pruitt, they sent Dode Chriss to the mound. When Chriss shut out the opposition in a 2–0 victory before three thousand Dallas fans, someone yelled, "Where in the hell is that fellow from?" A Railroader fan replied, "Born and raised in Cleburne!"[31]

As the first half of the season wound down, the Railroaders were playing like a championship team. They were mathematically out of the first pennant race, but they still played a role in the outcome. Dickson pitched a shutout against the Giants, and the team took two of three from the Dallas club. In a bit of irony, Cleburne helped Fort Worth win the first-half pennant. But for the early hole dug by the Railroaders, the pennant would have gone to Cleburne.

The Railroaders were playing well. The stands were full. And Roberts, guarantee in hand, was assured of finishing the season. Overall, the Texas League was solid, and it looked as though a complete season was in the bag.

While the Railroaders were financially healthy and looked to finish the season, it was becoming apparent that the Greenville Hunters were almost

out of financial ammunition. When it was clear Greenville would not make it past the first half season, the league began talking about dropping another team and keeping only four for the second half. Fort Worth, Dallas and Waco were definitely in. Cleburne and Temple were on the bubble. Ultimately, Cleburne won out. Temple was ousted. With the first half season of baseball behind them, the Railroaders could now start their work on winning their first pennant.

Third Inning

THE IMPROBABLE CHAMPIONSHIP

Luck is the great stabilizer in baseball.

—*Tris Speaker*

With Fort Worth's first-half pennant victory in the books, the slate was clean. The race was on for the second-half pennant and a place in the championship series. While most preferred a series between Fort Worth and Dallas, Cleburne was red hot and positioned to upset the balance of power.

In many ways, baseball seasons can be seen as a series of streaks. Teams get hot and then, just as quickly, they run cold. In 1906, Cleburne was no exception. As in the first half, Cleburne started the second half season on a losing streak. After the first week, the Railroaders were again in the cellar, with a record of 1-7, leaving many to scratch their heads. Why was the red-hot team of just a week ago now unable to win? Some blamed the sunshine that finally peered through the early summer rain clouds. More likely, it was the result of many errors the team was making. Regardless, the team was in the same position it held beginning the first half season—in the cellar. If there was a pennant to be had, the Railroaders would have to go from last place to first.

To make matters worse, Roberts sold one of the team's catchers to a club in Shreveport. Rumors immediately circulated that there were three other trades coming and that Roberts was slowly but surely dismantling the team. The team dropped to 2-8. All of a sudden, the team that Dallas feared even

more than the Panthers just weeks ago was competing for the league lead in errors rather than the pennant.

With its back against the wall, the team could fold, or it could claw its way out of the cellar. Dallas arrived at Gorman Park to find the Railroaders in a surly mood. They had had enough of losing. Dode Chriss took the mound with complete command of his pitches and proceeded to mow through the lineup with relative ease. Toward the end of the game, Dallas put two men on the bases before pitcher Bobby Wright saved the shutout for Chriss. At the crack of the bat, Wright took off on a dead run to reach the point where the ball was going to fall for a hit. Allowing a two-run single was not an option. With two outs, he stretched his bare hand out and leapt forward, lunging for the air where the ball would soon arrive. With the tips of two fingers, he caught the ball to end the inning. It was a miraculous catch. More important, it was the beginning of a turnaround for the Railroaders.

On the same day that Wright made his miraculous catch, a new catcher arrived in town. Parker Arbogast had played for Temple, but with that team now out of the league, the great catcher was available. Roberts's move a few days earlier now made sense. He wasn't dismantling the team; he was making room on the roster to strengthen the team. Arbogast would soon play an important role in the Railroaders' push at the end of the season. The man with a great eye for talent had struck again.

If sunshine was the problem for the Railroaders, then their fortunes rose when the rains returned to Cleburne. During the second game of a double-header with Dallas, the rains began in the fifth inning. In the middle of the inning, umpire Collins took his place behind the plate and yelled, "Play ball!" The heavy rain made it hard to see the dugouts, but Collins could see that nothing was happening. "I said, 'Play Ball!'" he yelled louder. Still, no one was stirring. For the third time, Collins cried, "Play ball!" As the umpire came over to chew out the players, he discovered that the teams had left the dugouts and were already in the clubhouse. With no ballplayers to order to the plate, Collins called the game on account of rain. In actuality, it was the lack of players to take the field.

As the rains returned, the Cleburne Athletic Club met to discuss the future of Railroader baseball. There was a certain measure of distrust for Doak Roberts. The local businessmen, still fearing that he would move the team, planned to take matters into their own hands. The club discussed the recent movement of players, then they discussed mutiny against Roberts. It was a funny thing how mere spectators had suddenly

1905 – OPENING OF CARNEGIE LIBRARY – with ladies and men who were responsible for its founding. No. 298

Local business leaders pose for the opening of the Carnegie library. Today, the building houses the Layland Museum. *Courtesy of Layland Museum.*

become baseball experts. Roberts had years of experience and an eye for talent. Yet these new "experts" were talking big and shaking things up. The rift between the locals and Roberts was widening. By season's end, it would become unbridgeable.

For the average resident, the Railroaders were a symbol of pride. The team energized the community by perpetuating the creation of baseball leagues throughout the city. There were amateur leagues, church leagues and leagues full of youngsters. On any given day, a pickup game of baseball would form in yards all over the city. In every way, Cleburne was now a baseball town. And it had the Railroaders to thank.

At Gorman Park, the professional teams practiced all sorts of legendary moves. Dallas pitcher Garrett used a copious amount of resin to crust his fingers. The result: a hard curveball that was impossible to hit. One hundred years later, pitchers across the country would get creative in hiding substances under their hats and in their hair, all in hopes of getting the ball to move a little more. In a game against Waco, the Railroaders tried the old hidden ball trick. Charlie Moran, the first baseman, visited the mound and, unknown to anyone in the park, returned to the bag with the ball. When the runner started his lead, Moran tagged him and showed the crowd the ball.

The early years of professional baseball in Texas were wild, and the tough, talented players got away with almost anything.

While the team was amassing wins, rumors of losing players persisted. Chriss and Dickson were in the middle of the discussions. The fans wanted to see their players go on to major-league careers, but they also wanted to keep their pennant-chasing team intact. Players and fans alike were on pins and needles. As it turned out, both Chriss and Dickson would leave for greener pastures, but not until the season was over.

On Friday, July 20, the Railroaders lost a game to Waco on a controversial call. The pitcher, Hickory Dickson, took a line drive to his ankle. He was in so much pain after the hit that he could not secure the ball, though it landed only a few feet from him. As he writhed in pain on the ground, the Waco players began circling the bases. Several runs scored, giving Waco the lead. Later, with the game tied 4–4 and two out, George Whiteman caught a popup by trapping the ball next to his body. For some reason, he tried to flip the ball up and throw it in. When he did, he lost his handle on it, and the ball flew out of his hands. He was so quick in the exchange that the umpire thought he dropped the ball and called the runner at home safe. The game was over for the players, but not for the umpire. The fans wanted to have a little visit with him—mob style. They surrounded the umpire and let him have it. For a while, it looked like a fight would break out, but the crowd soon dispersed. The blown call cost the Railroaders the game.

The next day, the same umpire was in Dallas for a game between the Panthers and the Giants. Once again, he blew a call. The Fort Worth club had heard about the incident in Cleburne the day before and declared that enough was enough. The Panthers packed up their gear and left the field in protest. The umpire called a forfeit against Fort Worth. Weeks later, when the season was coming to a close and Fort Worth was trying to scratch out enough wins to secure the pennant and the championship, the players likely wished they had finished the game rather than walked off in protest.

The blown calls affected the two teams quite differently. For Cleburne, it made the players stronger. They were now determined to do everything in their power to make sure an umpire couldn't negatively affect their game again. The Fort Worth players, however, were mentally weakened after walking off the field in protest. Unfortunately, these were not the only poor calls made by umpires in the league. During the early years of baseball, a single umpire behind the plate was responsible for the calls at the plate, at the bases and in the outfield. It was a tough job that often resulted in upset fans who tried to take matters into their own hands.

On July 23, fans in Fort Worth, where Cleburne was playing a series game, were more than upset. After a controversial finish, a group of fans left the stands to express their feelings to the umpire. The crowd soon got out of control with shouting and pushing, and it appeared that some hoodlums were going to beat up the umpire. Charlie Moran caught a glimpse of the scene. He had had enough. He picked up his bat and stomped over to the group. As he threw his bat up on his shoulder, he proclaimed, "Anyone wants to start a ruckus will get his coconut cracked!" The mob backed down and dispersed.[32] That authoritative voice would eventually be Moran's trademark as he became one of the greatest umpires in baseball history.

The next day, two umpires called a game that would make history, not for an off-the-field incident but for what took place on the diamond. Cleburne and Fort Worth squared off in one of the greatest pitching duels ever recorded. Dickson was on the mound for Cleburne and Dupree for Fort Worth. At the end of nine innings, the score was tied, 0–0. The teams marched on to extra innings. In an amazing display of stamina, the players continued until the bottom of the nineteenth inning, with both teams still scoreless. The game was called on account of darkness. The two teams set the Texas League record for most scoreless innings. Through nineteen innings, Cleburne secured seven hits and Fort Worth six; there were a total of 123 at-bats.[33]

When the dog days of summer arrived, the Railroaders climbed to an even record and were four games out of the lead. After so many losses in the first two weeks of the second half season, this Cleburne comeback was remarkable. That Dallas and Fort Worth once again found themselves virtually tied surprised no one. What no one saw coming was the steam that Cleburne was building. They were starting to play like a team full of major-league talent.

While Fort Worth and Dallas likely didn't notice what Cleburne was doing, Railroader fans did. They continued to fill the stands of Gorman Park when the team was at home, and the Rootorial Society continued to organize day trips for the away games. By the hundreds, the colorful fans traveled to Waco, Dallas and Fort Worth. The Texas heat could not sap the enthusiasm of the Cleburne bunch, on or off the field.

As they racked up more victories, the Railroaders moved into second place on August 1. A long series with Waco helped their cause. By this point in the season, Waco had faded to last place. It would have been easy for the Railroaders to cruise through the Waco series, but they were focused. They needed to finish off the Navigators to make up for their slow start. They had

passed Fort Worth by the slimmest of margins and were within two games of Dallas. Now more than ever, first place was within reach.

As the finale of the season was approaching, fans across Texas still believed that the Texas League champion would be decided in a playoff series between Fort Worth and Dallas. Then, as the teams were winding through the final month, Dallas received a huge blow. Edward Rodebaugh, their star pitcher, was sold to St. Paul. It was a good move for Rodebaugh's career, but a bad one for Dallas's chances of winning the second pennant.

While Dallas was contemplating its odds after losing its best pitcher, Cleburne rolled off five straight victories against Waco. The team finally made it to first place. The only problem was that the position was also occupied by Dallas, and Fort Worth had one foot on the same podium. The season was heading to a close finish, and the pennant was up for grabs. Rather than fold like a cheap suit, Dallas was galvanized by the loss of its pitcher. Fort Worth continued to play like the first-half pennant winners. And the Cleburne club continued to defy the odds. It was anyone's pennant.

The next day, Cleburne pushed Dallas and Fort Worth out of first place. The team had gone from cellar to leader. The players, focused on doing their best on the field, likely didn't notice—or care—that they had defied the odds in clawing their way to the top. The players wanted to win the last game of the season and hoist the Texas League championship trophy above their heads. The fans, however, were more than proud of their team. They boasted that no one could beat their beloved Railroaders, not even that soon-to-be-legendary team from New York.

Even with the Railroaders in first place, the rumor of the city losing the team somehow resurfaced. Without the huge Sunday game receipts, the team continued to struggle financially. Worse, Roberts and the Cleburne Athletic Club remained at odds. Roberts took shots by making public the details of Corsicana's offer to transfer games from Cleburne. The athletic club shot back that Roberts violated the agreement with the club by transferring games to Waco. The club intimated that it would not honor the guarantee that was made to keep the team in Cleburne for the rest of the season. Roberts was furious. How could this ungrateful bunch renege on the deal? The close friendship with Charles Thacker was likely strained. Thacker was crunching the numbers to determine the game statistics and the number of games needed to bring home the pennant and was probably unaware of the storm that was brewing. The continuing public feud inevitably made its way to the clubhouse. The players could control what happened on the field,

The Railroaders and many fans made the trip between cities, riding the rails behind steam locomotives. In many cases, the same locomotives were repaired in the Cleburne shops. *Courtesy of Sonny Burt.*

but off the field, they were as helpless as the fans in the stands. They were spectators in their own drama that was playing out before their eyes.

Things were so tense between the manager and the Cleburne Athletic Club that Roberts dispatched Ben Shelton to Greenville to see if that city wanted the team. Despite the heated pennant race, the team's captain was on a recruiting trip away from his players. Once again, it appeared that the season was about to unravel for Cleburne. It was looking more and more like the team would move before the last game. It looked like Cleburne would be left without the coveted pennant or a chance to play for its inaugural season championship.

Fortunately for the Railroaders, one of their biggest fans was Willmot Mitchell Odell. Born in Cleburne on March 16, 1878, Odell later graduated from the University of Texas and received a law degree from Georgetown University. He would finish a long and distinguished career in public service and as counselor for a national railroad. In 1906, he was a state senator and a rising star in both state and national politics. Odell

had the ear of powerful leaders and, more important, the ear of a loyal following from his hometown.[34]

When word of Shelton's scouting trip reached Senator Odell, he was furious. Enough was enough! This was not the way winners were supposed to act. The senator thought this was madness and that the battle of egos must end. So, he marched right down to Gorman Park, where he set up a campaign at the entry gate. As businessmen arrived to take their seats, they were greeted by the powerful senator. He decided it was time to raise the money needed to put the matter to rest. He would not let the businessmen take their seats until they committed to donating money to the cause. "The boys are not going anywhere; did you say $5 or $10 opposite your name?"[35]

After the game was over, the senator made his way to the scorer's box and gave a speech to the fans. He refused to let anyone leave the park just yet. Some complained that they had to catch a train to Dallas. He would not relent. He told the crowd that, although a tidy sum had been raised, more was needed to keep the team in Cleburne. "I feel sure," he went on, "there are others who would like to contribute to the fund, and I will certainly be glad to consult any who are liberally inclined."[36] The fans, and even the players from both teams, were moved by the impassioned speech. Cleburne had won the game, 4–3, but more importantly, the senator had won a purse of money to help keep the team in Cleburne.

As if the fight between Roberts and the Cleburne Athletic Club was not enough of a distraction for the players, they would soon find out that Temple was threatening to shut down the season. Temple was still upset over losing out when the league dropped to four teams following the exit of Greenville. Despite Doak Roberts's vote in support of Temple, the league voted in favor of cutting it. When Temple was advised to file a lawsuit against the league, word traveled to the Cleburne clubhouse.

Within a few days, it looked as if the season would end prematurely because of the Temple lawsuit. The legal action requested an injunction to shut down the league immediately. While there was no national precedent for such action, a judge was actually contemplating doing just that.

With two large clouds hanging over their heads, the Railroaders boarded a train for Fort Worth. Although the off-the-field drama was spiraling out of control, they still had games to play. They had worked so hard to get back into a pennant race. The season was shaping up to be one that could make history, and it was likely going to come down to the last pivotal game of the season, if there was a season to finish. The locker room was silent as the

players wondered if the next telegram they received would be a judge's order to stop playing the game they loved.

Speaker's Last Trip to the Mound

With a season in jeopardy, what is a player who loves the game supposed to do? With the club in Fort Worth, the players left their hotel rooms and walked down to the one place they probably should not have: Hell's Half Acre.

Hell's Half Acre was already a legend. Located on the south side of downtown Fort Worth, it was home to saloons and flophouses. For years, cowboys driving cattle could whet their healthy appetites of beer, gambling and a prostitute if they were so inclined. The district's impact on the Fort Worth economy was as large as it was on the lives of its guests. By 1906, Fort Worth's acceptance of the area was waning.[37] While most Fort Worth residents continued to turn a blind eye to the frivolity and sin that was rampant in Hell's Half Acre, Cleburne residents were not as accepting. In fact, such conduct was strongly disapproved of by the churchgoing community.

There is no mention during the season of the Railroaders wandering over for a drink at Hell's Half Acre—that is, until August 9, when it appeared that the season could be cancelled at any moment. Tris Speaker and his teammates stayed out late, drinking their sorrows away. When the sun came up the next morning, they half expected to pack their bags and head home. However, the telegram never came.

As the morning gave way to noon, the players made their way to Haines Park for a game against Fort Worth. Their heads were pounding, and their stomachs were on edge. They were hung over.

Tris Speaker was scheduled for an appearance on the mound. He likely didn't spend much time warming up, as his eyes could barely take the bright sun. His teammates, including archrival second baseman Coyle, were in much the same condition. As the game started, it was apparent that Speaker could not find the strike zone. Fort Worth, scoring early and often, jumped out to a huge lead. Despite Speaker's struggles, Shelton left him in the game to endure the greatest beating of his baseball life.

Years later, when asked about his remarkable career in the outfield, Speaker would instead recall his last career start on the mound. He could have talked about his batting average title, his World Series victories, his major-league records or his induction into the hall of fame. Instead, he told

the listener about the day his pitching career ended. With a smile on his face, he said he was left on the mound to rack up a final score of 24–2. (It was actually not quite that bad; the score was only 16–4.) Late in the game, he recalled, Ben Shelton was sitting in the dugout when he called out to his young pitcher. "Well, son, you haven't given up a single hit.…They're all doubles!"[38] In telling this story, Speaker's smile would widen. A fan's question about his career would be answered with insight into his character. The humble giant of baseball never took himself too seriously.

The threat of the team transferring to Corsicana passed, as did the threat of a season-ending injunction. Dickson and Chriss were signed to other teams, but they would not report until after the Railroaders' season ended. The team could now move past the hangover of the crisis and get back to playing baseball. And play they did. This team had to overcome obstacles on and off the field, and it would continue to fight through adversity and weather to try to win a pennant. During one game, a ball struck third baseman Roy Akin and bounced off his leg into the mud. He could not find the ball, as it was deeply buried in the slop. Dickson ran over from the mound to assist. While the two searched for the ball, two Panthers found their way to home plate. The missing ball cost the Railroaders the game. At times, it seemed even the weather was against the Railroaders.

The season was winding down, and everyone was focused on landing the pennant. Doak Roberts stopped talking about transferring the team and instead recruited Si Mulkey, an old ballplayer known for his fielding skills. Roberts was shoring up the roster by finding ways to decrease fielding errors. He knew that runs win games, but that defense wins championships.

For every baseball team in America during the dead-ball era, home runs were virtually nonexistent. Nevertheless, during a game against Fort Worth, the Cleburne fans became restless and started chanting for a home run. Gorman Park, with a very deep outfield, had not yet seen an out-of-the-park home run. George Whiteman stepped into the box, hoping to oblige the fans. He hit the ball with such force that the cover came off as it sailed into the outfield, and his bat split in two. A few days later, he broke another bat. Players usually only carried a single bat. After Whiteman broke two, there was virtually no chance that a teammate would lend him their bat. So Whiteman located an old wagon tongue and brought it to the Osborn Mill. There, he had a millworker turn the tongue on a lathe until a new bat emerged. Whiteman was not the only Railroader to transform wagon parts into bats. The team was often called the Wagon Tongue Swingers.

The Railroaders continued to swing away. While Whiteman's swing for the fence at Gorman Park fell short, Ben Shelton's didn't. The ball traveled over the center-field fence. It was the season's only out-of-the-park home run given up there. The fans raised twenty-one dollars, and a new suit of clothes was awarded to Shelton. After that game, he was recognized as the official sultan of swing in Cleburne.

During the final stretch, it was the team's pitching that was on display, and it was pitching that would carry the Railroaders to the finish. After the hangover from Hell's Half Acre, the Railroaders lost several games and found themselves looking up at the leaders again. If they were going to win a pennant, they would have to come from behind again.

With the end near, it was announced that Cleburne would play five double-headers. The Railroaders had a reputation for strong pitching, but the intensity and demands required of double-headers would almost certainly take the steam off the team's fastballs. Or would it?

The pitching staff was exhausted and in dire need of rest as the team was in the stretch run. On August 24, Rick Adams pitched both sides of a double header, winning both games. Instead of wearing down, his strength increased the longer he pitched. He won the first game, 3–1, and gave up three hits. He followed that feat by pitching a no-hitter to win 6–0.

Although the pennant race was serious, the players and fans were having fun. During a game against Waco, Cleburne was leading 10–0 in the late innings. The fans started yelling for the Railroaders to let Waco score. When a line drive was hit directly to second baseman Coyle, he picked up the ball and placed it in his pocket, allowing the runner to make it to first. The fans went nuts with excitement. Captain Ben Shelton also went crazy—with frustration.

A few days later, Charlie Moran was tending first base. A runner was on the bag, and an infield popup was hit directly to Charlie. He slowly moved a few feet in front of first base. With his body between the baserunner and the ball, he let the ball slip between his chest and his glove. He froze for a moment as though he had caught the ball, then nonchalantly reached down, picked up the ball, tagged the runner and then stepped on the base. It was an unassisted double play. The fans didn't realize what had happened, nor did the runner. Years later, this type of play would disappear with the advent of the infield fly rule. But in 1906, the Railroaders were making plays like this and having the time of their lives.

Off the field, the local skating rink invited the team to participate in a skate-off to determine which baseball player was the most accomplished on

wheels. The team members showed up and battled for the title of skating champion. They were young and oblivious to the risks they were taking. Several players fell until only one, Parker Arborgast, remained. The catcher was officially the best roller skater of the Railroaders. On and off the field, the team was making memories for a lifetime.

Sensing greatness in the making, Ben Shelton made arrangements with Shaw's Gallery to have the players photographed. The captain, and by now most of the town, realized that this team was special. It was likely that many of the players would move on to bigger and better things. While many recognized the team's potential, it would be decades before the players' careers were finished and the team was credited with nine major-league players, including the greatest center fielder of all time. The studio photographs would be the only ones ever taken of many of the Railroaders.

Cleburne was not the only team pushing for a pennant. While the Railroaders were mowing through the Waco lineup, Fort Worth and Dallas were in a battle. A championship series between the two was the talk of both cities. Cleburne was locked at the top with Fort Worth, but league leaders knew that attendance for the two larger cities would net more ticket sales. However, Dallas did not hold up its end of the bargain. After losing both sides of a double-header against the Panthers, it was virtually impossible for Dallas to win the second-half pennant. It was coming down to Fort Worth and that scrappy Cleburne bunch.

With a pennant in sight, the Cleburne fans began talking about what they might need to do to prepare a victory celebration. A hat would be passed around to take up a collection for the players. A feast needed to be planned, and a keg of "cool nails" needed to be tapped.

With a week to go, the Railroaders' pitchers were worn out and beaten up. It was debatable whether they had enough strength left in their arms to finish the season, let alone pitch at a championship level. That's when the genius of Doak Roberts kicked in. He remembered the pitcher he used for a single game early in the season. "Where was that man from?" Roberts pondered. "Let me see. Lillian, I think. Yes, that's right."

Wingo Anderson left Lillian and returned to the mound on August 29. The club was days away from the showdown series against Fort Worth, and the team needed its star pitchers rested. Wingo pitched two consecutive games, winning both of them. In doing so, he kept the Railroaders in the hunt for the pennant and, more importantly, gave the pitching staff a few days off to rest. The Lillian pitcher finished his Railroader career with a record of 2-1, yet he never pitched at home. During those last two outings,

Wingo gave the team just what they needed. He also set up one of the best season finishes in baseball history.

Going into the final series, Cleburne and Fort Worth were tied for first place. Although the series was set for Cleburne, the Fort Worth club wanted it transferred to Haines Park. The manager argued that larger crowds would attend in Fort Worth than in Cleburne. The actual motivation for this argument was likely the fact that Fort Worth had not fared well at Gorman Park. For some reason, Doak Roberts agreed to the transfer. If a pennant was to be won, it would not happen at Cleburne's home park.

Ben Shelton was furious. He knew that he held the home-field advantage, and he wanted every benefit he could get. A pennant was at stake, for crying out loud! "The Panthers don't want us at home for a good reason," Shelton likely argued. But Roberts would not budge. The game would be played in Fort Worth. "Then it will be played without me," Shelton stated.

"Then so be it," was the manager's reply.

On September 1, the Railroaders arrived at Haines Park in Fort Worth without their team captain. True to his word, Shelton stayed behind in Cleburne to protest the change of venue. The Railroaders appeared lost without their captain, and Fort Worth cruised to an early lead. When the seventh inning arrived, Fort Worth led 5–0 and was on its way to the 1906 Texas League championship and its second pennant win.

That's when Cleburne's bats came to life. The Railroaders came roaring back, scoring six runs. The game would end in victory for the Railroaders, 6–5. In the end, the change of venue was not enough to secure a win for Fort Worth. The Cleburne players, minus their captain, took care of business on the field. The pennant was now the Railroaders' to lose. All they had to do was split the double-header the next day, and they would win the pennant and the right to play for the championship.

On September 2, with the pennant on the line, Hickory Dickson took the mound for Cleburne. In the course of the season, Hickory had produced one no-hitter, four shutout victories and the record nineteen-inning scoreless tie with Fort Worth. He was an ace with a pitching record of 26-12.[39] On this particular day, he carried the entire team on his throwing arm. Before a large crowd that included over four hundred Cleburne fans, he pitched both sides of the Sunday double-header. And twice he pitched a shutout. The Railroaders won both games by a score of 2–0, and old Hickory was carried off the mound. When the last out was made, the Cleburne Railroaders became the second-half pennant winners of the 1906 Texas League.

With the pennant in hand, the Railroaders were now poised to play Fort Worth in the championship series. Doak Roberts met with Bill Ward, the owner of the Fort Worth club, and the two discussed ways to increase gate receipts. Besides playing games in Fort Worth, they discussed having Cleburne play its "home" games in Dallas. They also talked about shortening the series. Ward advised Roberts that he could not keep his players around indefinitely, as some of them had businesses that needed tending, and one had a family member with a serious illness. At the conclusion of the brief conversation, Bill Ward conceded the championship series to the Cleburne Railroaders. With that, he extended his hand to congratulate Doak Roberts and his Cleburne Railroaders on their improbable championship.

It was official: The Cleburne Railroaders were the 1906 Texas League champions. The small-town, first-season team had overcome adversity, tornadoes, injury, rumors and multiple trades to string together one of the finest seasons in minor-league baseball history. They bested teams from larger cities like Fort Worth, Dallas and Waco. Roberts called the players together and informed them that they were officially champions.

The team boarded a train for their return to Cleburne. When they arrived at the depot, it was raining. There were no fans there to greet the newly minted champions. The season's abrupt end meant that there was no band, no celebration and no party. There was no front-page headline announcing the championship. The local newspaper published the only photograph of the team on the second page.

The team gathered one last time to say their goodbyes. Captain Ben Shelton spoke a few words, and then Charlie Moran stood up and grabbed Ben's hand. "Ben, old man, you have made a better man out of me, and I am glad I came to Texas. I will bid you farewell: we may never be gathered together again."[40] With those words, there were hugs and tears as the players who had become a family through adversity said their goodbyes. These extraordinary men had come together for a common cause. Now they would return to their homes. Some would meet again in the big leagues. Some would never play professional baseball again. But on this day, the family of Railroaders were champions.

The Railroaders were awarded a trophy. Twenty inches tall, the sterling silver trophy was specially made for the 1906 Texas League championship. The trophy was purchased by the J.E. Mitchell jewelry company of Fort Worth. The jeweler commissioned the famous Rogers, Smith & Company foundry of Meriden, Connecticut, to create one of the most beautiful trophies ever seen. The Mitchell Company had assumed that it would end

up in the hands of its beloved Panthers. No one thought it would go to Cleburne.[41] The trophy was never displayed in Cleburne.

Before all the players dispersed, a few were given some gifts from the fans. Joe Hubbard, the proprietor of the eastside pool and billiard parlor, gave a box of cigars to the remaining players. Dode Chriss was given some socks. A fundraising game had been attempted, but only seventy-five fans showed up. The season was hard on the players, hard on the owner and hard on the fans. There was an air of relief that they had all made it to the end.

The man whose dream was fulfilled when professional baseball landed in Cleburne, Charles Thacker, paid the largest price for that 1906 season. Although his team defied the odds and won the championship, that year, he lost his wife, his friendship with Doak Roberts was severely damaged and his reputation had taken a hit. When the season ended with no celebration, that was the final straw for Thacker. He told the local paper that "as far as he was concerned, they could take the wood out of Gorman Park and turn it into chicken coops."[42] In early 1911, Charles Thacker died. He likely did not know that professional baseball in Cleburne would return. His house

One of the few photos taken of the 1906 Railroaders, by Shaw photography. *Courtesy of Layland Museum.*

was quiet, and there was little fanfare upon his departure from this life. But for that one glorious season in 1906, he kept score for the team he dreamed into existence.

It was not long after the last talk in the clubhouse that Doak Roberts packed up his trophy and his team and headed to Houston. There was no fanfare and no celebration. Just the slow march through fall toward the chill of winter. It would be decades before the magnitude of this team's achievement would be fully understood. For the most part, Cleburne went back to its daily routine. As the years rolled on, memories faded and fewer people recalled that improbable season of professional baseball. After a century had passed, hardly any resident in Cleburne knew that the city had once been home to a professional baseball team that included the beginnings of nine major-league careers. And still fewer knew the stories that were the heart and soul of that season.

However brief the moment, and despite the lack of fanfare, the Cleburne Railroaders were the improbable Texas League champions of 1906, and no one could take that away. History would later declare this championship team one of the finest in Texas history.

Fourth Inning

THE DISPUTED CHAMPIONS

When baseball is no longer fun, it's no longer a game.
—*Joe DiMaggio*

Almost five years had passed since the championship over Fort Worth, Dallas and the rest of the Texas League. With the team a distant memory and the trophy resting in Houston, there was a hole the size of a baseball diamond left in Cleburne. When the team packed up and moved to Houston in 1906, the town went back to the hum of daily life. The days apart from professional baseball rolled by. Months turned into years. America was on the move, and Cleburne was no exception. Still, there was something missing in Cleburne. There was a strong desire among its residents to again rally around a professional baseball team.

Cleburne's population continued to explode as the railroad shops grew. By 1911, there were 10,364 residents within the city limits.[43] That figure exceeded 15,000 when the outskirts of town were included. With growth came cultural entertainment, a state-of-the-art Carnegie library, new schools and an abundance of commerce. Cleburne was more than just a stop along the railroad tracks. It continued as a state leader in many aspects, and the community was proud of its progress.

Renewed community pride came to the town in 1911. Cleburne elected a new mayor, a man whom the *Cleburne Morning News* described as largely popular. "Cleburne can boast of having more mayor than any other city in Texas," the paper reported.[44] If things were bigger in Texas, Cleburne

wanted to lay claim to the title as well. It was clear the city wanted to lead the state again, even if it was simply to boast about the girth of its mayor, Charles W. Breech.

Cleburne sat on the bench as baseball spread across Texas. Teams came and went, just as they had in 1906. Some made it through the season, others folded midway through. Smaller markets, like Cleburne, continued to jockey for position, some successfully. Despite the grand 1906 season, Cleburne remained on the outside looking in. That did not sit well with a town that had become accustomed to leading. The time had come to do something about it.

As the winter chill wrapped the city in the first month of 1911, Joe Cole, a local business leader, began laying the foundation for the return of professional baseball to Cleburne. Following the 1906 season, the team was gone, but the park's debt remained. As with most small Texas towns, baseball seldom paid for itself, and it was a struggle to maintain the costs of both a team and a stadium. Cleburne and Gorman Park were no exception. If baseball was to return, a clean financial slate was necessary. Cole set out to lead the charge to restore Gorman Park, but he knew it would require the city to rally behind his efforts.

With several donations in hand and the community's support on the rise, Cole was able to retire the debt associated with the baseball park. The next step was gaining a team, and that meant finding a league willing to accept a team from a small community. Overcoming that hurdle was no simple task. Often, league teams were in proximity to one another. This kept expenses down when the teams made the "jump" from town to town. It was not just a matter of having easy access to a train—Cleburne certainly had that. It required several nearby towns that could support a baseball program. The Texas League had experimented with smaller markets, but by 1911, it had returned to the larger cities. Just when Cole's dream of a baseball team seemed unlikely, he heard of a league that involved several Texas and Oklahoma teams. The distance, however, seemed prohibitive.

If Cleburne was to play baseball in 1911, it looked like the Texas-Oklahoma League was the only option. The league was led by Wichita Falls businessman F.P. St. Clair, the superintendent of a large Wichita Falls company. Known as a solid businessman, St. Clair had fallen in love with the game of baseball. His passion for the game led to the creation of a team in Wichita Falls and ultimately landed him the position of president of the Texas-Oklahoma League. In late January, Cole wrote to St. Clair and made the case for including Cleburne in the upcoming season. St. Clair promptly responded:

A Railroader History

Feb. 3, 1911

Mr. J. W. Cole,
Cleburne, Texas

Dear Sir: Yours of the 2ⁿᵈ is at hand and the contents are noted. In reply would say that we think that probably the town of Cleburne would be a good town for the league but for one exception, and that is the distance from the other towns.

We will forward your letter to our field man and it is possible that the writer will call on you in person and talk to the matter over with you.

Thanking you for your inquiry and promising a further letter regarding this, I am, yours very truly,

F.P. ST. CLAIR[45]

Exactly how Cole responded is unknown. What is known is that he was persuasive and persistent. The door was open, even if only by a slight crack, and he would not take "no" for an answer. Within ten days of receiving the letter from St. Clair, the *Fort Worth Star-Telegram* reported that the league president was heading to Fort Worth for what would be an early version of baseball's winter meetings. And he was bringing details of Cleburne's entry into the Texas-Oklahoma Class D league. Cleburne was in! Cole's work in leading the community and his persuasion with St. Claire had paid off.

Cleburne's distance from the circuit was not the only concern. The 1906 team was put together hastily and did not have strong financial backing. The champions relied almost exclusively on gate receipts and had no financial safety net for emergencies. This caused concern for the local business leaders, for the baseball enthusiasts and, most importantly, for league officials. Cole had learned the lessons from 1906 and promised to raise a reserve fund sturdy enough to withstand lean times or emergencies. Cole had to ensure that Cleburne could make it to September and not fold like so many other Texas teams previously had done. Cole got the city into the league, but now he had to work to build the foundation that could keep them in it for the duration.

Cleburne's new league promised some interesting games and events. The early favorite to win the pennant was Wichita Falls. It is likely that St. Clair and his Wichita Falls team were not threatened by Cleburne's return to baseball. That would soon change, however. The other teams were

Denison, Sherman, Greenville and Ardmore. Durant, Altus, Bohnam and Lawton would also join the league later in the season as replacements or additional teams.

The Cleburne Baseball Association was formed to ensure sound financial support. Its first task was to give Gorman Park the makeover it so badly needed. With no professional team on the field for several years, the park had fallen into disrepair. It needed a fresh coat of paint, improvements to the stands and preparation for the field. The association set out to get the park and the town ready for the new season.

When spring arrived, baseball was once again the talk of the town. In early March, baseball players from miles around descended on Cleburne for spring tryouts in a swarm as thick as mosquitos. If a resident passed a stranger with an accent, it was a sure bet he was a ballplayer from another state arriving for the tryouts. There was a palpable sense of pride in the air. Whether in the barbershop or at the hardware store, the conversation was focused on baseball.

The players trying out for the team were in Cleburne because they loved baseball. And that was a good thing, since early professional players could not rely on their meager pay to support themselves. They worked

Baseball was a topic often discussed at Peacock's Barber Shop, located in downtown Cleburne. *Courtesy of Layland Museum.*

during the offseason and frequently took additional jobs in order to support themselves and their families. Some even tried their hand in the entertainment industry. The local paper took a poll regarding whether ballplayers should double as vaudeville actors. "I don't know how it will work out," replied one fan. "But I'm afraid that when the season comes around some fellow will forget himself and start up a ballad when he ought to be sliding to second."[46] Over the next century, fans continued to question whether athletes could succeed as actors. It would be some time before players of America's pastime became commercialized commodities. In 1911, folks just wanted ballplayers to be ballplayers.

While Cleburne would play several local clubs during spring training, the first game of baseball's return was something special. While the team's name, the Railroaders, was the same, its preseason plans were more expansive than they had been in 1906. These Railroaders would host none other than the famous Chicago White Sox. Cleburne fans filled Gorman Park in record numbers to watch their home team compete with the big leaguers for two games.

Cleburne, like many other Texas teams, benefited from a state connection to the windy city. A businessman from Mineral Wells, Teri Sullivan, knew Charles Comiskey, the famous owner of the White Sox. Comiskey was looking for a way to escape the damp, cold spring weather while preparing his team for the upcoming season. Sullivan leveraged his acquaintance with Comiskey to secure a swing through warmer Texas cities for Chicago's spring training. In 1911, Cleburne benefited from the swing trip.

While the Cleburne boys were not quite ready for major-league play, they competed well and held their own against the Chicago juggernaut. In fact, the Railroaders fared significantly better than the other Texas teams. A large Gorman Park crowd gathered to watch their team put up a gallant effort. Chicago won by a score of 6–2. As fans left the stands, excitement filled the air. Maybe the Cleburne boys could do the impossible the next day and steal a game from the legendary team.

The second game, however, was not as close. Chicago scored three runs in the first inning and another five in the second. After that, the scoring barrage slowed down, prompting one reporter to claim that the White Sox players were simply tired of running the bases. Cleburne's fielding was not crisp and was even ragged at times. The final score was 10–1 in favor of the Sox. Despite the disappointing loss, the Railroaders had hung in with some of the country's best ballplayers.

A few years later, the White Sox and Major League Baseball would find themselves embroiled in one of the greatest controversies in the history of

the game. As a result of what was dubbed the Black Sox Scandal, eight players were banned from baseball for life for throwing some World Series games for individual profit. Although the scandal was still a few years away, one thing was certain on those two March days in Cleburne: Chicago players had not yet learned how to throw a game.

During the preseason play of 1911, the Railroaders were managed by "Captain" Brockman. Well respected within Texas baseball circles, the captain was familiar with the Texas-Oklahoma League and was very much in command from the start. Also arriving in the preseason were new uniforms. Cleburne would play the season wearing white ball caps, black-and-white socks and white belts. With the new uniforms and a fresh energy, the captain began getting his team ready to march toward a winning season. Within days, for an unknown reason, Brockman was replaced with Billie Reed, who was later replaced by Albert "Dad" Ritter. Regardless of who was at the helm, Cleburne fans knew what a winning season looked like, and they expected nothing less than another one.

Opening Day is special. The spring air, the smell of roasting hot dogs and each team starting with one goal in mind: winning a pennant. Cleburne's return to baseball would start in Durant, Oklahoma. That opening game had plenty of excitement, and Durant's fans were delighted. Durant's shortstop was a single away from hitting for the cycle. Unfortunately for the Railroaders, their first victory of 1911 would have to wait. Durant poured it on and won, 9–3.

While the Railroaders fixed their attention on away games, the fans back home were busy raising money for improvements to a new park that was located just outside the city limits. Chase Park, as it would be called, would host several games; $700 was raised for improvements to the new park. Exactly why a second park was built is unknown. In a relatively short period of time, Gorman Park had generated baseball history and been the site of several great games. Nonetheless, the new park was the subject of controversy. It is a mystery why Cleburne felt the need to build a second professional baseball park. Maybe it was the town's penchant for publicity? Maybe residents felt the need for a backup plan, in case the fields of Gorman Park were torn up? Most likely, the second facility was a provision for Sunday games, which were prohibited within the city limits. Looking back, the construction of the new park generates more questions than answers, and the answers were buried with those who made the decision.

Starting the season 0-2 did not dampen the spirit of Cleburne fans. The Railroaders were returning home, and the city planned its Opening Day

Mrs. Harding, a Cleburne resident, was a member of a group of patrons the team sought. Women were often provided free entry into the stadium. Women were a vital part of the Rootorial Society that supported the team. They often wore beautiful hats to the games. *Courtesy of Layland Museum.*

festivities for Gorman Park. Cleburne was excited to kick off baseball's return. A petition was circulated among local businesses requesting that they close in honor of the team's first game. In addition, a parade was planned. Cleburne was ready for baseball's return.

April 29, 1911, Opening Day in Cleburne, was quite the spectacle. The *Cleburne Morning Review* printed two pages listing businesses that would be closed in honor of the grand event. The baseball association announced a discount similar to the modern-day "ladies' night": female fans could catch the game for twenty-five cents. At 2:30 p.m. sharp, a parade started downtown and made its way to Gorman Park. Fire wagons, automobiles and citizens filled the parade lineup, which was completed with players from the two teams.

When the parade arrived at Gorman Park, the party continued. The stands were packed, since the whole town had shut down for the game. The crowd was loud and in a good mood. Mayor Charles W. Breech made his way to the mound to throw out the first pitch. As he wound up and delivered

a strike across the plate, the crowd erupted into deafening applause. The whole town was ready. Professional baseball had returned to Cleburne.

Throughout the game, the umpire's calls were drowned out by the noise of the crowd. Whether it was due to the pent-up energy of five years of silence at the park or the outstanding play of the Railroaders, Cleburne won the first home game over Bonham, 3–0. When the fans spilled out of the stands, there was a smile on every face. All seemed right with the world.

The next day was a Sunday. And on this Sunday, the Railroaders engaged in another improbable feat: Sunday baseball within the city limits. The game marked the first time a professional baseball game was played on a Sunday in Cleburne. The baseball association passed out flyers touting the game as "your first and last opportunity to witness a Sunday game in the city limits. If you love good snappy ball playing, come out to this game."[47] Apparently the city did indeed love Sunday baseball, as the crowd repeated its solid attendance for the second game of the series. But the fact that this was the first and only Sunday game in Cleburne was not the most memorable part of the game; Mother Nature had something to say about the game.

That morning, while hellfire and brimstone rained down from pulpits across the city, heavy rains fell at the park. Although the rain stopped by game time, the infield at Gorman Park looked more like a pigpen than a baseball diamond. A newspaper reported on the situation this way: "A heavy rain, which fell in the forenoon, converted the diamond into a sea of mud and slush, but this failed to prevent an exciting game."[48] The Cleburne players slipped and fell in the mud and mire. Ground balls were swallowed up by the sloppy infield. A batter's only option was to swing for the fences and literally slide around the bases. The players adjusted their tactics for the conditions. In so doing, the home team beat Bonham again, by a score of 11–8.

Leaving the mud behind them, Cleburne packed their soiled uniforms and took a little of Gorman Park with them when the series headed to Bonham's home field. Unfortunately, the change in scenery also meant a change in results. Cleburne lost both games in Bonham. The Railroaders would continue to struggle when they crossed north of the Red River after getting swept by Bonham.

The team traveled to Durant for a series. The Railroaders shut Durant out in the first game, 1–0, but the second game of the series was described as "no fun." Durant's pitcher hit Cleburne's Tanner in the head, and he left the game unsure of his whereabouts. The blow was severe enough that it loosened several of his teeth and left him with a loud ringing in his ears. Not long after the bean ball to Tanner, a fielder named Harper was hit by a pitch

on his throwing wrist. Later, players Fritts and Lawson were hit by pitches. It seemed that the Durant pitcher found more batters than plate with his pitches, and the Railroaders felt like they were targets in a shooting gallery. The next day, the paper said, "Durant needs a cage for that wild man."[49] With a thin lineup left to finish the game, the Cleburne boys were ready to return to the comfort of their home field.

It looked as though Cleburne was heading to the bottom of the standings. "Cleburne is going down in the percentage column like a brick dropped off a ten story building," the paper reported on May 7.[50] Fortunately, injuries healed, and players returned to the lineup. Cleburne also recruited some new players to shore up the shell-shocked squad. Unfortunately, the new recruits did not arrive in time to stop a five-game losing streak.

Umpires are often a favorite villain in baseball. From youth leagues to the major leagues, umpires are booed and their calls challenged. During the early days of baseball, though, a good umpire was just as much the subject of discussion as a bad one. In 1911, Cleburne fans grew to appreciate the way one particular umpire called games. Jim McDonald was consistent in the way he officiated games and was in charge from the first pitch to the last batter. Texas teams had seen all sorts of bad umpires who were clearly slanted toward the home team. But with McDonald, players and fans knew the game would be fairly decided by the players' actions and not by a controversial call. McDonald often received as much, if not more, coverage than players in the local papers.

Thus far in the season, Oklahoma had been unkind to Cleburne. By May 12, Cleburne found itself in sole possession of the cellar. As St. Clair had hoped, his Wichita Falls club appeared unbeatable, with an early record of 13-4. Cleburne appeared to be no threat whatsoever and was the last thing on St. Clair's mind. That would soon change.

While the Railroaders were in Ardmore, W.H. Hillis, president of the Ardmore Baseball Association, offered to provide food and shelter to any ballplayers willing to walk one hundred miles to try out for a team. One husky fellow by the name of Jim Fannin took Hillis up on the offer. Fannin had played an abundance of recreational ball and most recently played catcher for a team in Joplin, Missouri. Joplin had too many catchers and decided to let Fannin go. Armed with determination and a letter of recommendation from the Joplin manager, Fannin set out on foot. When he arrived in Ardmore, the Railroaders gave him a look, then gave him a spot on the roster. This move would turn out to be important in turning things around later that summer. Although Cleburne lost the game against Lawton, it won a victory by signing Jim Fannin.

As baseball grew in popularity, so did the gossip surrounding players. Fans wanted to know more than just a player's on-field performance; they wanted to know what foods they liked, what hobbies they had and what women they were seeing. The latter category was the topic of much newspaper fodder, and the Cleburne paper was no exception. On May 11, in an article about "wives and sweethearts of players," one story stood out. Apparently, an unspecified player had claimed he was engaged to a woman for three months. So secret was the engagement that no one knew about it—including the young woman! Finally, the player officially asked the woman, knowing the only answer she would give would be "yes." And "yes" it was. One small problem remained, however: The girl's father was not as eager. He withheld his blessing, even in the face of pressure from the girl's mother and the rest of the family. He finally gave in, but he had one condition, which he detailed in a telegraph to the boy. In order to marry his daughter, the young man had to at least maintain the same batting average he had achieved the previous year. The boy's response in a return telegraph contained the promise that he would dislocate or break both arms if that's what it took.[51] Baseball had become a crucial factor in every aspect of life in Cleburne, including the fate of some marriages.

Cleburne hoped that its return to Texas would also be a return to the win column. Despite Cleburne's poor start, Gorman Park was once again filled to capacity. For this game, the crowd included a strong contingency from Gainesville. After eight and a half innings, the Gainesville fans were preparing to celebrate. They had almost shut Cleburne out and led by a score of 5–1. The percentages favored Gainesville, and all they needed were three outs to claim the win. But there is something magical about the bottom of the ninth inning. And on this sunny afternoon, magic was in the air. Cleburne set the stage for the second half of the inning by loading the bases. And with one swing of the bat, the magic happened.

> *Carson came to the bat. The psychological moment had arrived. Boggs sent the ball down like a shot out of a shovel. Carson caught the pellet near the end of the stick and sent it south, in the direction of Rio Vista. Three men came in and Carson reached the third sack. He picked up the sack and brought it in with him.*[52]

The Railroaders won in walk-off fashion with a grand slam. The final score was 6–5. Fans left the stadium with souvenir tickets in their pockets, and Carson left with a souvenir third base. The base was not the only thing Carson would take home.

In 1911, fans would reward a strong performance by passing a bag around to collect funds to give to the most outstanding player. After the walk-off grand slam, Carson was Cleburne's hero, and the bag was passed around the stands in his honor. By the time it reached Carson, his pockets were bulging with coins. The stands were still full, and Carson stepped out onto the field to take a bow. When he finally left the field, coins were spilling out of his pockets.

The celebration didn't last long. The next day, Cleburne and Gainesville ended a game in the tenth inning tied 5–5. They had run out of daylight and, likely, had also run out of energy from the day before. By sundown on Tuesday, Cleburne lost the third game. In a span of three days, they had gone from walk-off winners to walked-over losers. With this last loss, a whisper was heard around town. It was the whisper no small Texas baseball town wanted to hear: "Would the team make it through the season?" Although the fans continued to show faith in the Railroaders, it was well known that only the strong survived. Noncompetitive teams did not linger in Texas in the early 1900s. Texans wanted winners and would not long suffer losers. Hanging out near the cellar was a recipe for disaster, and that's where Cleburne found itself.

To make matters worse, the Cleburne players were preparing to ride the train north to play a series in Oklahoma, even amid the whispers. It was no secret that Oklahoma had not previously been O.K. for Cleburne. The team would have to work hard to scratch its way out of the cellar.

Fortunately, the Railroaders started off the Oklahoma swing with a bang. On May 18, they defeated Lawton, 21–5, and the next day, they left with a 6–1 victory. Leading the charge was Fannin, the boy who had walked one hundred miles for a tryout. The changes made during the last trip through Oklahoma were already paying off. However, the victories came against Lawton, a team dwelling near the bottom with Cleburne. It remained to be seen whether or not Cleburne could hang with the likes of league-leading Wichita Falls.

Despite the Railroaders' fight to claim the cellar, the *Cleburne Morning Review* continued to praise the club. On May 21, the paper's front page declared that "baseball fever is catching just now Cleburne has more baseball teams than any other town."[53] This curious statement referenced the fact that several amateur teams had been created throughout the city. Rather than a clever mascot or creative name, the teams adopted simple descriptors, such as the Dry Goods Clerks, the Druggists, the Butchers, the City Officials, the Printers, the County Officials, Santa Fe Store Department, Santa Fe

A Cleburne Santa Fe Shop team photo. The Santa Fe team uniforms were often more elaborate than the uniforms of the local professional teams. *Courtesy of Layland Museum.*

Mechanical Department and the Ice Men. Maybe it was the residents' personal involvement in the game, or maybe it was something else the city saw in its Railroaders. One thing was certain: Cleburne continued to back the Railroaders, even when they couldn't go much lower in the standings. This was quite different from the residents of other Texas towns, who deserted their teams when they didn't deliver wins. Cleburne's loyalty to its team would pay off in a huge way when the season entered the final weeks of 1911.

On May 21, Cleburne was in Wichita Falls for the first game between the two clubs. Based on the standings at that point, it didn't look like it would be much of a game. But appearances can be deceiving. "Big Lindy" Hiett took the mound for Cleburne and threw nineteen strikeouts in a thirteen-inning game. Wichita Falls won the game, 4–3, but it was not without drama. The umpire made several questionable calls that favored Wichita Falls. The officiating was so unfair that several Wichita Falls fans actually started cheering for Cleburne. Most Texas fans root hard for their home

team, but they also wanted a level playing field. Despite the questionable officiating, Cleburne held its own against the best. The controversy was an omen of things to come.

At the conclusion of the three-game series with Wichita Falls, Cleburne players boarded the train with three straight losses. However, they had proved that they could hang with the best, even on the road. Cleburne pitchers could strike out batters, and their own batters could make solid contact with the ball. Although the team was swept, it fought to the bitter end with an indomitable spirit. When the team's train left the station heading for Altus, it remained to be seen whether the players would give up on the season or find new life by continuing to play close games with the league's best.

While the state of Oklahoma delivered mostly losses to the Railroaders, it was in that state that the team added the final pieces to its roster. During a previous northern swing, the team picked up its catcher, Fannin. This time, the team changed mangers. After losing a game to Altus, the club signed Albert Ritter, a player-manager from Fort Worth known simply as "Dad" Ritter. Late in the night on May 25, Ritter left Fort Worth on a train bound for Altus to catch up with his new team.

When Dad Ritter took over, his new club was firmly in the cellar of the Texas-Oklahoma League. The Railroaders had lost twice as many games as they had won. On the contrary, Wichita Falls had won twice as many games as it had lost. If Ritter was going to bring his club into contention, he had a lot of work to do to help the team dig itself out of this deep hole.

Making matters worse, the home crowd's mood became somber as they resigned themselves to losing. Even the newspaper was resigned to losing when it reported that "Cleburne is defeated as usual; score 4–3."[54] Despite the losses, attendance at Gorman Park remained solid. The city knew that the player shake-up and the recent manager change meant something had to give. And they knew there was nowhere to go but up.

When the team returned from yet another bleak road trip, someone pointed out that the 1906 team had lost thirteen straight games before it rolled to the championship. That reminder seemed to brighten the mood of the town. The Railroaders were losing close games, and there was a history of the local team clawing out of the cellar. While the city was disappointed that the Railroaders were not competitive, they still supported their team. The club responded by adding promising new players, including Lex Terry, a solid pitcher from Dallas. Lindy Hiett was the club's ace, but a competitive team needed more than one good pitcher. Terry fit the bill, at least in theory.

On May 30, the painful losing streak came to a halt. Cleburne defeated Altus, 3–1. Building on that small bit of momentum, the Railroaders got another win the next day, 7–6. While only two games, it was a winning streak. Cleburne would take any good news it could find. It was time for some of those close games to fall Cleburne's way, and it looked as though that was finally happening.

The ball club's struggles on the field were not the only problem it faced. Off the field, a controversy over Gorman Park surfaced. In 1906, the Trinity & Brazos Valley Railroad Company had donated the land on which the park was built. In the summer of 1911, the railroad company wanted to convert the ballpark into a ginning plant. Because the once-winning team had grown stagnant, the company thought the land should be used for a more productive purpose. On the night of June 2, the community gathered at city hall to decide the future of Gorman Park. That morning, the *Cleburne Morning Review* urged those interested in the future of Cleburne's baseball team to attend: "All stockholders of the Cleburne Baseball Association are urged to lie at the city hall tonight at 8 o'clock. Matters of vital importance are to be discussed. No money is to be asked for.—Baseball Committee."[55]

What the Gorman Park debate actually accomplished was to rally the community in support of its baseball team, and this rallied the team as well. The community elected to keep the ballpark. Now it was up to the players to do their part. Cleburne was scheduled for a three-game series against one of the best teams in the league, Altus. While the fans and community leaders deliberated about the future of the club, the team won the first two games by close margins. Then, going for the sweep, the Railroaders were facing defeat until their bats came to life in the eighth inning. They left the field with a 7–3 victory and a much-needed sweep. It looked as if the season might be turning around.

The day after the town hall meeting, Cleburne took on Bonham at Gorman Park. In what can only be described as a freak accident, Lindy Hiett took the mound and was twice hit by line drives, both by the same batter. After the game, the paper reported that Hiett would "take out accident insurance, whenever he sees that batter coming."[56]

The next day, Cleburne was leading Bonham, 4–0, in the bottom of the eighth when a close call occurred at first base. The Bonham players got into a heated quarrel with the no-nonsense umpire Jim McDonald. Bonham was so upset over the call that it threatened to walk off the field. The team didn't get the chance. McDonald threw them off the field and awarded Cleburne the game.

Still reeling from the call at first and the resulting forfeit, Bonham was ready to avenge their honor the next day. Bonham would not serve a revenge victory. Although Cleburne committed eight errors and gave up twelve hits, the Railroaders managed to put together enough decent plays to eke out a 6–5 win. The hero of the game was none other than the manager, Dad Ritter. With the bases loaded and the team down by three runs, Ritter drove a hit to the fence. After the game, the fans not only took up a collection for their beloved Dad, but they also contemplated buying their favorite gentleman a stove-top hat.

In the next series, Cleburne swept a good team in Altus. But the real test rolled into town on the train from Wichita Falls. The league leaders were riding a wave of success, having amassed a 31-9 record and an eight-game lead over the next best team. From top to bottom, Wichita Falls boasted heavy hitters and solid defense. Assuming Cleburne was an easy target, the first-place team sent a backup pitcher to the mound to give its starters a rest. That was a mistake. When the game was over, Cleburne had scored eight runs to Wichita Falls' three. Cleburne was fast losing its reputation as a pushover.

The next afternoon, it appeared that Cleburne would take yet another game from Wichita Falls. In the third inning, Dee Poindexter, the only returning player from the 1906 championship team, broke his bat in two while making contact with the ball, which fell just short of the fence. Wichita Falls first baseman Tol Hiett had something to prove to Cleburne. The Railroaders had released him earlier in the season, and Hiett wanted to show his old team that his release had been a mistake. Six times he drove in runs. Despite his performance, Cleburne was closing in on a victory. But it was not meant to be. The Railroaders fell just short of a win. Although they lost the game, the team had succeeded in demonstrating that its first-game victory against Wichita Falls was no fluke.

With the series tied, the teams had no choice but to bring their best game for the finale. Much had changed since Wichita Falls rolled nonchalantly into town expecting a rest for their best players. Now they put their best on the field, including Louis "No Hit" Green, arguably the best pitcher in the league. He was known for taking his time on the mound as he worked up his "spitball." In fact, he spent so much time salivating over the ball that fans grew impatient. There were calls for rule changes allowing a designated "spitter" to work on the ball so the game would move faster. Cleburne's ace, Lindy Hiett, bested "No Hit" through seven innings. Unfortunately, a baseball game has nine innings. Cleburne

lost, 4–3. When Wichita Falls rolled out of town, it did so with a series win and a greater respect for the Railroaders.

Cleburne had figured out how to win at home, but the club still struggled on the road. The Railroaders would have to find a way to start winning away games if they were going to climb back into a pennant race. The team was out of the cellar at this point, but no one thought it was a serious contender. It would take more than a single winning streak to get Cleburne into the championship mix.

As is often the case in sports, a few wins with some luck sprinkled in often leads to good things. And that is what happened in mid-June. The Railroaders' losing streak on the road did an about-face. After victories over Bonham and Ardmore, Cleburne began looking forward to the quickly approaching second half of the season. There was no way of catching Wichita Falls in the first half, but the team had figured things out, and it was ready to start fresh in the second half. Cleburne had firsthand experience with winning a championship from the second half. After all, it's not how you start, but how you finish that matters. With the momentum finally swinging Cleburne's way, talk of a pennant in the second half season began to resonate with players and fans alike. Things were beginning to look up.

Team chemistry is a big part of baseball. A group of good players who are in sync with one another can have greater success than a team of great players who lack cohesion. That said, a pennant run begins and ends on the mound. A team without solid pitching will find it almost impossible to be in contention. With that in mind, the Railroaders added three new pitchers while in Oklahoma. Roster changes were becoming customary whenever the team crossed state lines. Familiar players were released and new players were signed. Cleburne was tinkering with its lineup, building for a pennant and a chance to take on Wichita Falls for the championship.

While the Railroaders were retooling for the second half, other teams did not fare as well. At the halfway point of a season, teams face a serious decision: get better, or drop out. The Lawton and Greenville clubs could not find their groove; they both folded before the first half season ended.

Although the first-half pennant was out of reach, the last games before the break were nonetheless thrilling. In one runaway game with Bonham at Gorman Park, Cleburne's overwhelming 10–1 victory was not nearly as exciting as one particular crack of the bat. Foley White hit the fence with a ball that nearly left the park. It was not the fact that the ball almost cleared the fence that amazed the fans. Rather, the excitement stemmed from the fact that it was the first time a ball came close to hitting a particular sign

on the fence. The sign, an advertisement for a local shoe company, simply read "Walk Over." The players and fans knew that hitting the sign would have resulted in a new pair of shoes for White. Although he failed to win the shoes that night, he again thrilled the fans the very next game with an inside-the-park home run. Cleburne was winning, and the fans and players were enjoying the ride.

After a loss to Bonham, the first half of the season was over. With great determination, Cleburne had managed to claw its way out of the cellar. Along the way, players were added and the team built momentum. Al "Dad" Ritter had turned the club around and restored the players' faith in their ability to win. And so it was on June 22 that the slate was wiped clean and the second half of the season started with a game against Durant at Gorman Park. While fans in Wichita Falls were celebrating their first-half pennant, Cleburne was focused on winning the second-half flag. Based on how Cleburne played at the end of the season's first half, many were predicting that they could actually win the second half and face Wichita Falls in the fall. In many respects, the Railroaders were repeating what landed them the championship in 1906. The thought on many minds was whether lightning could strike twice.

Second Chances

The second half of the season started with a controversial call. In a close game, Cleburne's Tanner came to bat. A runner was on second, and when the ball was hit, many believed the umpire was concentrating on third base to see if the runner would be thrown out. Instead, the play was made at first, where Tanner was promptly called out. Tanner, infuriated, stormed his way to the umpire and shoved him. During the melee, the stands erupted with boos. Some yelled "Rotten!," while others demanded that the umpire be thrown out. Then the fans began to chant, "McDonald! McDonald! McDonald!" The fans were actually rooting for an umpire, albeit one who was not in the game. Jim McDonald, or Mr. Mac, as some called him, was in the stands. He stood up, took a bow, then graciously sat down. The fans kept it up through the end of the game, but to no avail. In the end, the Railroaders lost the game to Durant, 3–1.

During the early days of professional baseball in Texas, smaller towns would start the season but not always finish. Fan support would wane, and

financial support was often shallow. Rumors were circulating around the state that the smaller-market Texas-Oklahoma League, in its entirety, would not make it to September. This prompted league president F.P. St. Clair to travel to Fort Worth for a meeting with the clubs' managers. Most of the managers passed on the meeting, choosing instead to focus on their games. St. Clair decided it was time to put the rumors about his league to bed. He told the reporters and the handful of people present that the strength of the league was found in the team from Wichita Falls, both on and off the field. His team had the strongest financial support, with ownership kicking in $35,000 for the city's park and grounds. Additionally, the league's attendance was growing in places like Cleburne and Ardmore. He described the league and its cities this way: "The people seem to be enthusiastic and the managers are giving them big league ball, so when Sept. 19 rolls around, I expect to see six clubs in the race."[57] St. Clair hoped that his confident report would dispel the rumors that his league was in danger of folding.

After the first five games of the second half, Cleburne was in a strange position: sole possession of first place. The Railroaders were on a tear, starting off with a record of 4-1. But Wichita Falls had no plans of ceding the pennant. They were only a game behind the Cleburne boys. After a couple more wins, the fans collectively wrote to Dad Ritter a note printed in the *Cleburne Morning Review* on June 27. "Dear Dad and all the kids: Congratulations to your pennant winning bunch. Keep wielding your tomahawks—and bring home a string of scalps and we'll celebrate."[58] In 1911, the peculiar use of "scalps" to describe wins was popular in Cleburne. It is unknown whether other cities used the same description or not. Regardless of what victories were called, one thing was clear: winning a pennant was important to the city. Getting on an early winning streak would make the task of winning the championship much easier than digging out of the cellar, as the 1906 team had learned.

If winning the championship was going to become a reality, it was no longer enough to just win. The fans wanted to win against the best. And at the start of the second half of the season, the best was Wichita Falls. There was a distinctive history between the clubs, and not all of it was good. In a previous series, a Wichita Falls player made the mistake of calling Dad Ritter a liar. Old Dad promptly punched him in the eye. Ritter and company had a chip on their shoulder where Wichita Falls was concerned, and a series victory over them would go a long way to removing that chip.

Cleburne fans were not the only ones talking about the upcoming series. Wichita Falls also had high expectations. Its ownership spent an enormous

amount of money on facilities and players. St. Clair wanted a championship for his city. Now the pesky Railroaders were threatening to steal the title. Days before the rematch with Cleburne, Wichita Falls went all in and signed a fellow remembered only as "Home Run" Witherspoon, arguably the best hitter in Texas. The season was, presumably, set up for a Wichita Falls championship, and the upcoming series was shaping up as a preview.

As talk about the Wichita Falls series continued, the Railroaders took care of the business at hand during a swing through Oklahoma. The team's performance was markedly different than it had been the first half of the season, and the league bracket bore witness to that difference. Before heading south to Wichita Falls for a series, Cleburne mowed through all six games in Oklahoma. An undefeated road trip through Oklahoma set the table for an interesting series with Wichita Falls.

Although Wichita Falls was the heavy favorite, Cleburne was on a winning streak, and people across the state were beginning to take notice. After the successful road trip, it was clear that the title was up for grabs, with the Railroaders firmly in the driver's seat for the second half of the season. It was ironic that Cleburne and Wichita Falls essentially traded places in the standings. During the first half, it was Wichita Falls that was virtually unbeatable; now it was Cleburne. And now, Wichita Falls, not Cleburne, was dwelling near the cellar.

After the hugely successful road trip, it was finally time for the Railroaders to head home. While everyone was thinking about the upcoming series with Wichita Falls, the series would have to wait. It was time to celebrate the country's birthday. The Railroaders' winning streak made the celebration that much sweeter.

For several weeks, the town had been planning a celebration for the team's return. When the train screeched to a stop on July 2, the team was greeted with a much-deserved welcome. Cleburne had just taken ten out of twelve games on the road, and a large contingency of fans met the ballplayers at the depot. The sound of a band filled the air as the celebration moved from the depot and into the town in a kind of parade. Local businessman Tom Hines arranged a feast for the team, and the players ate until their bellies were full. Cleburne knew what a championship tasted like, and they were hungry for it again.

Independence Day is a special holiday in America. Food, parades and fireworks are staples of the celebration. On July 4, 1911, the festivities were doubled in Cleburne, Texas. The Railroaders were on the hottest of streaks and leading the league. From morning until the wee hours of midnight, the town was buzzing with celebratory excitement.

Over time, the coal that fueled steam locomotives was replaced with oil. Cleburne's railroad shops continued to keep the Santa Fe fleet rolling through this transition. *Courtesy of Layland Museum.*

The nation's birthday was not a day to sleep in for the residents of Cleburne in 1911, as the town's foundry included a cannon. As the sun began to rise, it was this cannon that awoke the town with a twenty-one-gun salute. It was estimated that ten thousand visitors from several surrounding areas were on their way to Cleburne to help celebrate. Mayor Breech and his city had quite a party planned for the neighbors. The Railroaders played a double-header, with one game in the morning and another in the afternoon. There was a morning band concert. Following the concert and the first game was a town favorite, an old-fashioned parade. The processional included mounted police, Cleburne's band, artillery, merchant floats, a fire truck decorated to resemble a steam locomotive, groups from the Santa Fe Railroad shops and many other participants. The streets were packed.

The parade was followed by more concerts, a fiddling contest (Mrs. M.M. Sanders, the only woman contestant, finished fourth), a footrace, an automobile parade and a balloon ascension. Plenty of lemonade, ice cream and food rounded out the festivities. As the day wound down, a large group gathered for the traditional finale: a fireworks display. When the last firework exploded, the people went home tired but grateful for their country, state and city. Gorman Park was packed for both games, and although the team split the double-header, the mood could not be dampened. It was Independence Day, and the community had come together to celebrate its town and its team. The *Cleburne Morning Review* summed up the activity-packed day: "From the time the Cleburne Foundry's cannon awakened the city with the booming of twenty-one guns, till the ending of the fireworks program all was in expectancy and no one went away disappointed. Cleburne made good."[59]

Attendance at the two games held in Gorman Park was quite notable. The grandstands were overflowing with fans, and many more stood in the field next to the base-line fences. Ticket sales approached $900 for the day, which was quite a feat for a small town like Cleburne. The two games were fairly routine and resulted in a split in the short series, but the Fourth of July festivities made the series memorable. Now it was time to focus on a different set of fireworks: the upcoming Wichita Falls series.

On July 7, a train from Wichita Falls rolled into the Cleburne station full of players and fans for the much-anticipated series at Gorman Park. The weather did not cooperate for the first game. A north Texas summer storm rolled in, bringing lightning and dust with it. Many fans opted to stay at home, and those who braved the storm fought flying sand and debris. By the fifth inning, the rain clouds were not the only tempest. There was a storm brewing over the officiating. To say the calls were not going Cleburne's way

would be an understatement. The fans were more upset with the officiating than they were with the inclement weather. They were so displeased with the way the game was called that they would yell "Safe!" even when a runner was clearly out. Despite the fans' efforts, the Railroaders gave in to the storm on the field and lost the game, 5–2.

The next day, the rains continued. A player named Harrell was on the mound for Cleburne, and he pitched a jewel of a game against one of the hardest-hitting teams in the league. He shut down Wichita Falls, allowing only one hit. By the sixth inning, the weather overcame the players, and the game was called. Cleburne won, 4–0. The series was now tied.

The next day, both the weather and the game improved for the Railroaders, who came away with a victory. When the boys from Wichita Falls boarded their homebound train, they did so having lost the series. Things were looking up for Cleburne, which sported an impressive record of 15-5. And the fans from both teams knew they likely would meet again, when a championship hung in the balance.

While Cleburne was experiencing success, other teams were folding. By mid-July, Gainesville, Lawton and Altus had called it quits. If small-market baseball was a tenuous proposition for winning teams, it was almost impossible for losing teams. F.P. St. Clair traveled to Fort Worth to search for another town to take over the Altus franchise. Meanwhile, the Railroaders traveled to Durant for a series. The first game was rained out, but the second game went fourteen innings. Two Cleburne players were ejected before Cleburne finally won, 2–1. While Durant and Cleburne discussed whether to play a double-header to make up the lost game, other participating cities were discussing whether the league would even make it to the end of the season to award a pennant.

The good news was that while Cleburne was losing to Durant, the league was winning. St. Clair's attempt to find a replacement for ownership of the Altus franchise was successful. He secured a new owner who could carry the club through the end of the season. With plenty of teams to finish the second half of the season, discussion now turned to a series between the winners of the first and second halves. Cleburne fans were celebrating. They would get to see their team finish the season.

On July 17, Cleburne lost a sloppy game to Ardmore, 6–5. Rains turned the field to mud. But the weather and the game was not what most concerned the team. Apparently, the Altus franchise was again threatening to pull out of the league. At this point in the season, it was too late for another town to pick up the franchise and finish the season. So talk turned to

what would happen with the standings and the remaining games should Altus drop out.

Despite losing a couple of games during the July swing through Oklahoma, Cleburne was still running away from the pack. By July 20, Altus shifted the blame for its lack of success at the turnstile to Cleburne. Two other teams jumped on Altus's bandwagon, and together the three teams complained to the league that Cleburne was too far ahead in the standings and costing everyone money. Three of the league's team owners wanted to kick Cleburne out. They argued that while Wichita Falls, Bonham, Durant and Ardmore were geographically close, Cleburne was just too far away. While geographical distance was certainly a valid issue, it was another distance that was causing the problem: the distance Cleburne had put between itself and the other teams in the standings. It was clear that some of the other cities were tired of getting beat by Cleburne. As the *Ardmore Morning Star* summed it up, "Cleburne will no doubt make a hard fight to stay in, but it will be best for the league if she is dropped, as no other team has a chance of winning against them, the way they are going now, and the race would lose all interest to the patrons of the game."[60] If St. Clair and his Wichita Falls team weren't actually stirring things up, they certainly were not rushing to Cleburne's defense. After all, the league was built to feature St. Clair's home team, and it appeared that Cleburne was on such a roll that it would win the pennant and rain on Wichita Falls' championship parade.

While the debate brewed, the Railroaders continued to play ball and take care of business. They were either unaware or unconcerned that their season could come to a halt at any moment. Cleburne continued to steamroll through the schedule. They were unstoppable. League officials knew it. Owners knew it. And opposing players knew it. On July 19, Durant's shortstop walked off the field when one of his teammates made an error. When he tried to get back in the game, the umpire told him he was done. Cleburne's winning ways had gotten into the heads of its opponents.

The Cleburne bunch was so accustomed to winning that their lives revolved around the box scores. This was clearly the case when Charlie Gibson, Cleburne's catcher, took a tipped foul ball on the chin. He was knocked out cold, and many worried that his neck had been broken. When he regained consciousness, he asked, "Who won the game?" When he was told, falsely, that Cleburne won, he flashed a pleasing smile and sank back into unconsciousness. It was a few days before he recovered and discovered that his team had actually lost the game.

On July 23, the Railroaders were set to host Altus. However, the controversial team succumbed to its many difficulties and exited the league. It is unknown exactly what caused its demise, but that the team finally gave up the ghost was no surprise to anyone. Left with a field ready for play but no opponent, the Railroaders turned to a local club, the Santa Fe All-Stars. Some years later, after professional baseball left town, the task of entertaining the local fans fell on the shoulders of the railroad shop teams.

Cleburne's improvement on the field was not matched in the financial department. Despite the team running away with the league lead, attendance at Gorman Park had dropped off dramatically. Maybe it was the arrival of the dog days of summer. Or perhaps the town had become complacent with winning and was holding out for the championship series against Wichita Falls. Many fans chose to watch the game from the fences and perched atop a local gin platform instead of paying for tickets. While the team's record would not keep them from the championship game, the lack of finances might. With a title within reach, there was a real chance the Railroaders would run out of steam and not finish the season.

Knowing how close the team was to either a championship or a bust, the community got involved. A committee was formed to raise money to keep the team afloat through the end of the season. Other teams, like Durant and Bonham, had made their own arrangements to finish the season intact. It would be a shame if the league's leaders did not make it to the end to claim their pennant. Tom W. Hines, George McClung, R.J. Corson, Norman Smith and W.W. Murphy, with help from the community, raised the money needed to support the team. With the finances in order, it was now up to the players to keep the lead and secure the right to play Wichita Falls for the title.

The Railroaders got down to business on their home turf with Bonham. After a couple of close games went Bonham's way, Cleburne took the last two to even the series. The team's mental game was restored, now that the threat of disbandment was gone. And the players were grateful for the successful work of the fundraising committee. They rewarded those efforts with an error-free game. In 1911, an error-free game in Cleburne was as rare as a no-hitter.

Despite the solid play on the field, rumors started circulating that Cleburne was purposely laying off a bit to make the games close. Following the threats of getting kicked out of the league for winning too much, it seemed that the team was now "having fun" with their opponents. And who could blame them? The *Morning Review* summed it up this way: "This paper believes that Cleburne will keep close enough to the top to nose out, whenever she so

desires."[61] Although games weren't necessarily thrown, the players came up with ways to entertain themselves while toying with the opposition. They were just trying to keep things interesting; they did not consider the possibility that they were playing with fire.

Toying with opponents was fun for the Railroaders, but the town's residents were not playing around. They wanted the championship, with nothing left to chance. The town recalled the painful memory of losing its team days after the last championship. It was clear that if professional baseball was going to remain in Cleburne, it must be backed by a strong community organization that would raise money and manage the ballparks. So, on August 6, 1911, the Cleburne Baseball Club was officially organized. Jeff T. Neighbors was elected president. Having learned a lesson in 1906 when a single owner took the team and trophy and left town without so much as a celebration, the locals who wanted to keep baseball in Cleburne sought to make sure it was financially supported. The goals of the baseball club were simple: win pennants. President Neighbors addressed the group: "The Cleburne team is going to win the pennant. The boys have been doing good work and they will keep it up. The Cleburne team is in till the finish, and we predict that business is going to pick up all along the line, so far as making a good showing is concerned. We do not want anything short of the pennant—we must have it—that's all."[62] Even as the club laid the groundwork of support in 1911, it was also making preparations for the 1912 season.

In addition to local residents strongly backing the Railroaders, it appeared the tide was turning in cities throughout the league. In a public letter written by the Texas-Oklahoma League secretary, E.F. Morse, the league's position regarding Cleburne staying in was made clear.

> *I note in the Dallas News that the attendance at Cleburne has fallen off from the fact that it was rumored that Cleburne was to be dropped from the league, to make same a four-club league.*
>
> *I can safely say that nothing like that will happen. I had a long talk about this same thing with Manager Humphries of Bonham, and I honestly believe that if it came to a vote on this subject that Wichita and Bonham are with Cleburne.*
>
> *There is a number of reasons for this stand.*
>
> *1st. Because Cleburne leads the league and we do not want to have a case of "cold feet."*
>
> *2nd. Because Cleburne is one of the best ball towns in the league.*

3rd. Cleburne has always met all obligations.
Trusting this letter will set at rest all fears on this subject, I am,
Yours truly,
E.F. Morse,
Secretary of T&O League[63]

With the controversy laid to rest by a league official, all that was left was to play ball and drive toward the championship series.

The season rolled on under the hot summer skies. There were more wins and a few losses. The teams were entering the portion of the season that is often called "the grind." At the end of a season, players are tired from the travel and their bodies are beat up. As a season winds down, everything counts. Every hit, error, putout, steal and victory can make or break the outcome. During this point of the season in 1911, the grind was an undeniable reality, as noted by the *Cleburne Morning Review*:

> *The baseball season is drawing to a close and every day counts. It is like putting corn between the rocks at the mill. Somebody gets crushed every time the mill turns. For the last three days it has fallen to the lot of Ardmore to get crushed at Gorman Park. It is not altogether an enjoyable task, but if Cleburne does not crush somebody, she falls by the way side, and the other fellow noses up in the percentage column.*[64]

By laying off a bit, Cleburne allowed Durant to make a late-season charge. With the pennant still up for grabs and Durant closing in, Cleburne had to turn on the heat and finish strong. Coasting to the pennant was no longer an option. When Ardmore came to town, Dad Ritter shook things up. He moved players around, played the percentages and added a pitcher. The club did its part to get fans to the game with strong play, and the athletic club did its part by announcing that women would be admitted for free. Although ticket sales were no longer critical, losing the pennant in the final days was not an option. With the changes on the field and the stands full, the Railroaders continued to win.

On August 14, the team was treated to a celebration. Throughout the season, there had been parades, cheering crowds at the depot and many meals. Someone noticed that the team was particularly fond of eating cake. In fact, the players were getting a reputation for feasting on cake every time there was a celebration. Chocolate or white, it didn't matter. If there was a cake around, it was a sure bet that a passel of Railroaders traded their gloves

for forks. Therefore, it was decided that the team would be affectionately called the "Cake Eaters."[65] Although not official, the nickname stuck and would stay with the team into the next season.

Since Altus had dropped out of the league, the Railroaders had a gap in their schedule before they traveled to Wichita Falls for a late-season series. Instead of taking the time off, the team was offered money to travel to Weatherford to play a few exhibition games against an amateur team. The games would keep the team focused, and the players thought they might pick up one of the famous one-hundred-pound watermelons, like the one Weatherford had recently sent to President Taft. When the team arrived in Weatherford, its focus was not on expending the energy needed to win. However, when the Railroaders looked in the stands and saw a sizable group that had traveled from Cleburne, they turned up the volume, so to speak, and won the meaningless game.

Baseball fever was alive in Cleburne. After the series with Wichita Falls, the team finished the regular season at home. Spirits were high. The whole town had baseball on its mind. This prompted a young Cleburne girl to write a song honoring the team. The song went like this:

Can they play ball;
Well I should say,
Playing ball every day,
Can they play ball,
Well I should say,
They're going to win the pennant—
This very day.[66]

By the time Cleburne rolled into Wichita Falls, the pennant had been secured with a league-leading 34-20 record.[67] The remaining games were meaningless. With the pennants for each half of the season now decided, representatives from all the remaining clubs met in Fort Worth with league president St. Clair. The group decided to end the season on August 23 rather than wait until Labor Day. Wichita Falls and Cleburne would now play for the championship. The league discussed a best-of-seven format, with each team getting three games at home. Game seven, if needed, would be played on a neutral field.

THE CHAMPIONSHIP SERIES

The playoff series was set. Or was it? The telegraph lines heated up. Cleburne wanted to play four exhibition games before starting the series in Wichita Falls. St. Clair, however, had changed the previously agreed-upon series start date. The town of Cleburne was emboldened by the strong play of its team and by its recognition throughout Texas as a baseball community. However, St. Clair was a man used to getting his way. He threatened to pull Cleburne's franchise if it didn't give in to his demands. He also threatened to unilaterally enter a forfeiture on behalf of Cleburne if the Railroaders didn't do as he dictated. The scrappy Cleburne team and the start-up league had beaten the odds and made it to the playoffs, only to face another obstacle: St. Clair's ego.

When St. Clair refused to budge, the Cleburne contingent went to the other teams for support. The leaders in Bonham and Durant sided with Cleburne, which argued that it had not violated any rules in wishing to play a few exhibition games. St. Clair argued that since the season was over, there could be no games before the playoffs. The issue was just a matter of a couple of games. Was it really that big of a deal? In reality, another factor was behind Cleburne's desire to play the exhibition games. One of its star players, Foley White, was recovering from an injury. He needed a few more days to fully recover. But St. Clair wanted to capitalize on White's absence from the lineup.

Rather than risk losing the season to the league president's ego, Cleburne gave in. The series would start on August 24 in Wichita Falls. The teams would play three games there, then travel to Cleburne for three more games. If a seventh game was needed, it would be held at a neutral location. Cleburne wanted the series badly, and if caving to St. Clair was required, then so be it.

The series was set, but when August 24 arrived, the teams were forced to wait another two days. It rained hard in Wichita Falls. St. Clair's plan for capitalizing on Foley White's absence from the lineup failed. There was discussion of changing the playoff format to a best-of-three series. The teams were tired and their finances thin. After the drama of a long and grinding season and the turmoil of the past few days' negotiation with St. Clair, most were simply ready for it to be over, regardless of who won. A best-of-three series was the result.

When the first game of the series finally arrived, the Railroaders sent Harrell to the mound. Through five innings, he gave up three runs. A player

named Lewis went in as relief and held the heavy-hitting lineup to just one more run. Despite his effort, Cleburne lost the game, 4–3. The teams boarded a train and headed to Cleburne for a do-or-die game for the Railroaders. Word spread throughout the county, and fans from Grandview, Venus and Alvarado traveled to the county seat to see the game. The Railroaders were more than just a Cleburne team—they belonged to many communities throughout the county.

On August 31, the tumultuous season met its conclusion in a most bizarre way. The Railroaders made their way to the field and warmed up. They were ready to even the series. Unbeknownst to the team, the umpire and the fans, the Wichita Falls team had secretly loaded up and left town. No one knew the reason for its hasty exit. The league umpire, Bates Simpson, looked at his watch. At the appointed time, he called the Railroaders onto the field. Three strikes were called. At that point, the umpire declared a forfeit by Wichita Falls and awarded the game to Cleburne. Since Wichita Falls had left town and would not be able to return before the start of game three, Simpson also called a forfeiture of the last game and declared the Cleburne Railroaders the 1911 Texas-Oklahoma League champions!

The Cleburne Railroaders pose in 1911. *Courtesy of Layland Museum.*

When word of the forfeiture reached Wichita Falls, St. Clair was furious. He contacted the press. As reported in the *Cleburne Morning Review*: "Mr. St. Clair, president of the Texas-Oklahoma league, states that he will forfeit every franchise with the exception of Wichita Falls. He said Cleburne was not in good standing with the league, anyway. The actions of umpire Simpson, forfeiting the games to Cleburne, was illegal, according to the National baseball rules, also that Wichita Falls was the only team paying her dues."[68] Days later, St. Clair's team would argue that it left Cleburne because the Railroaders failed to pay the Wichita Falls Irish Lads their guaranteed payment. Cleburne countered that the payments were not due until the end of the series. Regardless of when they were due, the issue had not been raised until after the champions were declared.

With the season over and the championship secured, the players said their goodbyes. Many left for home, while others went to other Texas clubs finishing their schedules with the Texas League. Charlie Gibson, the catcher from Dallas, returned to the Dallas Giants. He was arguably the key addition that pushed the Railroaders over the top. One of the original players, pitcher Lindey Hiett, returned to Arlington. His play on the mound was equally important to the pennant race. All of the players contributed during the remarkable season, but it was now time to go back home to jobs and families.

In September, the remaining Texas League games wound down. The league crowned the Austin Senators its champion for 1911. Following Austin's title, many started calling for a series between the two leagues' champions. Although Wichita Falls, led by St. Clair, was still arguing against a Cleburne title, virtually the rest of the state credited the title to Cleburne.

The Austin Senators offered to play Cleburne in a series to declare a state champion. By the time the offer was made, however, most of the Cleburne players had returned home and were scattered across the state and country. Despite the difficulty in getting the team back together, Cleburne fans wanted to see the series. They arranged to auction tickets to raise the necessary money. Baseball fever continued in Cleburne.

A series was finally arranged. The first three games would be at Gorman Park, then the series would shift to Austin. Locals geared up for the competition and planned to make a spectacle of the games. Although the games were for exhibition, Texas bragging rights were at stake. Businesses gave their employees time off to watch the games. One of the famous attractions of the day was Robert E. Gatewood's bucking bronco, known as a "man-killing" horse. The horse would be on the field before the Cleburne

games for locals to ride. An invitation was extended to residents of Wichita Falls to come and watch the games. The offer was declined.

On September 6, Austin won the first game, 4–1. Cleburne had had plenty of rest following the end of the season. In fact, it had enjoyed too much rest. The Railroaders committed several errors and did not play their best ball. The next day, Cleburne returned to its winning ways and took the second game in the tenth inning. Austin, however, won the remaining games. Although bragging rights were at stake, the series was just for fun and was meant to raise money for the teams. Both goals were accomplished. Austin was crowned the unofficial state champion.

Following the Austin series, the *Morning Review* wrote, "Cleburne is the most enthusiastic baseball town in Texas, according to size. The visit here of the Austin pennant-winners, to play the Cleburne pennant-winners, was a big event and everybody enjoyed it inning by inning."[69]

The Railroaders packed their equipment and returned to their lives outside of baseball. Like the 1906 club, the team finished as champions. Unlike that year, the franchise would not leave Cleburne. Until Opening Day of the next year, the Cleburne Railroaders reigned as the champions of the Texas-Oklahoma League, albeit disputed by Wichita Falls.

Fifth Inning

RAILROADED BY INSUFFICIENT FUNDING

Baseball is a game where a curve is an optical illusion, a screwball can be a pitch or a person, stealing is legal, and you can spit anywhere you like except in the umpire's eye or on the ball.

—*James Patrick Murray*

By all outward appearances, Cleburne's position as a professional baseball town was solidified. But finances were to a baseball club what blood is to an animal—essential for survival. Cleburne's success was nothing more than an optical illusion unless the team was funded for another season. As the pages of the calendar turned from 1911 to 1912, the Railroaders' championships were not enough. Plans were underway for the defense of the Railroaders' title, and as was the case in most Texas baseball cities, Cleburne had to start early to ensure that the team had sufficient funds to make it to the end. The team also needed a league. With the way things ended between Cleburne and Wichita Falls the year before, it was doubtful there would be another season in the Texas-Oklahoma League for the Railroaders if St. Clair had anything to do with it. If professional baseball was to return to Cleburne in the spring, a new league was required. While local fans talked about another pennant run, the Cleburne Baseball Club wasted no time looking for a new league.

After several weeks of discussions, the prospects of another professional season looked grim. The members of the association called on several league representatives. They no doubt touted Cleburne's record, its fan support and

the fact that Cleburne was the only Texas city to have two ballparks. Chase Park had been built outside the city limits to avoid issues with Sunday play. The decision to use both parks in 1912 would impact the course of baseball history in Cleburne.

It was not until early March, just before spring training began, that Cleburne found a league: the South Central League. An association member, W.W. Murphy, attended a meeting in the east Texas town of Marshall, where the South Central League had been created. It was composed of teams in Paris, Texarkana, Marshall, Longview, Tyler, Corsicana and, now, Cleburne. With the teams set, the season would begin on April 23, 1912. To keep the teams competitive, the league implemented a team salary cap of $900. This condition ended up being treated as a suggestion by the honest and as a mere formality by the rest.

With the season weeks away and a place in a new league secured, T.W. Hines, a mainstay supporter of the team during the 1911 season, called a special meeting on March 6. The purpose of the meeting was to inject some new blood into the Cleburne Baseball Club. Earl Kirkpatrick was elected the new president of the Baseball Club, and he wasted no time getting to work, calling for more fundraising to ensure the team could make it through the season. Cleburne business owners recognized the importance of forethought where the issue of fundraising was concerned. If the team played poorly, it would then be virtually impossible to raise money, and the team could easily fold. It would take the entire community to ensure the team made it to the end.

Within days, the fundraising was going well. It looked as though Cleburne fans were putting their money where their mouth was. At the same time, the association started putting the team together, beginning with the choice of manager: "Dad" Ritter. He had a long baseball history and was currently the physical director at Cisco College. He had a knack for picking and developing talent. That is, when he wasn't picking a fistfight with a player, umpire or fan. His playing skills were fair, but his ability to size up talented players and get them to play beyond their abilities was off the charts. The last championship was won largely because Ritter knew his players, including how and when to push their buttons. He also knew how to adjust team chemistry. More importantly, he was loved by players and fans alike. When asked if he would take on another season in Cleburne, Ritter accepted the assignment and began assembling players.

Spring training included the usual tryouts and exhibition games. In those early years of professional baseball in Texas, preseason games often

The Cleburne Apprentices are seen in 1912. *Courtesy of Layland Museum.*

resembled sandlot contests. Games were scheduled at the last minute and were played against virtually any group of players available. During spring training in 1912, the Railroaders took on the Cleburne High School team. The varsity players gave it their best; it would be almost a century before the school would make waves in the Texas high school baseball scene. They lost to the Railroaders, 13–0. Then, on a cold April day before a very small crowd, the Railroaders lost to the Topeka Regulars. Topeka trained in the southern states until the weather turned warm up north.

Player signings were almost as haphazard as the exhibition games. Although Cleburne tried to re-sign some of its former players, many had already joined other clubs. By April 10, the roster was set. The team was ready to defend its 1911 championship.

With players still learning one another's names, the team traveled to Tyler on April 23 for the last preseason series. They won the first game, 4–2, with a starting lineup containing all new players, except for Dad Ritter. The next day, the bats went cold, and the Railroaders committed three errors on the way to a 2–1 loss. Still, Cleburne won the series by taking the third game, 6–3. As the Railroaders boarded the train for the trip back to Cleburne for the home opener, no one could yet determine if this was a team of champions or just a collection of ballplayers. Only time would tell. But the larger question was whether the fans would stick with a losing club. Despite

ups and downs, Cleburne was accustomed to championship baseball and hadn't dealt with weathering a losing season. No one even thought about the lack of talent on the current roster.

Opening Day was just as exciting as it had been in the past. Much like the 1911 season, there was virtually no business conducted other than baseball on the first day of the season. Music filled the air. A band from Venus was waiting at the depot with a few fans when the Railroaders arrived. Greetings were exchanged between the players and the residents, then it was on to the business at hand: celebrating the return of baseball. The band led a parade through town. The streets were lined with spectators who loved parades as much as they loved their ballplayers. The processional concluded with the teams. The party stopped downtown long enough for the band to perform a concert. Then it was on to Gorman Park to take on the Longview Cannibals.

One of the curious aspects of minor-league baseball are the team names. The early days of Texas baseball saw plenty of curious names. In some cases, a name had a special meaning to the local community. Sometimes, it was a nod to an industry in the town. And, at times, it was simply a fun moniker. During the early years of the Texas League, Paris fielded the Parasites. While this name was likely a nod to the name of the city, some leaders in the Texas League argued that it described what the Paris team did to the league. Other distinctive names in the league included the Austin Senators, Corsicana Oilers (a nod to the town's early oilfields), Galveston Sand Crabs, Sherman-Denison Students (a reference to a college), Waco Navigators, Wichita Falls Irish Lads, Borger Gassers, Marlin Bathers, Temple Surgeons, Terrell Terrors and Palestine Pals. For the home opener, the Cleburne Railroaders (also known to the locals as the "Cake Eaters") would take on a team with arguably the most curious name of all: the Longview Cannibals.

On this Opening Day, the Railroaders were not struck with fear of the Cannibals. Cleburne won the game before a packed house at Gorman Park. Before the game, the locals welcomed Grady White, a star player from Cleburne's 1911 team. White received a significant ovation from the crowd. When "Dad" Ritter took the field for his twenty-first year of professional baseball, he still had plenty of spring in his step. He still had what it took to catch a professional game. He demonstrated this by throwing a runner out at second. The next day, the Cannibals feasted on Railroader errors and ate them up, winning 4–2.

For the first few weeks of the season, things looked bright for the Railroaders. Pitcher Harbin threw ten strikeouts in a 4–2 win over Tyler.

The next day, he took control with his bat. In the bottom of the ninth, he hit a long drive that scored three runs to win in walk-off fashion.

Off the field, the team announced that ladies would enjoy free admission for Friday games and that admission for children under fifteen would be reduced. The Cleburne Baseball Club, knowing that the size of crowds could fluctuate throughout the season, took immediate action to increase attendance before the numbers at the turnstile dropped. The railroad town was quickly becoming known as the town of Railroader baseball, throughout Texas and across the country. The season looked promising, and many fans believed another championship was in the making. After all, the team had already produced two titles in its first two seasons.

Beneath the surface, however, a growing problem lurked. Mysteriously, attendance was slowly but surely decreasing. The team was playing solid ball and was winning most of its games. At first, the decline was thought to be an aberration. But as the season continued, so did the dropping numbers. Was it complacency, fan boredom or a lack of advertising? The cause was unknown, but the result was undeniable. Low attendance was like cancer to an early Texas professional baseball team, especially in a smaller town. Cleburne had a problem.

Despite the dropping attendance, female fans showed up in droves. For one particular game at Gorman Park, several fans from Paris showed up, many of them women. One woman in particular caught the attention of the locals. Upon arrival, she likely blended in with everyone else. But during the first few innings, some Cleburne fans heard something strange and unusual. They looked around, trying to locate the origin of the low, loud sound. Someone spotted the woman from Paris, rooting for her Parasites. Her voice sounded like a foghorn! The *Cleburne Morning Review* called her cheers the "tune of the dying swan."[70] This unknown woman certainly made the game interesting and entertaining, for fans and players alike. Fun days could still be had at the ballpark, even if the crowds were dwindling.

The majority of home games in 1912 were played at Chase Park. Unfortunately, this led to lower attendance. The attendance problem most likely stemmed from the difficulty fans had in getting to Chase Park. Gorman Park, home to two championship teams, was strategically located a short walking distance from the center of town. The only drawback was the prohibition of Sunday games within the city limits. Chase Park, standing outside the city limits, was built as a solution to the Sunday issue. But solving this problem created a new one. Instead of walking to the ballpark, fans now had to catch a ride or walk long distances. The exact location of Chase

Park is not known today. At one point, streetcars were enlisted to take fans from the courthouse, along the interurban tracks to the "first curve," which supposedly made travel to the park easier. It didn't.

Despite the lower attendance numbers, Cleburne was on an eight-game winning streak. By May 7, the team amassed an 11-3 record. They were firmly in first place and, by all accounts, looked as if they would walk away with the first-half pennant and earn a trip to a championship playoff. The *Morning Review* reported, "Cleburne is a sure pennant-winner this year, and will be able to play off the post-season games with whichever team wins the second pennant."[71] While league officials talked about Dad Ritter's impressive leadership and Cleburne's fast start out of the gates, the lack of attendance continued to draw concern. When the season began, Cleburne had a reputation for drawing large crowds. As the season went along, it was the east Texas teams that drew the large crowds. This caused many in the league to question Cleburne's prior boasting. It should have caused alarm for the Cleburne leaders, too. But, as is often the case, the problem went unrecognized.

The Legend of Dad Ritter, Cleburne's Most Colorful Player

Winning is often accompanied by eventual complacency and restlessness. The Railroaders were no exception. The team was winning so often that the box scores became predictable. Therefore, the players often created their own excitement, with ample encouragement from their fearless leader. On May 11, Dad Ritter was tossed from a close game with Longview because of his mischievous attitude, and the Cleburne catcher, Jutzie, was fined five dollars. No one knows if old Dad was upset over a close call, bored or just having a bad day. While he was a good judge of ballplayers, he was not always a good judge of personal discretion.

Ritter was quite the character. Born in a small town in Tennessee in 1884, Albert Lee Ritter's love of baseball and shenanigans developed early and continued throughout his life. Just how Ritter came to Texas is unknown, but his career in Texas minor-league baseball is the stuff of legend. He played minor-league ball for at least eight different teams over ten years. While his playing skills were barely above average, his temper was off the charts. Controversy seemed to follow Ritter wherever he went.

Al Ritter was given the nickname "Dad" early on in his career. One day, a reporter asked him how he got the nickname. "I look old," Ritter responded. "But I have not yet reached the twenty-eight mile post in life's journey. I will be twenty-eight in October. I always had a settled look."[72] Dear old Dad was a study in contrasts and was always in the middle of controversy. However, he almost always found a way to win ballgames.

From the start, Ritter made it clear that he would not back down. When Tris Speaker was inducted into the Texas Baseball Hall of Fame in 1951, a story was recalled by Dallas city judge Joe M. Hill. At the turn of the century, there was a group of town teams called the Red River League. Speaker was hired to pitch a couple of games in a series between Wolfe City and Honey Grove. During the final game, Speaker lost control of a ball and beaned "Big Bill" Lattimore. Lattimore was laid out at the plate for some time before he regained consciousness. When he did, he grabbed his bat and marched toward the mound to show Speaker his bat. Dad Ritter, who was catching that game, took control of the situation. "That's the way with you big rubes from the river bottoms," Ritter yelled. "We get you out of the sticks and put you in big league company and you don't know how to act!"[73] Thanks to Dad, Speaker got out of the game without a scratch.

In Ritter's first year of professional baseball, he was arrested. He was playing for a team out of Hope, Arkansas. Ritter's team met a club from Midland in Greenville for a Sunday game. However, Sunday games were illegal in Greenville. When the authorities heard about the game, they promptly arrested the teams' two captains. Ritter was released when he promised he would not play in any more Sunday games. Even after that incident, Ritter was often bounced out of games for fighting and arguing. On June 8, 1910, he was tossed from a game. Apparently, dear old Dad Ritter felt strongly that the umpire had blown a call, so he stormed out of the dugout and headed to the plate. Along the way, he let out a string of obscenities that the newspaper refused to publish. When he arrived at the plate, he shook his fist in the umpire's face. He was ejected from the game, but he refused to leave until the police chief was called to escort him out of the park.[74] The locals in Jonesboro, Arkansas, were not amused. "The capers of Dad Ritter yesterday are not elevating to the game," the local paper reported, "and do not increase his own personal popularity around the circuit."[75] Two days later, Ritter was again chased out of the park.

It was not long before Ritter's pugilistic reputation spread. He would punch a player in the nose for questioning his integrity, push an umpire he thought was being unfair and, occasionally, get into a ruckus with

fans. At one point early in his career, Ritter was barnstorming across Oklahoma. He was on a tear at the plate, hitting balls virtually at will. During a game in McAlester, Ritter made his way to the plate. "Hands up!" came a command from somewhere in the crowd. The voice was accompanied by the sound of a metallic click. When Ritter turned to see what was going on, he found himself staring down the wrong end of a pistol. "Strike out or I'll shoot you full of holes," was the next command given by the man holding the revolver. It is unknown whether Ritter obliged or not, but that was about the only way to get him to back down from a confrontation. Trouble just seemed to find its way to Ritter (or, Ritter found his way to trouble).[76]

Having outstayed his welcome in the North Eastern Arkansas League and having likely been run out of Oklahoma at gunpoint, it appeared that Dad Ritter was through with baseball—or, more apt, baseball was through with him. That's when a scout for Fort Worth by the name of Paul LaGrave ran across Ritter. The Fort Worth Panthers were in need of a backup catcher, and Lagrave saw potential in Ritter. In early February 1911, the Panthers signed Dad Ritter to a contract.[77] He played for the Panthers until late May, when he arrived in Cleburne.

The Fort Worth team had an abundance of catchers, so when the opportunity came to deal Ritter to the Cleburne Railroaders, LaGrave jumped at the chance to free up space on his roster. Fortunately, Dad Ritter was just what Cleburne needed. When he took over the team, they were twenty-three games behind the leader. He turned the club around and, in less than two seasons, secured two pennants and a championship. While he continued to find trouble, Ritter also found baseball success. Over a period of five years as a manager, Ritter won four Class D pennants.

When his career was over, Ritter settled down in Cleburne and worked in the Santa Fe shops. When Ritter first arrived for work at the shops, a man came over to greet him. "We used to know a Dad Ritter. Are you any kin to him?"

Ritter responded, "Well, yes, I am Dad himself."[78] Dad Ritter won baseball games and pennants. That he fought along the way made the journey more interesting. When it was over, he fit right in at the railroad shops.

Under Ritter's leadership in 1912, Cleburne kept winning. By the middle of May, the team had amassed an impressive 18-7 record. Dad Ritter and Jutzie led the team in batting, and the team's overall fielding was holding solid. One pitcher, Kerr, was called "the master of the mound." Locals were beginning to compare the 1912 team to Tris Speaker and his 1906

Ever the true Texan, Tris Speaker often performed roping exhibits before games. Here, he ropes none other than Will Rogers. *Courtesy of Jim Swan.*

champions. That locals would mention Speaker in the same sentence as the 1912 Railroaders spoke to just how good the team was.

The only team in the league good enough to give Cleburne a run for its money was Texarkana. In a short series in mid-May, Texarkana handed Cleburne two losses. Cleburne was in the middle of an eight-game winning streak when the two teams met. Cleburne sent a pitcher, Merrell, to the mound, and he shut the Texarkana batters out until the ninth inning. By then, nine Railroaders had already crossed home plate, and the only drama was whether there would be a shutout. Texarkana scored three times, but that was not enough. Cleburne went on to sweep Texarkana, putting to rest the question of whether or not Texarkana could hang with the "Cake Eaters." After that, the Cleburne players rightfully earned a new nickname: the Man Eaters.

But even a new nickname and continued wins could not solve the decreasing attendance. The games themselves were becoming routine and, at times, boring. Many fans became more interested in the umpires than in the players. Fans watched an umpire to see in which direction he was

looking, and they compared how each one made his calls. On May 24, the fans were particularly interested in the umpire. Cleburne was playing Marshall when the visiting team's catcher attempted to throw out a runner at second. Somehow, the ball caught the side of the umpire's head and knocked him out. For the rest of the game, the fans watched the side of the umpire's head to see how large the knot would grow. The media talked more about the umpire catching a bean ball than about Cleburne's ace pitcher, Kerr, who won his ninth game in a row, pitching a shutout. This indicated that boredom reigned at Gorman and Chase Parks. The fans were simply biding their time until the excitement of the playoffs.

By the end of May, rumors starting circulating. The first was that Cleburne was too good for the South Central League and that it should be playing with the big cities in the Texas League. Such rumors, often sparked by jealousy, can simply be a consequence of success. The rumor didn't gain much traction. The other rumor, however, was more problematic. There was talk in town and around the league that the Cleburne team might be breaking up. The rumor continued while the club traveled and began playing in the difficult portion of the season known as the grind. Yet, the rumors were the least of their worries.

By this time, Cleburne's team was getting noticed around the state and even the country. The *Miami Herald* reported that "Cleburne is running away with the pennant in the South Central League, having won 25 out of 32 games played this season."[79] The *Dallas Morning News* called the Railroaders "the bad man from Johnson County." The next best team was Longview, and they had lost twice as many games as Cleburne. The Railroaders were running away with the first-half pennant when they pulled into the Paris station on June 4.

When the Railroaders arrived at the park in Paris, they were greeted by fifteen hundred spectators, a number worthy of Gorman Park just a few months earlier. The fans were there to see a great team play a great game. What they experienced can only be described as a battle reenactment. Something sparked a debate, which turned into a heated argument. Then there was a rush to the diamond and a scene akin to a war zone. Both benches cleared, and the melee was on. Umpire Wilkinson, a no-nonsense ump, took control of the situation. When the dust settled and the players went back to their seats, the Railroaders were without Ritter, Jutzie and White. The next day, the *Dallas Morning News* placed the blame on Cleburne, reporting that "Ritter and White, Cleburne's catcher and center fielder, were put out of the park by umpire Wilkinson for attempting to assault him and the whole

Cleburne's domination of the South-Central League was recognized throughout the state. *Courtesy of the* Dallas Morning News.

exhibition was spoiled by squabbling on the part of the visitors."[80] While such behavior was expected from Ritter, it was not normal for Jutzie or White to get tossed for fighting.

When the team finished its early June road trip, large crowds were reported in each city. But back at home, it was almost accepted that Cleburne's attendance would continue to be dismal. "Cleburne's reputation as a baseball going town seems to be on the wane. A few years ago the people turned out in numbers to the local games, but the attendance of late has not been what was expected at the opening of the season. Since the Cleburne team has been on the road this time they report better crowds at each stop

than at Cleburne."[81] The newspaper called for people to support the team in a series against Texarkana. The team would need more support than usual, since Dad Ritter was suspended for three games, most likely for fighting.

By the time Cleburne split a double-header with Texarkana and lost to Tyler, the Railroaders were declared the winner of the first-half pennant. Discussion then turned to who would play Cleburne in the series for the championship. Longview and Marshall were the early favorites. In an effort to escalate the quality of play, the league had increased the salary cap from $900 to $1,200. There was also talk of adding more teams to the league. The teams from McKinney and Greenville had dropped out of the Texas-Oklahoma League, and it was doubtful that that league would make it through the second half of the season. Sherman and Denison were prime candidates to join the South Central League.

Only recently has instant replay made its way to baseball. For over a century, though, players and fans had to accept the decision of the umpire as the final word on a play. Many times, a blown call changed a game or even a series. On June 11, Tyler beat Cleburne because of a bad call. Apparently, the call was so egregious that the umpire reconsidered his call after he left the park and changed his decision. The result was a "do-over." The teams had to play a double-header in order to finish the scheduled game as well as the game in question. Another contest against Marshall resulted in a game being replayed when Marshall protested a call. The only difference between sandlot baseball and professional baseball appeared to be who got to call the "do-over."

As the first half was winding down and the pennant celebration was at hand, the Elks club gave the Railroaders a "smoker." Smokers, popular parties at the time, revolved around fine food, "suds" and good cigars. Before the party was over, it was announced that Texarkana had rolled into town for the game the next day. Being good sports, the Cleburne bunch invited the visitors to join the party.

Later in June, Texarkana was traveling to Cleburne for another series. Along the way, the team stopped at a cool spring in east Texas for a rest. It failed to catch the train heading to Cleburne and missed the game. The umpire had a Cleburne pitcher throw three balls across the plate and then awarded the game to Cleburne, 9–0, as a forfeit. The next day, the teams were in the third inning when a dust storm arrived, forcing the game to be called.

On June 18, the Railroaders won a thrilling game against Marshall at Gorman Park. The game went to eleven innings before the Cleburne team

put Marshall away for good. While there is no mention of the attendance, those present were said to have made a deafening sound by, of all things, slapping their hats on their legs and yelling, and they beat their umbrellas against the stands. Virtually all the fans had lost their voices by the end of the game. On June 21, the fans were treated to a visit from an old friend. The Paris team was led by manager Rick Adams, who had played for the 1906 Cleburne champions. Many fans were pleased to see him, especially given the fact that the Railroaders beat his team.

Cleburne's leading pitcher, Kerr, was at it again on June 27. He pitched a shutout against Marshall but had to work around loaded bases several times. Throughout the season, Kerr threw what only a team's ace can throw, and he proved that he could pitch close games under pressure. He would be valuable to the club if it could make it to the end of the season for the championship series.

When July arrived, interest in baseball waned in Cleburne, Texas. Attendance remained low, and by this time, news of the team's progress was no longer on the front page of the local paper. In fact, many of the articles that were printed about the team were "specials" sent in by fans because reporters were not covering the games. Cleburne had weathered the prospect of its team folding in each of its prior seasons. This time, it was different.

On July 10, 1912, the *Cleburne Morning Review* included the following headline: "CLEBURNE'S LAST GAME—will be played at Gorman's Park today.—Team to be Transferred.—Management will move pennant winners to some other town for lack of support."[82] The article went on to state, "What will be Cleburne's great loss in more ways than one, and a black eye to the reputation of the city as loyal supporters of all local institutions, will be the gain in all respects to some more enterprising city, if this change is made." The team left for a road trip not knowing if it was ever coming home again. It was apparent that the rumors of Cleburne losing the team had substance.

On July 12, the South Central League announced its second half season. Games would be played among four teams. Unfortunately, Cleburne was not one of them. That was it for Cleburne. A first-half pennant and a lost chance at another championship were what the Railroaders had to show for the 1912 season.

It is ironic that Texarkana was named the 1912 South Central League champions. It won the second half of the season, and when Cleburne folded, the title was awarded to Texarkana without dispute. This was reminiscent of the way Cleburne had secured the 1906 Texas League championship,

winning the second-half pennant only to see the first-half winner drop out. Just weeks earlier, Cleburne had invited the Texarkana team to join its celebration. This time, it was Texarkana celebrating while the Cleburne players were already packed and back at their homes. In Fort Worth, some Panther fans knew how their friends in Cleburne felt.

Had the attendance rallied, there is no doubt that Cleburne would have either won the second-half pennant or played for a championship. But there was no rally, and the city soon experienced the fate of other small Texas towns: a team folded because of finances. The gates were closed at Gorman and Chase Parks. And when winter set in later that year, a chill settled over the empty baseball diamonds. Professional baseball in Cleburne would experience that chill for the next decade.

Sixth Inning

PROHIBITION DIDN'T STOP THE MARCH TO THE CELLAR

There are three types of baseball players: Those who make it happen, those who watch it happen, and those who wonder what happens.
—*Tommy Lasorda*

In the early 1920s, America was changing. The Roaring Twenties were just getting started. Prohibition was the law of the land. And by 1920, more Americans lived in cities than in rural areas. By March 1921, the Nineteenth Amendment had been ratified, granting women the right to vote, and Warren G. Harding had been elected president in a landslide.

Baseball was changing, too. The dead-ball era ended as Babe Ruth emerged as an offensive force. Stadiums were built around Ruth's home-run capabilities. Rube Foster strengthened the Negro leagues, setting the stage for Jackie Robinson to tear down baseball's racial barriers. Radios were commonplace, allowing fans to hear their favorite teams play on the road. And in 1920, Cleburne's discovery, Tris Speaker, led the Indians to a World Series championship. Many call the 1920s the golden age of baseball.

Just as the country and baseball were changing, so was Cleburne. By 1920, the town's population exceeded twelve thousand. The former agricultural center had completely transformed itself into a true railroad town. The streetcars and interurban transportation systems to Fort Worth instituted in 1911 were now in full swing. Automobiles were no longer a novelty. A new

The kiss of victory. After making the final out of the 1920 World Series, Tris Speaker ran straight to his mother's embrace. *Courtesy of Jim Swan.*

high school was open, operating under the leadership of Emmett Brown. The school started a new tradition that would shape the community for generations: the "house" system.

> *First the system of changing from one study hall to another each year was abolished. The student remains in the same study hall throughout the four years. Next, the term "study hall" was done away with and "house" substituted. Each house was given a name so that it would have a personality to which the mind of the student could attach itself. The boys' study houses are "Thomas A. Edison House," "James Whitecomb Riley House," "Woodrow Wilson House"; the girls': "Jane Addams House," "Frances E. Willard House," and "Clara Barton House." Over each house dwells the personality of the one for whom it is named. Students, upon entering school are allowed to choose their house. They go prepared to be loyal to it, absorb the principles that governed the reasons for whom the house is named, and fight for it by mouth, pen, or fists.*[83]

The one thing that had been missing for almost a decade was professional baseball. After the collapse of the 1912 Railroaders, Cleburne's two parks saw action from local amateur teams, but there were no professional games. With modern changes sweeping the country, the stage was set for professional baseball's return to Cleburne.

Like the music of the Roaring Twenties, pro ball came roaring back to Cleburne. By March 1921, players arrived to try out for a new team in the Texas-Oklahoma League: the Cleburne Generals. The Railroaders had failed a decade earlier, so the team was renamed in honor of the town's namesake, General Patrick Cleburne. The team would return to the Texas-Oklahoma League, which was composed of teams from Paris, Sherman, Bonham, Ardmore, Graham and Cleburne. M.H. Robertson, known as "Robbie," was hired as the manager and was charged with assembling a team.

Excitement filled the air as the town began talking about baseball once again. There was an effort to create a loose affiliation with Oklahoma City, a Class A affiliate team in the Western League. The affiliate team would assign players to Cleburne for the purpose of improving their game. Cleburne immediately picked up three players in the deal: Fruth, a utility player; Tabor, a pitcher; and LeClaire, a Native American outfielder who could run like nobody's business. The affiliation would develop Oklahoma City's players while elevating the level of play for Cleburne. At least that was the theory.

With a roster forming, efforts shifted to raising money to restore Gorman Park. The park had fallen into disrepair and could not host a professional game in its current condition. Some toyed with the idea of building a new park downtown, but that effort failed. City leaders contributed money for the restoration of Gorman Park, but the fundraising was slow. So, the team got creative. Season tickets were offered at discount prices. Five dollars would get a woman in for all the home games; it would take forty dollars for a man to do the same. Although the field was almost ready and new netting had been installed, by mid-March, it was apparent that Gorman Park would not be ready when the season started. The decision was made to start preseason games at the Johnson County Fairgrounds. The team now had a league and would soon have a home. All that was missing was a rival.

In an attempt to create solid rivalries for the season, the manager from Paris met with Cleburne's manager. They discussed the upcoming season; then came the challenge. The two men agreed that when their teams met for the first time, the manager of the losing team would have to walk from the ballpark to downtown in his bare feet! It is unknown whether the loser

While the Railroaders received top billing, the Santa Fe Railroad shops had several teams that played in amateur and semipro leagues. For decades, these teams were the pride of Cleburne and often competed with Santa Fe Railroad teams from Topeka and Houston for recognition as the best Santa Fe team in the country. *Courtesy of Layland Musuem.*

made good on the bet, since there is no report of crowds lined up to see the barefooted walk. Later in the season, Cleburne's Robertson would need more than his shoes to keep his job. But for now, the preseason was filled with hope, excitement and some good-natured, albeit corny, fun.

While the community continued to work on the park issues, Robertson assembled his team. As in other seasons, the team checked out local talent, scouted the state and even went north of the Red River in search of players who could help add another pennant to Cleburne's flagpoles. Some players came from Alvarado, Midlothian and Maypear. Some came from the Santa Fe Shop teams. Several North Texas men with experience playing for Fort Worth and Oklahoma City arrived for the tryouts, as did players from surrounding states. When Robertson wasn't busy running practices, he was scouting players.

Once enough players to field a decent team were in place, the Generals were ready to stretch themselves beyond their tedious drills and test their skills against other teams. First up was a college team from Meridian. By game time, the Generals had their starting lineup ready. In fact, there were enough players to field two squads, so two practice teams were formed. The

first team went to Meridian to play the college team, while the second squad continued to work out at the fairgrounds. The game in Meridian was not close, but some loyal Meridian fans were acquired from the experience. Robertson was assured that when the season started, he could count on Meridian folks to travel to Cleburne to root for the Generals. The same thing happened a few weeks later in Alvarado. The Cleburne Generals were fast becoming a regional favorite.

After the practice games, the team played its first exhibition game in Cleburne against a local bunch called the All-Stars. Then, it was time to start playing other professional teams. These games were not so easy for the Generals. There was a loss after a close game to Greenville, then a win against the Fort Worth Independents. On April Fools' Day, they played the Schepp's Bakery team from Dallas. The Bakery boys were considered by many to be the strongest independent team in Texas. The Generals proved themselves to be stronger, beating the Bakers, 6–5. The Schepp's boys left the field wondering if they had been the subject of an April Fools' joke, or if the Generals were the real deal. It was clear that things were looking good for the upcoming season, and it appeared that Cleburne baseball was going to pick up where it left off a decade earlier. However, the victory over the state's strongest team could have just as easily been a cruel joke. Only time would tell if the Generals were for real.

On April 11, the Fort Worth Cats were scheduled to come to Cleburne for the first time since the showdown between the two cities fifteen years earlier. The 1906 season had provided entertainment and a solid rivalry. It had started with a bang when Fort Worth arrived and ended with a championship. Many wondered if lightning could strike again.

By 1921, the city recognized the historic aspect of its 1906 team, which had been loaded with major-league talent, including Tris Speaker. He had just won the World Series for the Cleveland Indians, and the man with a "C" on his cap was the subject of discussion in another town whose name began with "C": Cleburne. The buzz included memories of that historic season and the rivalry with Fort Worth. Discussion always ended with the frustration that the championship series never happened. The city's residents, feeling fifteen years of pent-up emotion, talked with bravado about the rematch. As luck would have it, however, the game was cancelled because of bad weather. Once again, there would be no game between Fort Worth and Cleburne.

With the season looming, baseball was the talk of the town. The Generals would play at home for the season opener. The league had laid down a

challenge to its cities. The city with the largest Opening Day attendance would receive a commemorative cup. Cleburne loved to play for cups. On the same day that the rematch game was called off, the team's new jerseys arrived. They were gray, with "Cleburne" across the breast. This symbol of community pride was put on display at Foster-Fain's drugstore for everyone to see.

The rest of the preseason saw more wins than losses; by all appearances, another successful season was in the works. On April 14, Warden, a pitcher acquired from the Oklahoma City team, threw fourteen strikeouts against Mineral Wells. The Generals, led by newly acquired third baseman Fortier, were driving the ball hard and long. There was one more game to go before the regular season started.

When spring weather is combined with professional baseball, evocative sensations are brought about. The smell of freshly cut grass wafts through the cool spring air. Hot dogs begin to boil. Children see the freshly prepared diamond for the first time. And every team, player and fan believes that this could be their year. Spring weather is nature's way of exclaiming, "Play ball!" Lifelong memories are created at ballparks, and in 1921, a spring league game between Cleburne and Ardmore would be a day none of the attendees would forget.

For the last preseason game, the teams arrived and began warming up while the fans made their way to the stands. There was excitement in the air. The umpire brought the players to the field and yelled, "Play ball!" As the game proceeded, something began to change, almost unnoticeable at first. It didn't take long for fans to recognize that the smell of cut grass was overcome by the smell of charring wood. "Fire!!!" Commotion ensued as people discovered what was going on under their feet. A fire had started somewhere under the wooden grandstands, and smoke was billowing out from the stands. As everyone scrambled to safety, it became evident that some of the cars parked under the stands were on fire. All of the fans, dazed, made it to safety. Several people then rushed under the stands to try and save the automobiles.

The flames engulfed the grandstands within minutes, quickly generating a bonfire. When the fire department arrived, it was too late to save the grandstands. The firemen bravely fought the flames, but it was a losing battle. After twenty minutes, the stands were nothing more than a smoldering pile of rubble. The heroics of the firemen saved the bleachers next to the grandstands. Many fans suffered smoke inhalation; fortunately, no one was seriously injured. The same could not be said for the vehicles parked under

the stands. A Buick sedan owned by a Dallas man who drove to Cleburne to catch the game was the fire's first victim. The second was Dr. C.V. McSwain's Ford Roadster. These automobiles were the only two recorded victims of the Opening Day fire.

In a moment of resiliency, the teams and fans borrowed an oft-used line from show business: "The game must go on!" Since the firemen had saved the bleachers, and the field was still intact, the game resumed a mere fifty-five minutes after it had started. Fans filed into the bleachers. Most of the fans, perhaps with the exception of Dr. McSwain, remained to watch the game.

The opening of a baseball season in Cleburne had once again been accompanied by difficulty. In 1906, a tornado almost ended the season before it started. This year, it was a fire that threatened the game. Both years, the fans rallied around their team, and the games continued.

The game remained scoreless until the seventh inning. When it was all over, the Generals won, 2–0. As the fans and players filed out of what was left of the fairgrounds, talk centered on doubling efforts to finish Gorman Park. Given the loss of the fairgrounds, the town called for making Gorman Park a multiuse facility.

In the days that followed, plans were made to rebuild the grandstands at the fairgrounds using insurance money. At the same time, efforts were focused on getting Gorman Park ready for home games. Ben Johnson, the son of well-known oil magnate B.J. Johnson, led the efforts. Under his leadership, the grandstands were improved and enlarged. A fence was erected around the park's entire perimeter. Overall, the goal was to not just reopen Gorman Park, but to modernize it as well. Because of Johnson's leadership and efforts, Gorman Park was renamed Johnson Park. The home park, originally named after a railroad man, was on April 21, 1921, renamed for an oil man—a fitting tribute to the two industries that shaped the Texas economy and landscape.

Opening Day is a time-honored tradition across America. Some argue that it is one of the best aspects of the game. The slate is clean. The stands are full. Hope is in the air. There is pomp and circumstance and celebration that winter has finally given way to baseball season. Cleburne, Texas, was just as giddy as any other city in America on this particular day in 1921. And for Cleburne, it was more than just another home opener—it was the first one in almost a decade.

The town was ready to celebrate baseball's return. The newly renovated and renamed Johnson Park was ready for action. When April 28 arrived, the

teams were ready. The fans were ready. Local businesses shut down, just as they had for the previous three home openers. As was Cleburne's custom, the day began with a parade. The Cleburne band led the procession, followed by baseball officials, including the league president, in town to personally witness Cleburne's traditions. Then came the Cleburne Generals and their opponent, the Graham Hijackers. The typical parade entries of decorated automobiles and fire apparatuses rounded out the festive procession.

The parade meandered through downtown and made its way to Johnson Park, where a record crowd packed the stands. Attendance estimates ran as high as three thousand. As the fans entered, many commented on the new outfield fence. They talked about the heady days of 1906, when Ben Shelton led the Railroaders to a Texas League championship and played his part in grooming the legendary Tris Speaker. When Mayor R.E. Mitchell finally threw out the first pitch, it must have bounced over the plate or completely missed, as a fan stood up and yelled, "Take him out!" Everyone laughed. The atmosphere was electric, and everyone was in a good mood. After all, it was Opening Day in Cleburne.

When the umpire finally yelled "Play ball!," the Generals knew they needed to prove they were worthy of the "Cleburne" emblazoned on the front of their jerseys. In three previous seasons, Cleburne teams won three pennants and two championships. The Generals had big shoes to fill. Out-of-town press attended the game, including reporters from the *Dallas Morning News*. Fruth hit the first home run in the newly renovated park, and for that feat he was awarded a pot of thirty-two dollars collected by the fans. In the end, the Generals won the game, 8–4. It appeared all was right with the world. Pro baseball had returned to the sleepy little railroad town, and the team took its first step toward a pennant and a championship. But it was just one game. The rest of the season would not be as easy as this first victory.

The next day, a local doctor was called to the field; Graham's first baseman was injured after he and the pitcher ran into each other. After he left the game, his team did not fare well against the mighty Generals, who won, 12–5. The first winning streak of the new season was on. The next day, the Generals finished a sweep of Graham, 8–1. After a glorious opening home stand, the team left for a series at Paris. Unlike in previous seasons, the Cleburne players were not digging out of an early hole.

The conditions in Paris were miserably wet and cold. The field was soggy, the play was slow and the Generals missed their home field full of loyal fans. The game's outcome was no better than the weather. The Generals lost the game, 13–1, and then were swept by Paris.

The team returned to Johnson Park for a little hometown magic. The Sherman Lions were up. In the second game of the series, a Sherman batter stepped up and pounded the ball to left field. The hard-hit ball was heading straight to the fence when the wind slowed it down a bit. The Generals' left fielder, Bartell, was in a dead sprint to the fence. At first, it seemed as if he was racing the ball. But when the wind slowed the ball down, Bartell stretched out his bare hand and, just before slamming into the fence, made the catch. Everyone in the place, except the Sherman players, were applauding and yelling. Sherman was robbed of at least a triple, and the fans witnessed a rare bare-handed catch. After Cleburne's victory, Bartell's swollen hand became even more so as a result of the many congratulatory handshakes by players and fans.

The teams finished a three-game series at the fairgrounds. Although the grandstands had not yet been rebuilt, the team chose to play a game there. It is not known why baseball and town officials thought it necessary or desirable to maintain two ballparks. In 1912, the Railroaders played in two parks, and the results had been disastrous. Attendance dropped like a lead balloon, and the team eventually folded, unable to finish the season or play for the coveted championship. Perhaps the Generals maintained two parks for bragging rights. No other small city in Texas had two professional baseball parks. Maybe it was an attempt to give fans a change of pace or to provide a competitive edge against visiting teams. The reason remains unknown, but history would not prove kind to the decision.

The Generals were faced with more adversity in the first weeks of the season. After the fire, they played through sandstorms, rain and a bit of bad luck. The team suffered several losses. The stands were largely filled for some games and strangely empty for others. No one could identify the exact reason for the erratic attendance. Fearful of what would happen if attendance continued to drop, the Cleburne Baseball Association attempted to fill the stands by offering $100 to churches that sold large blocks of tickets to their congregations.

Sports fanatics and athletes are often superstitious, and baseball players are no exception. There are stories about players wearing the same socks over and over in order to maintain a hitting streak, pitchers who refuse to change caps and managers who wear lucky undershirts. Some players have strange pregame routines. The great Satchel Paige had his throwing arm rubbed down with axle grease before he pitched. Stan Musial ate two eggs, then two pancakes, then two more eggs each game-day morning. In 1894, the entire Orioles team would sit down together at a table, where they would

each chug a glass of turkey gravy before batting practice. When Reggie Jackson was traded from the Yankees to the Angels, he took his lucky batting helmet with him and had the Angels' logo painted over the Yankees' "NY."[84] One thing is certain: players like routine and abhor change. Yet, dramatic changes were in store for the Generals.

Through the early weeks of the season, Cleburne and Paris battled for first place. The Generals were keeping pace with the talent-heavy Paris team. The season reached mid-May, with the Generals right in the mix for a pennant. The season was still early, but the town wanted to ensure the Generals were marching in the right direction. So, on May 17, the Cleburne Baseball Association called a meeting at the chamber of commerce offices. The space was packed when O.L. Bishop, the association's president, called the meeting to order. There is no record of what was discussed, but whatever it was, it certainly had an impact on the team's morale and performance. But not in a good way.

On May 18, 1921, manager M.H. Robertson was let go, and the association began to conduct interviews for his successor. It is unknown just why Robertson, in spite of his team's position in the standings, was fired. How could this sudden, drastic change not affect the whole team? To shake things up even more, the city itself became the owner of the franchise. This change was curious indeed. The primary purpose of city government is to provide basic services such as police and fire protection, water, sewage treatment and road maintenance. When cities branch out into other areas, they often find themselves in trouble. Cleburne was no exception. The mayor had trouble getting the first pitch over the plate on Opening Day. How was the city going to manage a professional baseball team? Whatever the wisdom of the decisions, it was time for the city and the team to move forward together.

When the new manager, Pete Dillon, arrived, more changes occurred. For starters, Dillon noticed that at home games, fans packed a grove of trees and a shed positioned on the south side of the field. These spectators should have been sitting in the stands. Fans would crowd the rooftop of the shed, and the tree branches would strain under the weight of spectators. Dillon had officers clear the shed and the trees trimmed. If someone wanted to watch his team, they would have to pay the price of admission.

Area cities began sending large groups to the Generals' home games. On May 22, Grandview sent some two hundred residents to watch the game. On the mound for Cleburne that day was Siddon, a Grandview native. Siddon pitched his best, but it was not enough to overcome Bonham. The visiting club took the game, 4–2, at Fair Park. While the Grandview fans

were hoping for a Cleburne victory, what they really wanted to see was their favorite son pitch a professional baseball game. Other outlying cities would make the trek to Cleburne from time to time, proof that Cleburne was a team for the whole area.

The team continued to win a few and lose a few. Then, on May 27, a little rivalry began between Ardmore and Cleburne. A local Ardmore business, E.J. Company, sent a telegram to the Cleburne team: if Cleburne could hold Ardmore scoreless, the company would raise a purse of money from the fans. The challenge was accepted. Two days later, in Ardmore, the Generals' second baseman, Fruth, led the charge. He hit the ball so far that someone in the stands yelled, "Babe Ruth is on the field!" The Generals gave it their all and won the game. Unfortunately, they allowed Ardmore to pass one runner across the plate, narrowly missing out on a bag of money. The fans, players and workers of the E.J. Company all had a good time.

When June arrived, the summer heat began setting in across North Texas, apparently sapping the energy that the Generals needed to win baseball games. During the first days of June, the Generals began a slow march toward the cellar. There were a few bright spots, like pitcher Warden throwing a shutout against Bonham in a 9–0 win, but these victories were few and far between. On June 9, in an effort to cheer up the Cleburne fans, the local paper wrote, "In the old days it was said that no team could play Cleburne on the home grounds and get away with a majority of the games and it is believed that this rule will soon be established here again."[85] Unfortunately for the fans, these were just wishful words, and the rule was not reestablished. The team continued to struggle, even at home.

As the temperature began to rise, so did the frustration level of the fans. With no one else on whom to take out their frustrations, they turned on every baseball fan's favorite target: the umpire. On June 11, a regrettable game took place. Ardmore arrived in town to take on the Generals at Johnson Park. In the early innings, umpire Myers made a couple of bad calls. With each disputed call, the fans displeasure increased. Then it happened. Myers blew a call at home plate. He called an Ardmore runner safe when he was clearly out. That was it. The fans had had enough. Typically, a bad call like that would cause a chorus of boos and catcalls from the stands. But when the home team is on a rapid descent to the cellar and Prohibition keeps fans from drowning their sorrows in an ice-cold beer, there's nothing else to do but storm the field! So that's exactly what they did.

The fans emptied the stands and rushed to home plate. That the game could be forfeited to Ardmore was probably the last thing on the fans'

minds. The Generals were already losing games left and right, and for weeks the fans had watched helplessly as their team marched all the way to the cellar. It was time for action. The dugouts emptied as well, but the players were likely rushing to Myers's rescue rather than looking for a fight. Somehow, the Generals' manager made it to Myers's side and tried to reason with the fans. When the fans eventually calmed down a bit, Myers was still alive and in one piece. But the fans remained on the field. Cleburne's manager knew that his one duty was to get Myers out of there! Somehow, the manager and umpire made it through the crowd, and Myers was placed in an automobile and whisked away to safety.

The manager later recounted the events. "I talked to the fans and kept them from attacking Mr. Myers. I got him in my car and made a run with him to the city."[86] With Myers secured, arrangements were made to bring in a new umpire for the next game. While there is no account of any dustup between the fans and the new umpire, it was clearly on the umpire's mind. In the game, the pragmatic umpire called ties for the home team rather than, as was traditional, the runner. After all, it was just a game and not worth a trip to the hospital.

Embarrassed by the events, the manager summed up how local leaders must have felt. "I regret very much the trouble that came up at Johnson park Friday afternoon. We certainly hope that nothing like that will come up again. Sometimes things of this kind are unavoidable in a baseball game. We only want to win games by playing good ball and this will be our aim. We will be at the park Saturday and do all we can to win."[87] Never before and never since has such a mob scene occurred in Cleburne.

As the summer days got longer, so did the losing streaks. The games were becoming predictable, causing the local newspaper to start writing about semipro and city league games. While the Generals had fortified their position in the cellar, Paris marched to the top of the standings. The two teams played in late June, and it was evident that the standings reflected reality. Paris won games by scores of 14–5 and 11–2. There was concern that the Generals would fold before the season's end. This prompted a sale on season tickets for the remainder of the games. A community meeting was called at the chamber of commerce to offer the discounted packages. It was all hands on deck to save the team.

By the end of June, the first half of the season was finally over. As expected, Paris won the pennant. With a chance for the team to begin anew, Cleburne tried to mix things up. Johnson Park had been purchased by Tom Lutton, so the city changed the name to Lutton Park. Team uniforms were

The 1911 Cleburne Railroaders were the last professional championship team. *Courtesy of Layland Museum.*

cleaned and readied. And to kick off the second half of the season, the Generals would have the the pleasure of playing none other than Paris. The midseason changes worked. The Generals gave Paris a taste of its own medicine, winning 8–2. Cleburne was finally out of the cellar—at least for a day. But this winning moment was brief. The next day, the old Generals were back. The stark contrast between Cleburne and Paris continued. And this contrast was most evident on the Fourth of July.

Cleburne had a tradition of playing a double-header to celebrate America's birthday. In 1921, the tradition continued, but this time without Cleburne's professional team. The first game was between the Fort Worth amateur league champions and the Cleburne All-Stars. The second game pitted Fort Worth's Axtell team, led by Texas Christian University college players, against Cleburne's Sunday school league all-stars. The crowds were light and unimpressed. More noticeable was the absence of the Generals.

Like Cleburne, Paris, too, had its Fourth of July traditions. The Parasites, too, played a double-header, but it featured two professional teams: Paris

and Cleburne. Before a record crowd of 1,515 fans, Paris swept the Generals. For years, Paris had struggled to support a professional team. Usually, it lost out to other cities, like Cleburne. But by 1921, the town's persistence had paid off, and it was fast becoming a strong baseball town. On the field, the fireworks went off, but the celebration was not for the visiting Cleburne team.

The Generals concluded a long road trip without a single victory. The last road game was rained out, sparing the team another embarrassing loss. The community was frustrated. This time, instead of taking it out on the umpires, the fans directed their ire at the team. Even the *Cleburne Morning Review* took its shots at the team. "It does not take any skill whatever to be at the bottom of the percentage column. Any team in the world can hold such a place. The Cleburne team has defeated every team in the league but for some reason, which the players alone can explain; they have not won a single game since going away from home. No team is expected to win all of the games away from home but all teams are expected to win some of the games when they go on the road."[88]

Despite the community's frustration, it understood the importance of finishing what had been started. This was baseball, and anything could happen. Talk of abandoning the team and dropping out of the league prompted a community meeting to discuss the Generals' future. The Cleburne Baseball Association hosted the meeting. Usually, such a meeting would draw a large crowd, but not this time. The gathering was small but enthusiastic. The participants determined that dropping out of the league at this stage would have a negative impact on the city's image. They decided to underwrite the team through the end of the season. They needed to raise $600 to get the Generals to the end of the campaign.

The committee completed the task of raising the money, and the Generals were now in a position to finish the season. Unfortunately, despite the removal of the financial burden, the team continued to play subpar baseball. Its losing ways had become so predictable that the newspaper began covering the Sunday school league more often than the professional league. Teams from Sand Flat joined the ranks of Cleburne's Bear-Cats and All-Stars as worthy of coverage. Despite the lackluster performance by Cleburne's professional team, the town continued to enthusiastically support baseball in general. Teams from the Santa Fe Railroad shops took the field at Lutton Park, and Field Street Baptist Church's team battled for first place in the Sunday school league. Field Street's team not only won the championship, but its starting pitcher, R. Stout, was called on to fill in on the mound for the Generals. Several Generals had fallen ill, and the team needed help. While

Cleburne High School baseball players are seen in the 1921 *Santa Fe Trails* yearbook. *Courtesy of Layland Museum.*

the Generals didn't have a prayer of winning a pennant, with the Baptist pitcher on the mound, they reached what was for them a peak, beating Sherman, 9–1.

The team continued to shake things up. On July 26, it brought in a new manager, Johnnie Tabor. The team had released manager Billy Reed and catcher Powell. It was almost too late to make a difference, but the Generals were desperate. As with previous shake-ups, the managerial change brought a new face to the same old result: losing baseball games. The Generals' losing ways even rubbed off on their new pitcher, Stout, who was not accustomed to losing.

The march back to the cellar was not without some bright spots. The Generals took two out of three in a series against Bonham at Lutton Park. However, the last game was marked by controversy. The Bonham manager protested the game when the umpire ruled that a runner was out at third base before another Bonham player, McDowell, crossed the plate. The protested game meant nothing to Cleburne, but it could have been significant for Bonham's place in the standings. There were also some victories over Paris. New manager Tabor was tossed in the eighth inning of a loss to Paris. A decade earlier, it had been nothing for Dad Ritter to get tossed from a game or even get into a fistfight. Tabor, though, was more reserved. Getting ejected was not his style, and he certainly had not signed on to lose games.

When the season entered the grind, Cleburne was at the bottom of the standings. For the most part, it was business as usual for the Generals: a few wins sprinkled in with a pile of losses. On August 11, the manager and several players were tossed from a game in Sherman for contesting calls. The calls were so bad that even the Sherman fans began hissing the umpire. In previous years, contesting calls was a normal part of the game. But in this golden age of baseball, the sport had become less of a Wild West scene and more of a gentleman's endeavor. Gone were the days of fistfights with the umpires and baseballs shot out of midair by cowboys on horseback. Texas baseball had been transformed from a frontier version of the national pastime to the prime breeding ground for big league players. Unfortunately, the Generals were not breeding much more than defeat.

Goodwill and sportsmanship were the trademarks of baseball in the golden era. During a bi-county championship game, sportsmanship was on full display. In a close series, a Cleburne amateur team was set to finish off its counterpart from Glen Rose. There was just one problem. One of the Glen Rose automobiles had suffered a flat tire on the way to the Cleburne park. The car and the players occupying it were nowhere to be seen at game

time. Cleburne loaned the Glen Rose team two good players from its roster. This goodwill gesture cost the Cleburne bunch the game, but it earned the players a reputation for solid sportsmanship. Winning baseball games was important, but the way the game was played was paramount.

As the season wound down, the grandstands at Fair Park were finally going back up. The season would end as it had begun, with Cleburne remaining one of the only cities in Texas to boast two professional baseball parks. Hundreds of fans continued to attend the games to see the Generals play or to watch local teams battle. The fans' interest had turned from the Oklahoma-Texas League to local games. In one exhibition game, the Sunday school champions from Field Street Baptist Church squared off against the Generals. The way the professional team's season had gone, it was anticipated that the game would be a good one. But when the game was completed, the difference between amateur and professional baseball remained clear. The Field Street boys didn't have a prayer. The Generals shut them out, 14–0. Still, the community enjoyed watching two of their teams go at it.

Labor Day weekend is generally considered to be the mark of summer's end. In 1921, Labor Day also marked the end of the regular season for the Texas-Oklahoma League. The Generals played a double-header at home before a large crowd. When the sun finally set on the day and on the season, the Generals finished strong by winning both games. Ardmore won the pennant, but the Generals' finish on this day set up winter discussions about whether another season made sense. The march to the cellar was completed, but the battle plan for the next season was already underway. While Prohibition sought to end traffic to the wine cellars, for Cleburne, it did not stop the march to baseball's cellar.

A RALLY WAS IMPOSSIBLE

In baseball, there's always the next day.

—*Ryne Sandberg*

Winter baseball meetings are filled with hope and excitement as the countdown commences to Opening Day. In small Texas towns, these meetings also set the tone for survival. In past years, winter baseball meetings in Cleburne were well attended. The purpose of the meetings was to discuss the upcoming season, the team itself and the amount of funding needed to ensure professional baseball would make it through the season. In 1922, Cleburne was about to embark on its fifth year of pro ball. Through five seasons, Cleburne teams had amassed three pennants and two championships. Overall, that was an outstanding record for a small railroad town in north Texas. But, as is often the case, it's the last season that gets the attention.

The Cleburne winter meetings of 1922 were particularly interesting. Doak Roberts took over as president of the Texas-Oklahoma League. Baseball fans in Cleburne had a love-hate relationship with Roberts. This was the same Doak Roberts who first brought professional baseball to Cleburne, discovered Tris Speaker and led the team to the Texas League championship against all odds in 1906. But this was also the same Doak Roberts who packed up the Texas League trophy and, with his team in tow, left Cleburne without so much as a celebration. He took the team and hardware to Houston, where he changed the team's name to the Buffaloes.

Although Roberts had put Cleburne on the baseball map, he was not popular with the locals.

While Roberts's name likely garnered mixed reactions in 1907, this was 1922, and things had changed. Progress spread rapidly in small towns during the Roaring Twenties, and Cleburne was no exception. Since Roberts left Cleburne, baseball had made a successful return. Roberts continued his trail of success in Houston and established a national reputation for winning. So, bringing him in as commissioner of the Texas-Oklahoma League added stability and credibility to an otherwise second-rate league. His name was associated with winners, and he could bring much-needed notoriety to the league. Cleburne needed redemption for its disappointing season, and Roberts craved to again hit the big time in baseball. If Roberts could make the league relevant once again, then Cleburne was willing to lay aside any hard feelings for his abandoning the town years earlier. It was a good fit.

On February 25, 1922, Cleburne's winter meetings took place with Doak Roberts on board. There was a report about what the league president was doing and what changes he would bring. Lindy Hiett, the team's new manager, gave a report on spring tryouts and the upcoming goals for the season. There was the usual discussion about how to raise the money necessary to complete the season. Everything seemed just like old times, but with one difference: attendance at the meeting was inexplicably poor. Whether due to a scheduling conflict or a lack of interest, the meeting was so poorly attended that it was recessed and rescheduled for February 27 in hopes that more citizens would show interest.

The second attempt at the meeting was more fruitful, though attendance was still not stellar. There was talk about whether or not Cleburne would remain in the Texas-Oklahoma League, but with Doak Roberts sitting at the league president's desk, this discussion was largely academic. Regardless of whether they liked each other, Doak believed in Cleburne, and Cleburne believed in Doak. Lindy Hiett was formally tapped as the team's manager. He had pitched for the team in 1912 and had an impressive playing record. Roberts hoped that Hiett's playing skills would translate into solid management for Cleburne. The townspeople had forgiven Roberts for leaving, and they hoped he would do for minor-league baseball what Judge Kenesaw Mountain Landis had done for the major leagues. Landis had been appointed commissioner of Major League Baseball to clean up the mess that eight Chicago White Sox players made when they threw a few games in the 1919 World Series. He was a well-respected, no-nonsense judge. Doak Roberts had achieved the same level of credibility, and any team playing in

a league led by him provided a boost for that team's city. Roberts and his reputation were major factors at the winter meetings; what was missing was the initial presence of the fans. Eventually, their attendance at the meetings increased, and the planning continued.

Doak Roberts came to Cleburne on March 16. What he lacked in speaking ability, he made up for in reputation and in general baseball knowledge. Cleburne was none too happy with the team's finish the year before, and having Doak in town reminded the residents of the championship years. Roberts addressed the crowd and finished with these words: "I'm sure if the people of Cleburne can get started, they will prove real fans just as they are in everything else they undertake, and I truly want to see your good town in the race."[89]

Despite having left Cleburne, Doak Roberts had a special place in his heart for the town and its people. After winning the 1906 pennant, he was interviewed by a Chicago reporter. The reporter, unfamiliar with Texas cities, asked Roberts if Cleburne was as large as Dallas. While today that question seems ridiculous, it was not an unreasonable query at the time. At the turn of the century, many believed that the arrival of railroads would allow Cleburne to keep pace with the likes of Fort Worth and Dallas. The town grew exponentially for several years after the Santa Fe Railroad set up shop. However, in time, the growth leveled off. As Roberts answered the reporter's questions, he knew that Cleburne was as good for him as he was for Cleburne.

When Doak Roberts became president of the league, he heard that attendance was low and that Cleburne was not supporting its team. Having experienced the unparalleled passion of the local fans in 1906, he was quite skeptical of the report. Coming back to Cleburne was like coming home, and he wanted to pick up where he had left off more than a decade earlier. The thought never crossed his mind that Cleburne would be unable to host a team for the 1922 season. It would be weeks into the season before he began to doubt his decision to include Cleburne.

For now, it was settled that Cleburne would remain in the Texas-Oklahoma League. With that, ticket sales commenced. Offers included a flex package for five dollars, by which two people could attend five different games of their choice. Tickets were made available at businesses up and down Henderson Street. On the first day that tickets were offered, over one hundred five-dollar packages were sold. The Cleburne Baseball Club set a goal of pre-selling one thousand tickets. The association was well on its way, or so it thought. Although sales started strong, by March 23, only four

hundred tickets had been sold. Poor sales could have been attributed to the team's dismal performance the previous year. Certainly, the Depression was a factor. The professional baseball season would start as usual, but it was anybody's guess whether Cleburne would finish or not.

When the Texas-Oklahoma League began the season later in the spring, Cleburne was joined by teams from Corsicana, Greenville, Paris, Sherman, Bonham, Ardmore and Mexia. Among the team names were the Corsicana Gumbo Busters, Mexia Gushers, Ardmore Producers, Paris Snappers and Greenville Togs. It was not uncommon for teams to change names over time, and Cleburne was certainly no exception. In 1906, the Cleburne team honored the town's railroad connection by calling itself the Railroaders. Although the team remained known as the Railroaders in 1911, the "Cake Eaters" nickname stuck with the locals. In 1921, the team paid homage to the town's namesake, General Patrick Cleburne, adopting as its name the Generals. However, no one wanted to remember the Generals' cellar-dwelling performance. So, the team started 1922 nameless. Ultimately, they were named the Scouts, likely in honor of the Chisholm Trail heritage (and perhaps a nod to the team's desire to scout out the unfamiliar territory of first place). The team and the town were now free to work together on planning a successful baseball season.

A team name was secured, and enough money was in the coffers to start the season. Then, the Scouts received new uniforms. By the end of March, spring training was in full swing. Teams from the cold northern states arrived. In 1911, the Chicago White Sox left the Windy City for Cleburne. In 1922, it was the Kansas City Blues who migrated south for fairer weather. The Blues were part of the fledgling American Association. In fact, Kansas City had been the 1918 AA champions. A few years after playing in Cleburne, it would field a team that many would call the greatest minor-league team to ever play baseball. The Blues' contributions to baseball included the start of many great careers, the most notable of which was that of Mickey Mantle. But in 1922, the Blues rode a train to Cleburne for a little Texas-style baseball.

Despite the concerns regarding support, over three hundred people attended a practice on March 28. The park was well groomed, and the grandstands were prepared for the fans. The memory of the Generals' 1921 performance had melted during the spring thaw. The schedule was announced in early April. Cleburne would play on the road for opening day on April 19. Two days later, the Scouts would return to Cleburne for the home opener. It was baseball season in America, and Cleburne was ready.

Just before the season started, a major change in the schedule was announced: there would be no Sunday afternoon baseball in Cleburne. Sunday games were critical to the success of a ball club, and Cleburne tried to add the day back into its schedule. Local preachers rallied support to cancel Sunday games, and they gained enough traction to get it done. This was an age of temperance; Cleburne was changing from a wild boomtown to a reverent, churchgoing community. The impact of the announcement prohibiting Sunday play would be felt in Cleburne, Texas, for decades.

Religion was important in Cleburne. For a century, church steeples sprang up continually across the town's landscape. Many new churches were born out of splits when families feuded over things like song selection and pew colors. Following the repeal of Prohibition, Cleburne remained a city that valued keeping up appearances. For the most part, drinking was frowned upon from the local pulpits. Not surprisingly, though, some citizens who sat piously in their pews on Sunday mornings burned a trail to the liquor stores on Friday evenings. Many congregates were careful to store their beer in a garage refrigerator, away from Sunday school fellowships that took place in their kitchens. Long after the era of Prohibition and bootleggers, things remained the same: Friday night's hellions were often Sunday morning's angels.

As in the previous season, president Roberts promised a trophy cup to the city with the largest home-opening attendance. Not wanting to lose out, Cleburne kept its tradition of closing businesses to celebrate the return of baseball. On April 19, a long list of closings was announced in the newspaper. From Bradbury's Clothing Company to Altaras's Dry Goods, the list included most of the town's cafés, department stores and grocery stores. The railroad shops didn't close, but plenty of railroaders called in "sick" so they could support their team. Cleburne wanted to win the attendance cup and show the other cities that while its team may not always be the best on the field, its fans were the best in the stands. There is no record of who won the cup, and the trophy could not be found in any of the dusty storage rooms where much of Cleburne's history resides today. But there is no doubt that the town supported its team.

As the season approached, it was clear that this Cleburne team was different from the prior season's team. In the preseason games, the Scouts' lineup gained notoriety as a hard-hitting list of batters, from top to bottom. If sound, fundamental play and defense couldn't make the team competitive last year, this year's team was built to slug its way to a pennant. And, short of a pennant, a strong lineup meant exciting games. That was just what Cleburne needed.

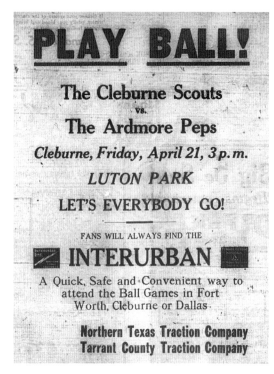

PLAY BALL!

The Cleburne Scouts
vs.
The Ardmore Peps

Cleburne, Friday, April 21, 3 p.m.

LUTON PARK

LET'S EVERYBODY GO!

FANS WILL ALWAYS FIND THE

INTERURBAN

A Quick, Safe and Convenient way to
attend the Ball Games in Fort
Worth, Cleburne or Dallas

Northern Texas Traction Company
Tarrant County Traction Company

Newspaper advertisement for a game in 1921. *Courtesy of the* Cleburne Times Review.

On April 19, while the town was getting ready for the home opener, the team rode the train to Ardmore to officially kick off the 1922 Texas-Oklahoma League season. The bats were in full swing, and the Scouts won the opener in a slugfest, 9–7. If one game could predict a full season, then Cleburne was in for a wild ride. Unfortunately, opening day victories are worth no more than any other game in the season.

The home opener was filled with excitement. Not only did the local businesses honor the team by closing, but they also took out ads to show their support. The W.E. Miller Drug store bragged that it had the largest supply of balls, bats and gloves. The Dillon and Son Funeral Home announced that it was closed and all-out for the game. And Conley Bros. Cleaners announced that if the Scouts won the opening game, it would clean all the players' suits for free. There was no doubt that local businesses were backing baseball. The question was whether they would stand strong if fans became fickle during the late-summer grind, especially if the team was in contention for the basement again.

The first game at home was a time to celebrate the return of America's pastime. The grandstands were filled with 721 fans. They watched the Scouts duke it out in a close game. By the end of the ninth inning, the Scouts rewarded the fans with a 5–4 victory. Whether the motivating factor was the excitement of the crowd or the promise of a clean suit, the players put it to the Ardmore Producers. Gary Lacy, the catcher, put on a batting clinic. After he hit a two-run triple, his teammates screamed, "Ol' Lacy is there!" Lacy's performance secured suit cleanings for the

whole team. Lacy himself received enough money from the fans to buy a new suit.

By the time Ardmore boarded the train to leave Cleburne, the Scouts had taken the series, 3-1, and were at the top of the standings. The next day, they defeated Bonham, 6–1, and moved into sole possession of first place. It looked like last season's performance was a distant memory. However, as the Scouts were settling into a solid winning streak, the weather changed and reminded the team that it was spring in north Texas. Several games were rained out; the weather threatened to douse the Scouts' hot hand.

On April 28, a new baseball buzz was heard around town. On this date, the team battled the cold and the wind to produce an exciting 8–1 win. The excitement prompted one fan to proclaim, "These Cleburne games are so good that old Jack Frost tried his best to make [attend] the one yesterday."[90] Another fan proclaimed, "Now days when a fellow speaks of 'fly' weather, you can't tell whether he's a bugologist or a ball fan." With the team solidly in first place, happy days had returned to Cleburne.

The euphoria of first place was temporary. The team quickly dropped to the middle of the pack. Despite the losses, the Scouts continued to produce exciting games. On May 3, the team won a squeaker over Greenville, 6–5. The game started when the first pitch to a Scout batter was hit out of the park. On the other end of the box score, Greenville loaded the bases in the

In 1920, the Cleburne Yellow Jackets were the first Texas High School Football champions the state recognized. *Courtesy of Layland Museum.*

bottom of the ninth. The Scouts hung on and secured the final out when their backs were against the wall. The crowd was thrilled.

While professional baseball got most of the attention, Cleburne was becoming a dual-sport town. Football was on the rise, and this could only mean one thing for Cleburne: the pursuit of another championship. As the fall of 1920 gave way to winter, the state of Texas decided to start a new tradition for high school football: playoffs culminating in a state champion. Unlike their college counterparts, Texas decided to have high school teams run through a playoff series until there was one team left standing.

The Cleburne High School football team weaved its way through the playoffs and arrived at the first state championship game. When the final whistle blew, Cleburne was crowned the first Texas High School Football co-champion.

By 1922, support for football was growing, but baseball was still the national pastime. Using the momentum of one sport for the benefit of the other was not out of the question. And when it came to the local Rotary and Lions clubs, both sports could be used for the community's benefit. "Why not raise some money playing baseball?" was the question the two clubs asked. It was the best of both worlds. From the establishment of both organizations, a desire existed to give the other club a good-natured hard time. But at the heart of every Rotarian and Lion was the strong desire to make the world a better place, starting with Cleburne, Texas. If they could have some fun while doing that, all the better.

The two clubs decided that a charity baseball game would be the perfect vehicle for raising funds to help the community. They decided to square off, play some baseball and have a little fun, while at the same time raising funds to improve the fences surrounding Rhone Field, where the gridiron players battled. The money raised would also build a house for a local woman, Ms. Hamblin, who was raising eight children by herself.

While the game was the means by which the clubs would raise the money, the sideshows that transpired in the days leading up to the game were the real attraction. There were editorials printed in the local paper, wherein club members poked fun at one another. The Lions club was already known for its propensity to pull practical pranks, and plenty of pranks were promised in the days leading up to the game.[91] The Lions promised full prosecution by one of its players, Gayle Prestridge, who was also the local prosecutor, should any Rotarian hit a ball past him. One Lion wrote an editorial proclaiming, "the 'whelps' didn't have no more chance of winning than the thought of starvation would come to a three headed mouse in a cheese factory."[92] The

days leading up to the charity game provided tremendous entertainment for the community.

After days of chatter, ribbing and pranks, the community anticipated a game where anything could happen. The poor umpire likely thought he was going to call a baseball game. What he didn't know was that he was going to supervise a three-ring circus played out on a baseball diamond. The fans poured into the grandstands of Lutton Field under a hot Texas sun, and the two clubs made their way to the field. "Play ball!" cried the umpire. It was time to take the show to the diamond.

After several innings, the Rotary Club team led 10–3. It appeared that the Lions' pregame boasting was just that. But then something magical happened. The Lions came roaring back. By the ninth inning, the Lions scored five runs to tie the game at 17–17. The players and crowd were having so much fun, hardly anyone noticed that the sun was beginning to set. As the shadows on the field were growing longer, the two managers met at the plate to discuss the game. They decided to call the game a tie for a perfect finish.

When their decision was announced, the crowd went wild. Many called for the teams to play in the dark until there was a winner. Others called for a series of tiebreakers. In the end, the Lions and Rotarians shook hands with smiles on their faces. They had just raised $65.40, which would be used to help improve the high school football team's stadium fence. More importantly, they had raised money to help build a house that the two groups would later construct for a local family. Almost one hundred years later, the two clubs continue to raise money and improve the lives of others, and they still know how to have fun while making a difference.

While the Rotarians and Lions were raising money, the Scouts continued to play. For the Texas-Oklahoma League, 1922 was becoming the year of the bat. With a month of the season in the books, there were over forty league batters with an average over .300. The Scouts were counting on their bats to lead the way to a pennant. Unfortunately, in 1922, so were most of the other teams.

The Cleburne boys progressed through the first part of the season with the usual wins, losses and streaks. There were slumps, and by mid-May, the fans grew particularly worried. Several team members suffered injuries. By all indications, the Scouts were headed toward a less-than-stellar finish. The team counted themselves lucky to have survived a last-place finish the previous year. It was doubtful that professional baseball in Cleburne could endure another finish in the basement.

Within days, the Scouts' bats came to life. The team began moving up to the middle of the standings, and fans' worries gave way to optimism once again. On May 17, after the Cleburne team scored seven runs in the seventh inning to win, 8–7, local fans compared the victory to a satisfying cigar or a good round of golf. That the fans were comparing their baseball team to material things, rather than the other way around, proved to be ominous.

While the sport of baseball was substantially more refined than life in the earlier pioneer days in Texas, many players still possessed feisty attitudes that at times boiled over. In a game against the Ardmore Producers, a player for Ardmore named Clopp was at the plate and was apparently having a bad day. With two strikes in the count, he was caught looking and heard strike three called. Normally, a batter who experienced such a call would shake his head and walk back to the dugout. Sometimes, he would stare at the umpire; occasionally, he might argue his point a bit. Clopp did none of these.

On this day, Clopp simply stayed in the box as if the call never happened. He began swinging his bat and digging in his spikes. He was in the box for another pitch. When the umpire directed him to the dugout, Clopp simply made a few more practice swings and stayed in the box, waiting for strike four. Things got heated, yet Clopp remained in the box and refused to leave. At some point, Cleburne police officers were summoned to the plate to escort him to his seat. One officer whispered something in his ear, and that seemed to do the trick. Clopp walked out of the box with an officer on each arm. There would be no "sit-in" protest at the plate after all. The whole ordeal made no difference, as the Producers shut out the Scouts in a 5–0 victory.

Not long after Clopp's protest, the Scouts' manager, Dillon, instigated a new rule for his players: no swearing on the field. He announced that if any of his players were heard swearing during a game, they would be cut from the team. Dillon wanted to make sure his players kept the game family-friendly and that they remained good examples for the kids who came to watch them play. Dillon made it clear to his players: "There's no swearing in baseball." Some players no doubt swore under their breath at the order. If Dillon had applied the same zeal toward the skills of his players as he did to their vocabulary, the 1922 season likely would have been different.

As the season progressed, the Scouts remained stuck in the lower half of the standings. They just couldn't seem to gain ground on the league-leading Greenville team. By late May, the season seemed to be a wash. In a fitting salute of nature, rains poured down on Lutton Field. It rained so hard on May 22 that the local paper surmised that the Scouts should turn their jerseys in for bathing suits. The next day, Sherman arrived in town for

a double-header. The visitors were worried about slinging mud and soiling their jerseys while running the bases. Their worries were in vain; when the game was over, their jerseys were as pristine as the day they were unpacked. Joe Gaines, Cleburne's pitcher, mowed through the entire lineup, striking out all but one batter. The Scout fielders were just as much spectators as were the fans in the stands.

While the professional boys struggled to break free of the middle of the pack, the fans continued to enjoy the ongoing series between the Rotarians and the Lions. While the civic leaders' fundamentals were anything but sound, their antics made for fine entertainment. The two clubs were slated to grace Lutton Field on May 26, and the days leading up to the game were almost as much fun as the game itself. For days, maybe weeks, there was plenty of fun poked at both the players and the clubs. What the Harlem Globetrotters would later mean to basketball, the Rotary and Lions teams meant to Cleburne in 1922.

As game day approached, the players for both clubs intensified their training. It was said that "many gallons of 'rub liniment' have already been purchased" and that "several of the Lions and Rotarians have taken out life insurance the past few days."[93] One player, Lee Battle, was so small that the clubs were having a hard time finding him a uniform. For game day, players were encouraged to leave their umbrellas at home or in the grandstand, so as to avoid confusing the umpire.

Silliness aside, there were some club members who could really play baseball. For example, a Dr. Streetman was said to have some affiliation with the New York Giants. For the charity game, it was reported that his arm was in great shape. One thing was certain: neither team was concerned about winning the game, but they were extremely concerned about losing it. The losing team would have to bear the burden of getting bested by the other club. It was the thought of humiliation that caused the Rotarians and Lions to settle down and play a serious game of baseball. In the end, the Lions won the game, 2–0. It was a great victory for the Lions, not because they won, but because their pregame predictions actually came true. The celebration, however, was short-lived.

The day after the mighty Lions roared to victory, a problem surfaced. Sometime before the game was even played, an unknown gentleman had been nominated to become a Lion. During the excitement of the game, the nominee played two and a half innings before someone realized that the club had not yet voted him in as a member. Recruiting ringers was strictly prohibited; players had to be confirmed members of their respective

organizations to play in the game. The nominee was removed from the game once the Lions realized what had happened.

The next day, William Riviere, the Lions' president, wrote to the president of the Rotary Club. "I regret to inform you that an ineligible man played on the Lions' team in the baseball game this afternoon....When the error was detected the player was removed, but the game was already technically forfeited. However, as the crowd expected nine innings, I gave no publicity to the matter at that time. I take this means of informing you what has taken place and of apologizing to you and to the Rotary Club in the name of the Lions Club."[94]

The Lions won more than a game that day. They won the respect of Rotarians and Cleburnites. When it was all said and done, it was about integrity and fidelity. Both clubs handled the matter in an exemplary manner. For the next century, the clubs would remain competitive with one another, yet both would continue to value integrity over victory. It was not surprising that the Lions would forfeit a game they clearly won, and it was not surprising that there was no ribbing or joking about the matter from either side. Both clubs took seriously matters of improving the community and displaying integrity.

Early June is often considered the unofficial start of summer. It was at this time in 1922 that Bonham came to Cleburne for a series at Lutton Park. Although the Fourth of July was still weeks away, the opening game provided fireworks on the field. The teams battled back and forth, and the lead often changed hands. The game went into extra innings. By the bottom of the tenth, the score remained tied, 6–6. Jack Puddy opened the tenth by walking. Roy Johnson laid down a sacrifice bunt that moved Puddy to second. Then T. Wilemon hit a soft grounder to second that advanced Puddy to third. With two outs and Puddy at third, Gary Lacy stepped into the batter's box. With the crack of the bat, Lacy almost knocked the cover off the ball. It went up and up, and out and out, until the scorekeeper watching from the scoreboard nearly broke his neck watching the ball sail over the outfield scoreboard. It was a walk-off victory, compliments of Mr. Lacy! The fans went nuts.

The next day, the newspaper printed one fan's impression of the walk-off home run. "With two down and one on, it's a shame to smack one over the score board in the tenth, but sure enough, Lacey did it, and won the game yesterday. He's crippled, but after all, there's not much use in runnin' when the pill's over in the brush. Just wonder if he killed any buzzards or snakes when his aim found it's mark."[95] It was a great start to summer for Cleburne

baseball fans. But, as is often the case, the emotional victory was followed by a sloppy defeat. Bonham won the next two games, 8–3 and 7–3.

Rain continued to play a role in the Texas-Oklahoma League games. When Mexia came to town for a series, the games were delayed; the teams had to play two double-headers in two days. Although the team wanted as many fans in the stands as possible, there was one fan they wanted banned. "It seems that old Mr. Rain is always determined to see the game himself, but when he's present, it leaves the rest of us out, so the king of showers has been kindly asked to stay away for these two days."[96] In an effort to get more people in the stands for the double-headers, the team offered a two-for-one admission. Unfortunately, Mr. Rain didn't read the paper; he missed the fact that he was uninvited to the games. The first double-header was rained out. The next day, the teams played two games, splitting them one apiece.

Whether it was the rainouts or the lack of Sunday play, the Scouts began to struggle financially. Attendance was down, and the prospects of finishing the season were now in doubt. On June 8, H.A. Oliver, the chamber of commerce secretary, stood up in the stands and announced that the team was selling an additional two hundred shares of stock to raise money to help finance the team. "We cannot afford the black-eye that would come with losing the team during the season. Not only would Cleburne lose the advertising that comes with having a professional baseball team, the team would wander around the league and would be known as the Cleburne Orphans! That would reflect poorly upon our community."[97]

The speech seemed to work. Several community leaders passed the bucket around the stands, and multiple shares were sold. As the chamber secretary continued his plea, leaders passed the bucket as though they were taking up an offering at church. The newspaper carried the message in its report the next day, and more funds were raised.

Despite the fundraising efforts, fan support continued to wane. Many discussions in town centered on this topic. At the local barbershop, men talked about whether or not the team's flirtation with the cellar was the cause for the drop in attendance. At the railroad shops, locomotive mechanics gathered around the water cooler during their breaks and determined that it was the ban on Sunday games that was the culprit. Most of them worked six days a week, and a Sunday afternoon was about the only time they could take in a game. Who was right? More important, how was the community going to fix the problem before it was too late?

Was the team's poor performance truly the root of the problem? A few hundred miles to the east, there was a Texas League team in Shreveport,

Louisiana. That team was in last place, having lost two-thirds of its games, yet the fans continued to support it. Was it the lack of Sunday games? Other teams across Texas and America were faced with the same challenge, yet they continued to receive support. Was Cleburne too small to support a professional team? Other small markets, including Cleburne in the past, had supported professional baseball. After almost one hundred years, it remains a mystery why Cleburne appeared to turn its back on professional baseball in the summer of 1922. You don't always know what you've got until it's gone. Cleburne was faced with losing professional baseball—again!

The mystery was made all the greater because baseball in general continued to see support from the community. Fans turned out for the Sunday school league games. On June 13, they witnessed a contest between the First Baptist and the Presbyterian teams. The Presbyterians didn't have a prayer at the plate, as a pitcher named Ferrell hurled a no-hitter for First Baptist. Railroad department games were wildly popular, although it was clear that they were not on a par with the professional games.

It was almost as though there was a disdain for the Scouts. Injuries had depleted their ranks, and fortune turned its back on the team. By the middle of June, Cleburne had cooled on its own team. The Greenville Togs were in

Cleburne Apprentices from an unknown year. *Courtesy of Layland Museum.*

town to witness the Cleburne fans "sneering" at the Scouts. The fans hurled insults when the Scouts came to bat and booed their own players when they took the field. As the game moved to the ninth inning, Cleburne was losing, 9–0. The fans, still hurling insults, filed out of the stands. When the last batter stepped into the box, the stands were eerily silent and empty. It was an omen of things to come.

The mood in town was so negative, it was thought that even a vote on a bond issue might cheer folks up. The hope was that on Election Day, citizens, happy to vote for road improvements, would then make their way to Lutton Field to cheer on the home team. It didn't work. The town's other league games, however, were well supported. The car men division of the railroad shop were undefeated in the Railroad League, as were the First Baptist bunch in the Sunday school league. But the Scouts continued to struggle on the field as much as in the stands. Wins and crowds were both conspicuously absent. After a 9–1 loss, an unknown visiting player said that the Cleburne fans were the absolute worst he had seen. He was shocked at how hard the local fans rode their team. Gone were the days when Cleburne was proud of its team. It wanted a winner; instead, it was heckling a loser.

On June 24, the schedule for the second half season was announced. The Scouts hoped to escape from the first half as quickly as possible. No one in the state of Texas was more ready for a fresh start than the Scouts. They knew that Cleburne had a history of strong finishes. The two prior championships had been won in the second half. They also knew that history would remember them more for how they finished than for how they started. There was hope.

When the books were closed on the first half, Cleburne finished just out of the cellar, alongside Mexia. Greenville won the first half, with Paris right on its heels. Now, the Texas-Oklahoma League teams started their race to see who would play Greenville for the championship. Cleburne came out of the gates fast with a win. Then it was quickly back to .500 baseball for the Scouts.

When the Fourth of July arrived, Cleburne celebrated with its traditional double-header. But in 1922, it was not the flagship team that took the field. Instead, it was the best of local amateurs who took on teams from other cities, including Burleson and Godley. The theme this year was community pride. Just up the interurban rails, the Cleburne All-Stars took on the A.J. Anderson team from Fort Worth at Riverside Park. Several former Cleburne professional players joined the game in Fort Worth. When the sun set, it was a clean sweep for the Cleburne teams. There were the usual bands and

parades to help the locals celebrate America's birthday, but there was no game with the Scouts. That the professional team was not included in the day's festivities was both telling and surprising.

A day later, the Scouts won a game in sixteen innings, but the stands were sparsely populated. Despite the win and a strong start to the second half of the season, the Scouts were soon back in the cellar. It was becoming easier to find a good seat for a Scouts game. In fact, there were more fans attending All-Stars games than Scouts games.

On July 25, the Scouts lost a game to the Paris Snappers. The players tried to make a last-minute comeback, but they fell short. They remained in the league's cellar. And with that, professional baseball in Cleburne, Texas, came to an abrupt end. The team folded before the season was over. As quickly as professional baseball had arrived in 1906, it was over just as fast in 1922. As with the conclusion of the 1906 season, the 1922 players boarded trains and returned home to carry on with their lives. The assessment by the *Cleburne Morning Review* of the final game pretty much summed up the end of professional baseball in Cleburne: "The scouts try for rally was impossible."[98]

Professional baseball in Texas would carry on, but it did so without Cleburne. For almost a century, a rally was impossible.

THE FORGOTTEN BOYS OF SUMMER

The way I figured it, I was even with baseball and baseball with me. The game had done much for me, and I had done much for it.

—*Jackie Robinson*

Baseball was forever changed on April 15, 1947. In front of a crowd of twenty-five thousand fans at Ebbets Field in Brooklyn, New York, a twenty-eight-year-old player made his debut in the major leagues. For almost a century, players had been called up from the minor leagues to play in the big leagues. But this player was different. He was Jackie Robinson.

Robinson was special. He was fiercely competitive and amazingly talented. But, more importantly, he refused to accept the rules of segregation. Robinson was the first athlete to letter in four sports for UCLA. He served in the army until he was honorably discharged for refusing to sit at the back of a bus. And he could play baseball like few others. It was the combination of these attributes that caught the attention of Branch Rickey, the owner of the Brooklyn Dodgers.

Rickey wanted to end the unwritten rule of segregation that remained in the major leagues. He chose Jackie Robinson to help him change baseball and make history. The first year was challenging, but over time, Robinson tore down the barriers of segregation in baseball by doing the one thing he did best: play ball. When his career was over, Robinson was inducted into the hall of fame, had a world championship ring, held a career batting average of .311 and was noted for his ability to steal any base he wanted,

including home. Robinson's number, 42, is the only uniform number that has been retired for the entire sport. There are two eras regarding the issue of black and white players in baseball: before Jackie Robinson and after.[99]

Cleburne was no exception when it came to segregation and baseball. "Segregation was a way of life," was the response of Zuma Kidd Cleaves at a reunion of Cleburne's Booker T. Washington High School.[100] Black teenagers were required to attend high school at Booker T. Washington until 1965, when the high schools were integrated. Students would walk to and from school. When they had spare time, many would organize a game of sandlot baseball after classes. Unlike many other aspects of life prior to desegregation, people in Cleburne enjoyed a good baseball game regardless of the color of the players on the field. While segregation sought to keep the races apart, baseball often brought them together.

In baseball's early days, the unspoken rule was that black players were not allowed on the field with white players. When it was clear that blacks would not be allowed to play on major- or minor-league teams, a group in New York formed its own league, the Henson Base Ball Club.[101] In 1859, two teams, the Jamaica of Queens and the Unknowns of Brooklyn, squared off for the first recorded all-Negro baseball game. It was clear from the beginning that America's pastime was for all Americans, even if they were not allowed to play on the same field at the same time. Soon after the game in New York, other Negro leagues sprang up across America.

As baseball continued to take root in Texas, the need for a Negro league was becoming apparent. In 1902, a young black pitcher out of Calvert, Texas, gained notoriety for his play. His name was Rube Foster. He played for several teams in north and central Texas and later began barnstorming across the country. Barnstorming was popular with black players for almost a century. A team of all-stars would form and travel to different cities across the country, playing against local, semipro and professional teams along the way. Barnstorming players would receive pay only when the gate receipts exceeded the costs of the exhibition game. Most often, the games were played for the pure love of the sport. Foster played much of his career in this fashion. Every once in a while, an attempt was made to form a colored league. In 1920, the Texas Negro League was formed. That same year, Foster helped establish the Negro National League.[102] Barnstorming and Negro leagues offered many black players a chance to play the game they loved.

It was against this backdrop of racial segregation that a black player from Cleburne was first recognized. In 1906, Cleburne won its first professional championship; it was also the year that a remarkable black

player came on the scene. That player was Oscar Frame. He was born on June 28, 1883, under the heat of a Texas summer sun. While he was delivered without a baseball bat, it would not be long before he picked one up. Like most Texas boys, Oscar and his friends ran through town and played in the nearby fields. At some point, Oscar was given the nickname "Fudge" by his friends. The name stuck. When the boys became teenagers, they did what most teenagers did: complete chores assigned by their mothers, play ball and, when time permitted, fish and hunt.

When Fudge was fourteen, his father gave him a shotgun. On his first hunting trip with the new gun, he invited his friends to come along. While he was waiting for his friends, he placed the gun, barrel up, under his left arm. The gun went off, and his life was forever changed. "Oscare [sic] Frame, a negro boy, was accidentally shot in the arm and shoulder yesterday evening while out hunting. He was standing by the roadside waiting for his two companions and was leaning on his gun when the piece was discharged, the full load of shot going into his arm and shoulder. Physicians amputated the arm last night."[103]

Baseball is a difficult sport when a player has the use of all of his limbs. It is virtually impossible when the player has only one arm. As a practical matter, the hunting accident should have ended Fudge's love of baseball. It didn't; it solidified it. It should have made it impossible for him to play baseball. It didn't; it made him extraordinary. Losing a limb would make most mortals fall into a state of depression, giving them cause to flounder through life. Fudge Frame was no mere mortal; he was a "good natured, funny man who did not let this adversity affect him." He would not be denied his love of the sport.[104]

There is no account of just how Fudge learned to play without the use of his left arm, but he did it. He not only figured out how to play, but he also learned how to excel at the game. In 1906, while the Railroaders were on the road, Fudge roamed the outfield of Gorman Park, where he played baseball for a team simply known as the "Cleburne Colored" team. He was joined by Henry Davis, D. Heron, James Ligggins, H. Lewis, R. Granbury, R. Matthews, M. Foster and P. Henderson Simpson. Virtually nothing is remembered about this team because there was no media reporting of colored teams. This is likely one of the greatest tragedies of early baseball; much of the records, feats, statistics and stories are forever lost.

Fudge went on to play across the state and across the country, where he consistently attracted the attention of baseball fans. "A large crowd attended the double bill and much rooting was in evidence over the fast fielding and playing of the two teams which were featured by Left Fielder Frain [sic] of

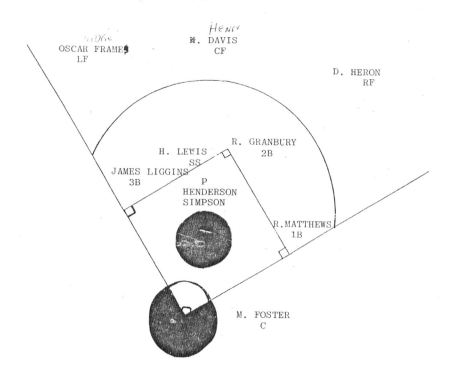

1906
OSCAR FRAME
LF

HENRY
H. DAVIS
CF

D. HERON
RF

R. GRANBURY
2B

H. LEWIS
SS

JAMES LIGGINS
3B

P
HENDERSON
SIMPSON

R.MATTHEWS
1B

M. FOSTER
C

THE CLEBURNE 'COLORED' TEAM

1906

The starting lineup for the 1906 Negro team. There is no record of the team name or any other facts other than this starting lineup. *Courtesy of Layland Museum.*

the visitors, a one-armed player, who made several spectacular catches and a remarkable throw from the garden to the plate which caught the runner in plenty of time."[105]

Oscar "Fudge" Frame played baseball for the Wichita Falls Black Spuds and the New York Lincoln Giants. When his baseball career was over, he

learned to play the piano. He settled down in Houston, Texas, where he lived out the final years of his life. On March 26, 1973, the one-armed playing wonder breathed his last. His body was returned to Cleburne, where he was buried at the Chamber Memorial Cemetery. Sadly, other than these brief reports, not much else was recorded about Fudge's inimitable career and life.

Other than the scant coverage given Fudge Frame, little was recorded of the Negro teams that meandered through the outfields of Gorman Park. While the Railroaders were on the road, Gorman Park saw plenty of action when Cleburne's Negro teams took the field. Both black and white fans enjoyed the games. From the time Fudge Frame picked up a bat in 1906 until a player

Oscar "Fudge" Frame. *Courtesy of Layland Museum.*

by the name of Jabe Brazzle first took the mound in the early 1950s, many talented young black men played baseball in Cleburne. These men played not for fame, but for the love of the game. While their names are forever lost and their memories all but faded, these unknown players kept the game alive in Cleburne. These guardians of the game were and forever will be the forgotten boys of summer.

One of the rare glimpses into the history of Negro baseball in Cleburne came on July 14, 1922. The professional team, the Scouts, were momentarily out of the cellar but were just days away from folding. Doak Roberts, the league president, was in town to pay his last respects to baseball in Cleburne. During that visit, however, he would witness something spectacular. The interurban rolled into town from Fort Worth. When the railcars screeched to a stop, black players and fans associated with the Fort Worth Woodmen of the World club unloaded. They had been invited by their counterparts in Cleburne to come for a baseball game. Locals and visitors packed into the Scouts' Lutton Park. The action that followed the game would draw headlines for days.

At the conclusion of the game, a concert and an unscheduled fireworks display finished the evening. The band played music that lightened the

summer air and brought smiles to the fans' faces. When the sun had barely slipped past the west side of town, the stadium lit up with a warm glow from fireworks being set off from the field. When the commotion started, many families left their dinner tables and some called the newspaper to inquire about the excitement. "What the heck is going on?" was the question many asked. The next day, the paper reported that those calling said they "thought the playing of the band indicated that someone had been elected."[106] The black fans were putting on quite a display of support at the ballpark. Unfortunately for Cleburne, the Scouts' fans were not present, nor did they follow suit. Days later, the Scouts would fold.

WHEN EAGLES SOARED

During the era of segregation, newspapers seldom covered Negro baseball. Despite the lack of coverage, the impact of baseball on the black community was profound. Cleburne's black community knew that fans were more than mere spectators. In the 1950s and '60s, a semipro team, the Cleburne Eagles, soared across the city and the state. While most of its roster played for the love of the game, some went on to play professional baseball. Sylvester Carter, Jabe Brazzell and Billy Jo Earl each had short stints with minor-league teams. Although there is little recorded history, the memories of baseball on the east side of Cleburne still burns bright for those who grew up watching the Eagles.

It is unknown just when Carver Park became a gathering place for residents of the east side of Cleburne, but from the 1950s until the 1980s, it was Cleburne's location for baseball. Years before, Luther Prince Sr. worked at the Santa Fe Railroad shops and often wandered the fields of Carver Park. The park was a center for picnics, and the muddy Buffalo Creek was the site of many baptisms for parishioners attending church on the east side of Cleburne. Prince had a different idea for the location.

Prince had a vision of building a baseball park. He eventually shared his vision with others in the community. Soon after, the work of building a field began. Each Sunday after church, several men would work for hours clearing underbrush and briars from the location. Once the field was cleared, Prince snuck out old crossties and timbers that were wasting away on the railroad shop grounds. Women would bring meals to the workers who had gathered at the park's construction site. Under Prince's watchful instruction, they framed up the grandstand and the fences.

Once Prince had the stadium ready, Mitchell Husk put a team together to take the field. During the week, Husk worked as a bellhop at the Liberty Hotel. On the weekends, he recruited young players, mostly from Booker T. Washington High School and the Santa Fe shops. Husk paid the players a small amount, along with the promise that if they won a championship, they would receive an additional four to five dollars each.

Unlike during the earlier years of baseball in Cleburne, games at Carver Park were almost exclusively played on Sundays. Players and fans would go to church in the morning, then grab a bite to eat before heading to the ballpark. Each afternoon, hundreds of fans would pack the stands, line the fields or just sit in cars to watch the game. There were no turnstiles and no tickets. Once the fans took their seats, Prince would pass around a cigar box to collect the admission price of fifty cents.

A young boy by the name of John Warren would go to Carver Park after Sunday lunch to catch a game. When he arrived at the park, Warren and his friends had another game to play before the Eagles took the field. The boys would sneak under the stands while Prince was passing around the cigar box. When he wasn't looking, the boys would take turns sliding up into the stands. Most days, they would go undetected. Sometimes, they would get caught and have to shell out a quarter. Regardless, they would take their place in the stands before the teams took the field.

Game day at Carver Park was the highlight of the week for many Cleburne residents. The air was electric when the hometown Cleburne Eagles took the field in their gray uniforms. Although the team was unaffiliated with any organization, these semipro players traveled to different cities on barnstorming tours. Although there still was virtually no coverage of the games, the team had plenty of black and white fans who loved to watch a good game.

During warmups, the Cleburne Eagles often engaged in a routine known as shadow ball. From their fielding positions, the players would engage in a choreographed mini-game in which they would throw the ball back and forth in rapid fashion. However, they did it without a baseball. Their movements were so rapid and smooth that the fans often didn't know the baseball was lying in the dirt next to the rubber on the pitcher's mound.

When the umpire finally yelled "Play ball!," the real excitement began. Baseball games at Carver Park were more than a spectator sport; the fans were very involved. There was good-natured ribbing between the players of both teams and multiple interactions throughout the game. The fans often worked hard to get into the heads of the opposing players. Despite the jawing

that went on, rarely were there any confrontations. The fan interaction was just part of the game, and everyone expected it. "Today, baseball often resembles a wake where the fans sit quietly," said John Warren. "That's sad. Back then, the fans and players constantly went at it. It was part of the game and it made it fun."[107]

After the game, the players and fans gathered in the parking lot to either celebrate a victory or harass one another as only friends can do. Often, a large group would congregate at the open trunk of a man simply known as the "bootlegger." For fifteen cents, a cold bottle of beer was available. For the player who had a bad game and a little more money, a shot of whiskey was made available.[108] Summers at Carver Park were special, and baseball games were a part of life for many teenagers growing up on the east side. Lifetime friendships were formed, and fond memories were made.

All but one of the players associated with the Cleburne Eagles have passed away, taking with them many of the stories and memories.[109] The scorekeeper, John Warren, recalls the days when the Eagles graced the fields of Cleburne and beyond. One sunny day in the mid-1950s, the Eagles were scheduled to travel to Glen Rose to take on an all-white team. As John arrived at the city limits, he noticed a sign on the side of the road. It read: "Nigger, if you can read this, you better run. If you can't read this, you better run faster." At that moment, he knew this would not be an ordinary game and that trouble might be waiting for his team.

When the team took the field, the stands were full. One white man stood up and began yelling at the home team, comprising white players: "Why ya'll playing with a bunch of niggers?" Through several innings, this man continued to heckle the Eagles, yelling insults such as, "Niggers go home! Strike out the nigger!" The Eagles were there to play baseball, so they kept on doing just that, paying little attention to the man in the stands. John "Casey" Warren kept taking notes as he scored the game, but he could not deny that the heckler was quickly getting on everyone's nerves. The fans were there to watch some baseball, but this guy was making a fool of himself.

As Warren looked up from his score sheets, he saw his high school friend Earnest King Jr. step up to the plate for the Eagles. Junior, as he was known, was a solid batter. "Looks like another nigger at bat," came another heckle from the man, now standing at the top of the stands. Junior took a couple of pitches. Then he got ahold of a pitch and sent a line drive straight into the stands. Before the obnoxious man could open his mouth again, Junior's foul ball hit him square on the forehead. The blow was so strong that it knocked the man off the back of the stands, and he landed on the ground with a

An unidentified team from the 1950s. *Courtesy of Layland Museum.*

thud. The fans and players went silent. About that time, a white woman stood up. "I'm glad it hit that son-of-a-bitch! I was tired of listening to him. Let's play baseball!" And that was that. The players and the crowd followed the lady's demand and enjoyed the rest of the baseball game.[110] No one remembers who won the game, but everyone recalled that it was the heckler who lost that day.

Year after year, the Cleburne Eagles would barnstorm around Texas throughout the summer until late July, when the team would join other Texas semipro Negro teams for an annual tournament at Katy Park in Waco. The tournament had a double-elimination format, with bragging rights as the state champion at stake. Cleburne was always in contention for a spot in the finals.

Except for a brief period in 1953 following a devastating tornado that destroyed Katy Park, the tournament continued to be an annual highlight for Waco and for fans across the state. Throughout the 1950s, the team to beat was almost always the Jasper Steers. Though memories have faded in the intervening years, Warren recalls a championship game when the J.M.

Eagles stunned the Steers, knocking the assumed champions off their game. In 1960, Cleburne played a team out of Tyler in the championship round. Going into the final game, Cleburne needed to win just one of two games to secure the championship. Unfortunately, Tyler overpowered the Eagles in both games. Wearing an Eagles jersey for that series was a man who would become one of Cleburne's unknown heroes.

A Virtually Unknown Hero

For several years, the Cleburne Eagles had one of the greatest black baseball players in the town's history on the mound, Jabe Brazzle Jr. Jabe was born on July 26, 1929, long after the last professional baseball game was played in Cleburne. As he grew, it became evident that Jabe could throw a baseball, and he could throw it hard. He often took control of a game for the Eagles, allowing the other players to relax a bit. If Brazzle was on the mound, it often meant a victory for Cleburne. Under the leadership of Brazzle, Cleburne often found its way deep into the annual tournament at Katy Park to battle for a spot in the finals.

It wasn't long before he caught the eye of minor-league scouts across the state. In 1952, Brazzle signed up for pitching duties with the Longview Cherokees. For the next two years, he traveled across the state, taking the mound for five different minor-league teams. He quickly discovered that playing professional baseball at the minor-league level was quite different than his barnstorming days back home with the Eagles. But he

Jabe Brazzle. *Courtesy of John Warren.*

held his own while amassing a 4.54 career earned run average. While the level of play was different, what remained the same was Brazzle's love of the game. It was this love and what it taught him about life that he chose to share with others.

With his playing days and the challenge of segregation largely behind him, Brazzle continued to seek out ways to mold the lives of his students at Booker T. Washington High School in Vernon, Texas. He wanted to make a positive impact on these young men before they entered the harsh realities of life. In 1975, after he assisted with integration of the Vernon schools, he decided one of the best ways he could relate to his students, black or white, was through baseball, so he created a baseball program at Vernon High School, where he coached until his retirement in 1990. Year after year, Brazzle taught ballplayers the fundamentals of the game, engaging students in his life story in an effort to turn ordinary boys into extraordinary men. Brazzle didn't stop there; he volunteered countless hours to community service organizations. And when Texas joined other states in integrating schools, Jabe Brazzle was Vernon's leader to accomplish the task. On February 24, 1997, Cleburne's greatest black baseball player breathed his last, and the book on an extraordinary life of service closed. Soon after his death, Vernon honored his memory by naming the baseball field he created after him. And on May 12, 1997, the Texas Senate passed a resolution in memory of the Cleburne Eagle legend. Like many other forgotten boys of summer, Brazzle left his mark on the lives he touched.

Ninth Inning

LITTLE LEAGUE DREAMS TO BIG-LEAGUE REALITY

If you put a baseball and other toys in front of a baby, he'll pick up a baseball in preference to the others.

—*Tris Speaker*

Kevin Gee took a shovel and began pilling dirt up in the backyard of his Cleburne home. After several hours of moving the dirt, he began molding it into a pitcher's mound. He built the mound to teach his eight-year-old son, Jared, how to pitch. After measuring the exact distance to home plate, he was ready. There was just one problem: Kevin's three-year-old son, Dillon, wanted to match his older brother pitch for pitch. So Kevin measured off the halfway point for Dillon. During each windup and release, little Dillon Gee dreamed of taking the mound in a major-league game. Two decades later, his dream finally became reality.

For over a century, baseball has been a part of the very fabric of America. Boys have dreamed of making it to the big leagues. Throughout the past century, several of those little league dreams became big league realities. For most young players, it starts with a league that was the product of one man's dream.

In 1938, in Williamsport, Pennsylvania, a lumberyard clerk by the name of Carl Stotz had an idea. He had no boys of his own, but he often played catch with his two young nephews. One day, likely while they were throwing a ball around, Carl had a thought. He wondered why neighborhood children were relegated to playing makeshift sandlot games rather than having organized seasons on fields that were designed for smaller players. For an entire year, he

worked on determining dimensions for such a field. He carved out a home plate and calculated just the right distance between the bases and the mound. He also toyed around with equipment appropriate for younger players.

The next year, Stotz took his idea to the next level. With the help of his wife and her two brothers, he and his family hosted a series of games between three teams of preteen players: the Lycoming Dairy, the Lundy Lumber and the Jumbo Pretzel. Volunteers were recruited to oversee this new league, and sponsors were sought to cover the costs of uniforms and equipment. The organization was called the Little League. On June 6, 1939, the first Little League game took place when the Lumber beat the Dairy, 23–8. Soon after, the concept took off, and rules were created to make sure that all neighborhood children in the community had a fair opportunity to play ball.[111]

What Stotz couldn't envision in 1939 was the impact Little League would have on the game of baseball and on small towns across America. By introducing the game at an early age, it elevated the level of play for generations and brought communities together. For Cleburne, the impact of Little League was profound.

In early 1952, Louey Chafin went on a trip. While away, he saw something that grabbed his attention: eleven- and twelve-year-old boys playing baseball on a smaller-than-normal diamond. Their equipment was smaller, and they were wearing jerseys. Everything from the field to the uniforms resembled the makings of a full-sized baseball game, just scaled down. When he returned to Cleburne, he shared this vision with his friend, Pete Smith, a local newsman who had a passion for sports, baseball in particular. Smith listened intently to Chafin's story. Soon thereafter, Smith heard similar stories from two other Cleburnites, Walter Holiday and Bob Anderson. What these men witnessed gave them an idea, an idea that led to the formation of Little League baseball in Cleburne.[112]

The men began meeting regularly to discuss how they could accomplish something similar in Cleburne. Meetings lasted well into the morning hours as these men and others began planning a league. In all, they met fourteen times. There was paperwork to complete, details to iron out and multiple requirements to meet in order to receive one of the coveted charters for official Little League play. The Optimist Club heard about the plans and got involved. Throughout 1952, these men planned a program that would spark a positive change for Cleburne the next summer.

By the spring of 1953, baseball was the talk of the town. The Little League charter was granted, and a board of directors was established, composed of

Tigers Little League team. *Courtesy of Layland Museum.*

Pete Smith, Brooks Conover, Jack Stepp, Emmett Mahanay and P.L. White. Tryouts were scheduled for early May. Boys from across town lined up to register and to receive a number that would be their only identification for several days. When tryouts concluded, 215 boys tried out for positions on six teams. Parents and fans filled the Yellow Jacket baseball stadium by the hundreds to watch the tryouts. The demand for playing time was so great that the club asked the community to raise more money so they could form two sets of teams, a major league and a minor league. Each major-league team was associated with a minor-league team that would act as a farm system for the major-league team. When the tryouts concluded, the coaches met in secret to draft the players.

After the tryouts and the secret meeting to select players, six teams were formed. The Cardinals were managed by Bob Anderson, the Dodgers by C.A. "Smokey" Munsch, the Giants by Lewis Chafin, the Braves by L.C. "Blackie" Mansfield, the Tigers by Jack McClure and the Indians by Jack Stepp. The minor-league teams were called the Buffaloes, the Cats, the Sports, the Eagles, the Oilers and the Exporters. Local businesses sponsored

each team, and the whole community raised the money needed to buy equipment and uniforms.

The city prepared a Little League field in the same location where Tris Speaker once roamed the outfield for the Railroaders. Despite the historic significance of this location, it was the field at the southeast corner of Hulen Park that was the focus of the city. For the next two decades, much of the city would spend its summer Friday nights watching Little League games. This field had a grandstand built of rock with a mysterious heart-shaped rock as the centerpiece. Fences dotted with advertising and an old wooden concession stand completed the scene. The announcers sat perched on a raised platform supported by four tall telephone poles erected just behind the grandstands. Cleburne was once again a baseball town.

With the league created, the players selected and the coaches in place, there was just one more thing to do: plan a parade. Cleburne had a long history of kicking off baseball seasons with parades, whether the season was for professional or semipro ball. So, on May 25, 1953, members of Cleburne's first Little League teams donned their jerseys and filed into parade formation. They were joined by league and city officials, the junior high school band and a formation of Shetland ponies. It seemed as if the whole city lined the parade route that wound through downtown and made its way to the park.

When the processional arrived at the park, the stands were already packed, and more fans lined the field. The boys lined up along the baselines, removed their caps and placed their hands over the hearts as the flag was raised. Mayor Walter Holiday threw out the first pitch as a north Texas TV station filmed the inaugural event.[113] The players were smaller than the professionals who once played in Cleburne, but the crowds were every bit as large.

Little League Opening Day became a highly anticipated event in Cleburne. As fields turned green in the spring, players counted the days until baseball season started. "Opening day was right up there with Christmas

Opening Day ceremonies for an early 1950s season.
Courtesy of Layland Museum.

morning, you couldn't wait until it got there," former Little Leaguer Garey Wylie recalled. Parents would file into the stands early, because the seats would fill quickly. Overflow crowds would line the fence lines three to four deep, and some fans would park their cars along the outfield fences and sit on the hoods. Players and moms would work in the wooden concession stand, making snow cones and popping popcorn. One young boy in particular spent most of his summers either on the fields playing or working the concession stand. Years later, he would become the county judge.[114]

Little League was a part of life for most Cleburne boys. But Roger Harmon saw the impact of baseball from a different perspective. For ten years, his father, Larry Harmon, was the president of the league. Under Harmon's leadership, Cleburne baseball expanded. When he took over, there were six teams and no girls' softball teams. Ten years later, there were eighteen teams and a girls' softball league.

Little League was a community effort to support the kids. "All they wanted to do was to help kids," said Judge Harmon.[115] Often, coaches were more than just coaches; they were role models. When Glen Bledsoe heard that one of his players might not be able to play because his family couldn't afford a glove or cleats, the coach bought them for him. Each season, the Birdwell Broom Company would provide a supply of brooms and mops at a steep discount for the league. On any given Saturday morning, dads with trucks would load up a stack of supplies and, with boys in tow, sell the brooms across the city. The fundraiser became so successful that many residents would not buy a broom from the store because they were waiting on the players to knock on their door.

Sportsmanship was paramount. Coach Chase Robinson would pull his cigar out momentarily to encourage a batter who struck out. "You'll do better next time," the laid-back, downhome man would say. Discipline was crucial. Coach Blackie Mansfield would step out of his math classes to drill players on the fundamentals. He wanted them to be competitive and disciplined. Most of all, he wanted them to become leaders in their community.

An unidentified Little League team. *Courtesy of Layland Museum.*

While players and coaches wanted to win games, they also understood that some things in baseball were more important than a win—the elusive no-hitter, for instance. In 1963, Garey Wylie was throwing a no-hitter when Coach Bob Matlack made his way to the mound. "Son," he said, "you just hit your maximum innings for the week. You can either stay in and go for the no hitter, or I can pull you. If you stay in and the other team realizes you are over, we may have to forfeit the game. So, what do you want to do?" Garey did what any competitive pitcher would do; he finished the no-hitter.[116] When it was over, the team forfeited the game, but they helped their pitcher attain the rare feat.

Not all of the Little League stories ended in glory. On the same day that Garey Wylie was pitching, his cousin was playing another game at Carver Park. Rickey Morris Looper was an energetic thirteen-year-old boy. A student at Fulton Junior High, Rickey was a solid rider in the Midway Saddle Club. On this day, he was the catcher for the San-Mar Restaurant team. In the third inning of a game against a team from Burleson, the batter popped up a foul ball. Rickey threw his mask off and positioned himself to make the catch. He misjudged the ball and it caught him on the throat, crushing his windpipe. Right fielder Grady Easdon watched helplessly as Looper lay on the ground until he was carried off the field. Rickey was rushed to the hospital where, later that night, he lost his life. When Easdon picked up the paper to check box scores the next day, he read about Rickey's death. "Like the others, I was devastated."[117] Rickey Looper's major-league dreams had died with him.

Through the years, other players donned a Little League jersey in Cleburne. Jim Abt would become known throughout Texas as one of the greatest swim coaches in the state, but for a few summers, he stayed dry on the mound, where he pitched many games. In 1963, a Little League all-star team from Cleburne finished second in the state. That team included Dick Turner, who later played for TCU, and Danny Elam, who later became a teacher. Almost a decade later, another Cleburne boy would start a baseball career that would land him in rare company as a leader in major-league baseball. His name was Spike Owen.

The year 1979 was an exceptional one for Spike, his teammates and his community. The same year in which Tommy Webb was voted teacher of the year would provide a first for Cleburne High baseball. Coach Jay McCarty and his team had fun mowing through the competition during the regular season, and major-league scouts watched Spike play shortstop. With the regular season over, the magic continued all the way to Cleburne's first berth in the state tournament. The magic ran out in the championship game,

The 1979 CHS state qualifying team. *Courtesy of Cleburne Independent School District.*

when DeSoto squeezed out a win over the Jackets.

When the game was over, so were the baseball careers of most of the team. Sonny Burgess went on to a country music career, and Perry Rosser traded a bat for a golf bag before opening a funeral home. Others went on to various colleges and careers. While the country was dealing with gasoline shortages and low morale, this 1979 baseball team was distinctively unique. "We knew this would be a special bunch," said Mark Banton. "We watched them play from the time they were in little league. We always knew they would be special—and they were."[118]

Growing up, Spike Owen had competition from within his own house: his brother Dave. While the Owen brothers played ball in college, their hometown talked about which professional teams would select each one of the Owens. Both Spike and Dave started at the most difficult position in baseball: shortstop.

While many argued that Dave was too old to make it, it was his heart that landed him in the big leagues. The Chicago Cubs saw his passion for the game and drafted him in 1979. Four years later, he took the field and played professional baseball until 1988. In 2014, Dave was the director of player development for the Detroit Tigers. When his playing days ended, Dave continued his major-league work by developing young players. "Our role is to get these kids in sports to gain experience and have success. We want to give them an opportunity to grow as players."[119] After playing, he decided to give back to the game he loved.

Spike's dream of the majors became a reality in 1982, when the Seattle Mariners drafted him in the first round. He got his first major-league hit in his debut game, on June 25, 1983. For twelve years, he played for five major-league teams. During that time, he laid claim to several amazing accomplishments. He set a National League record by playing in sixty-three consecutive games without an error. On August 20, 1986, he was the first major-league player in over forty years to score six runs in a single game.[120] He also helped win a championship.

Like his brother, Spike began coaching when his playing days were over. He worked his way through the Texas Rangers' minor-league organization. In 2016, he reached third base in a major-league game for the first time in over twenty years, this time as a coach.

From the era of Tris Speaker to the time of Spike Owen, Cleburne produced several notable major-league talents. Not long after the Railroaders won their first championship, Cleburne native Al Baird got his start for the New York Giants. He played in 1917 and 1919. In between, he served in the U.S. Navy during World War I. Richard "Rich" Gee played for the Lincoln Giants in the Negro league during the 1923 season. George Milstead pitched for the Chicago Cubs from 1924 to 1926. In the 1950s, Jay Avrea and Morgan Fine both played in the majors. Fine was thirty-two before his big league dream came true, when his name was added to the roster of the Boston Red Sox. When his career was over, he returned to Cleburne and worked for an oil company until his retirement.[121]

Little Dillon Gee moved from the backyard mound his dad created to the high school mound. In 2004, Dillon's Yellow Jackets stormed through the playoffs to another state tournament berth. Coach Ross Taylor took a group of boys that had played since Little League and sculpted them into a playoff team. Players like Trey Grundy, Colt Walls, Russell Young, Ryan Stepp, Troy Waldron, Joseph Oleksak, Patrick Jones and Josh Morton joined Gee on the college signing boards. Seven of the players would sign on to play college ball. During the regular season, Gee pitched two no-hitters.

When the team arrived at the state tournament, it learned that it would face Denton Ryan's ace pitcher, Javy Guerra. Guerra would later become a closer for the Dodgers. He threw ninety-six-mile-an-hour fastballs that were unhittable. Throughout the playoffs, Denton Ryan mowed teams down with these notorious fastballs. During the semifinal game, coach Taylor called a bunt. Josh Morton squared to bunt when Guerra's fastball ran inside and caught him square on the jaw. As Morton lay on the ground near the plate,

Taylor and others picked up nine of Josh's teeth that had been knocked out. Later, Colt Walls made contact with eighteen pitches before securing a walk. As he made his way to first, the crowd gave him a standing ovation, and the future major-league closer tipped his hat. Despite losing the game, Cleburne had gained the respect of a future major leaguer.

Defying the overwhelming odds against a twenty-first-round pick making it to the major leagues, Dillon Gee put on a New York Mets jersey and took the mound on September 7, 2010. That he was able to start that game was a miracle. In 2009, a shoulder injury had ended his season and made his dream of starting for a major-league team seem an impossibility. In his debut, he became the first Mets pitcher to register a hit in his first game. In 2012, the Gee family was faced with not one, but two life-threatening obstacles.

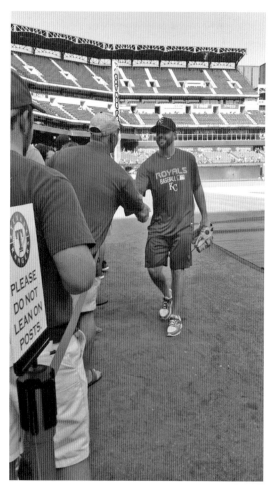

When Dillon's big brother, Jared, was diagnosed with leukemia, Dillon spent countless hours on the telephone checking on his brother and the family. "It was hard. I had to be in New York, but I'd try to keep up with them, see how they were doing and try to just talk to him," said Dillon.[122]

Not long after Jared's treatments began, Dillon noticed numbness in his arm. A blood clot one inch long was discovered in his throwing arm. Season-ending surgery was required. Most thought his career was over. However, the very next season, Dillon Gee was the starting pitcher

Author visits with Dillon Gee prior to a game between the Kansas City Royals and the Texas Rangers in 2016. *Author's collection.*

on Opening Day for the New York Mets. A three-year-old's dream born in his backyard became realty.

Not all Little League players end up on the roster of a major-league team, and not all Little League teams stay together through high school graduation. But, occasionally, miracles happen. In 2012, Cleburne produced a team without a single superstar but with a lot of heart. The seniors and juniors on the team played together from Little League through high school. No one expected the 2012 team to get out of district, let alone amount to much in the playoffs. But this team was a family, and each time they played, a different player would step into the role of hero. Throughout the playoffs, the pundits declared the Yellow Jackets' season over. And throughout the playoffs, the team proved the pundits wrong.

Cleburne fans followed the club across the state. The fans, led by an enthusiastic student section, showed the state how spectators could take control of a game. The fans used propane tanks filled with bolts, cowbells and a unified voice—the noise at games was deafening. At times, the noise got into the opposing pitcher's head. During one game in particular, the pitcher was so rattled by the noise that he left the mound not realizing that he was heading toward Cleburne's dugout. He gave the Cleburne stands the bird and turned to walk to his own dugout. In the end, he lost more than his composure; he lost the game.

When the 2012 team arrived in Round Rock for the state tournament, it fell behind early against Austin Westlake. Down by six runs, the Yellow Jackets' winning streak appeared to be over. Then things started falling into place. The Cleburne players had come from behind to claim victory more than once that season, and this game was no exception. Each player was willing to sacrifice for the sake of the team. Defying the odds, the Cleburne bunch clawed their way back. They won not only the game but also the right to play for a state title. Although the team ultimately fell short of the championship, this was the stuff of which Little League dreams are made. The 2012 high school team demonstrated that a group of boys could play together as one and that ordinary boys could unite for an extraordinary cause. In the process, they united a community. It was baseball at its finest.

You're playing a game, whether it's Little League or Game 7 of the World Series. It's impossible to do well unless you're having a good time. People talk about pressure. Yeah, there's pressure. But I just look at it as fun.

—*Derek Jeter*

Extra Innings

RESURRECTING THE RAILROADERS

Be on time. Bust your butt. Play smart. And have some laughs along the way.
—*Whitey Herzog*

As the dog days of summer 2015 arrived in Cleburne, my youngest son, Matthew, and I started playing catch. As we threw a baseball back and forth, we talked. We talked about baseball. We talked about the upcoming football season. We talked about cars. We talked about girls. And we talked about life in general. I hardly realized my shoulder was older and beginning to ache.

As Matthew and I played catch in our backyard, I thought about the historic opportunity Cleburne was facing. It was almost one hundred years since Cleburne could lay claim to a professional baseball team. As fortune would have it, the city had the chance to bring the Railroaders back.

October 2014 was a difficult month for my administration and for the City of Cleburne. As I was preparing to sneak away for a weekend with my wife and our two closest friends, I received a social media message about a local dog shooting by one of our officers. As I left town, I worried that the matter could blow up before we had a chance to investigate. I was worried that the whole matter would escalate quickly if we failed to act decisively and appropriately. And just as I had feared, the whole matter spiraled out of control as the troubling video of the shooting went viral.

While I was monitoring the situation, I received a message from Cleburne's local florist, John Patrick. He sent me a story about a minor-

league team in Fort Worth, the Cats, getting kicked out of LaGrave Field and needing a new place to call home. Along with the article, his message read, "Let's bring the Cats to Cleburne. Hahaha." I read the article and then went back to figuring out damage control and what we needed to do to ensure a fair investigation for the police officer while maintaining transparency and public faith in the process. Baseball was the furthest thing from my mind that weekend.

As the investigation concluded and the officer was cleared, I thought about John's tongue-in-cheek note and asked myself, "Why not?" I picked up the phone and reached out to the Cats' front office. The recent opening of the Chisholm Trail Parkway, a toll road connecting Fort Worth and Cleburne, was a game-changer for our railroad town. Overnight, Cleburne became part of the north Texas Metroplex. Growth was sure to come as people discovered the small-town charm of Cleburne. Perhaps professional baseball in Cleburne was not as far-fetched as I had originally thought.

To my astonishment, the Cats were interested in meeting with us. With a meeting scheduled, I met with our chamber president, Cathy Marchel, and our economic development director. We needed to pull out all the stops if we were going to have a chance of landing a minor-league team. I knew other cities would be competing for this opportunity. Knowing that our high school baseball team was fast becoming a perennial powerhouse, we needed to demonstrate that Cleburne could support a minor-league team. We needed to demonstrate that Cleburne was still a baseball town.

We gathered all the photographs of Cleburne's baseball history and prepared baseballs and bats to welcome the delegation. We also secured copies of Wiley Whitten's excellent work on the 1906 champion Railroaders. I confess that I didn't know much about Cleburne's baseball history or much about the Railroaders, other than that they had won the 1906 championship and that the legendary Tris Speaker played on the team.

The meetings went well. We talked about minor-league baseball and all the entertainment options that come with a team. We met with the high school coaches and staff to discuss how the professional and high school teams could benefit from each other.

As we toured the city looking at potential locations, one spot stood out as the logical choice. Nestled at the end of the toll road was a corner property that was easily accessible from the north, east and west. The southeast corner of Nolan River Road and the Highway 67 bypass was clearly the most important piece of real estate for Cleburne's future. It had the potential of becoming a gateway to the city.

A year earlier, a rumor had circulated that plans were underway to build a full-service truck stop at the end of the toll road. This would be the front door of Cleburne's new entrance. While we wanted and needed a truck stop, the new front door of the city was not the right location. We had one chance to get this gateway right, and it would set the tone for future growth for the next fifty to one hundred years. We needed something in that location to let visitors know that they were entering a special city. This was a chance to tell the story of Cleburne.

Almost overnight, a groundswell of controversy bubbled up as we quickly passed an overlay that would protect this new entrance into the city. This type of action was relatively unheard of in Cleburne. As Rick Holden, my former city manager, often said, "Cleburne has eighty years of tradition, unhampered by progress." Planning for the future was something we just didn't talk about. But the area was a blank canvas, and we had to think carefully about how we wanted to color the future of Cleburne. The overlay was passed, and the stage was set to do something special. That something special arrived when we met with the professional baseball delegation.

After the initial meeting, things moved very quickly. We conducted more planning meetings and composed a letter of intent to convince the committee that Cleburne was the city for the team. We were told that we would need to come up with a temporary location for the 2015 season and have a ballpark operational by the spring of 2016. I researched every minor-league baseball park in America. I read countless articles and reviewed endless photographs, striving to determine what factors made some teams successful and others failures.

The common theme for successful minor-league teams was a diverse, multiuse facility. Those cities that used the stadium for more than just baseball drew bigger crowds, and those stadiums were more valuable to their communities. They also featured retail shopping, dining and other forms of entertainment. Cleburne desperately needed more family-friendly entertainment and more shopping options. For years, residents traveled miles into the Metroplex to shop and dine. Such a development with a minor-league stadium at the heart of it would create the sort of catalyst that could get our economic engine started.

During the planning sessions, discussions turned to a retail center associated with the ballpark. A developer was introduced to us, and he informed us about the retail aspects of a center. As we considered creating a unique retail component, we also talked about making the project uniquely Cleburne. I stressed that even as Cleburne merged with the Metroplex, it was important to keep our unique identity as a railroad town.

Along the way, we discovered that since the Cats rightfully belonged to Fort Worth, the true intent of this move was to create a new team in Cleburne. Initially, we were somewhat dismayed by that revelation. However, we were also excited about doing something that was uniquely Cleburne. Instead of this project being about the acquisition of a new team, it was now about our city's return to its baseball roots. In 1906, Cleburne won a championship. However, before the city got a chance to celebrate, the owner took the team and the trophy to Houston. This was our opportunity to resurrect the Railroaders and ensure we kept them this time.

At first, we wanted to move quickly, before another city could take the opportunity away from us. But as we started delving into the details, we realized we needed a more comprehensive plan that would make sense to the citizens of Cleburne, promote the success of the project and allow the residents to have the ultimate say. At the same time, the proposed developer was pushing hard and fast. Later, we would learn that there were problems with some members of the development team that almost derailed the whole project.

Right after New Year's Day in 2015, a meeting was scheduled with a prospective investor on the development side. This meeting would later prove critical to getting the Railroaders back on track. That developer was Donnie Nelson, the general manager of the Dallas Mavericks and partner of developer Matthews Southwest. When Donnie enters a room, you can feel the energy level rise. As a tall man, he fit the bill for an NBA general manager. I was pleasantly surprised by his midwestern charm and complete lack of pretense. I would soon witness this man's love for small towns and how much he truly cares about people.

While the others waited to start the meeting, I offered Donnie a cup of coffee. While we stood in the kitchen, waiting for the coffee to brew, I told him about the history of the Railroaders and how important this project was for the future of the city. I had no idea at the time that a short conversation over a cup of coffee would be the beginning of a friendship and the foundation for a project that could transform my hometown. As I started the story of the 1906 Railroaders, Donnie's eyes were bright and engaged. The coffee was ready. I handed Donnie his cup and took a sip from mine. "You see," I said, "we never had the chance to defend that championship. Never had a chance to celebrate that team." It was as if we were talking about something that was in yesterday's headlines. I love telling people about Cleburne. With Donnie, I found someone who loved hearing about the town. Together, we would find a way to bring the town together to write a new chapter.

The development team was forming. Donnie described the various roles each member of the team would play. His coaching and management style was infectious. He explained that we each had a role to play in bringing the Railroaders back and in creating a unique retail and entertainment development. Most important, we had to make sure every aspect of the project was transparent and open for the citizens of Cleburne.

The first step was to secure the real estate for the project. Donnie brought in Jamie Adams, a real estate broker who understood high-profile transactions. Jamie was an old-school, "your word is your bond" kind of guy. He was a man of impeccable integrity. Whether you were the president or a snot-nosed kid, Jamie treated you the same way. I immediately liked him.

Because of the volatile nature of real estate deals, the rest of the development team was supposed to sit tight and wait for Jamie to secure option contracts on the land so the city and development team could perform their due diligence, a process by which they would determine whether or not the project made fiscal sense. Only then would we bring it to the public for a vote. Any leaked word of the potential public/private venture would send land prices skyrocketing and would kill the deal.

Despite Donnie's instructions to wait on Jamie, one of the early developers lost patience and contacted the landowners. I was in my office when he dropped by. He handed me contracts on the real estate and said he needed a $20,000 check from the city to secure the contracts. "Wait a minute," I said. "First of all, that's not how it works with a city. We have to have a plan, council has to approve expenditures and there are hearings that we have to have. We must have public transparency." I also wanted to know why he jumped in when Jamie was in charge of securing the contracts. Red flags and alarms were going off in my mind. What was this guy's hurry?

Things had progressed so quickly that I had not had time to look into the prospective development team. After a couple of minutes on the computer, I discovered that there were some issues with one member of the team that would not reflect well on the team or the city once the issue was disclosed. I was not going to work on a project with someone who could jeopardize the project and the integrity of the team members. And I sure as heck was not going to lead the city down that path. I soon learned that two of the other potential developers also had issues. It looked like it was time to pull the plug on the project.

I picked up the telephone and called Donnie. "You are not going to believe what I just discovered." I told him what I had found. After telling him about the discovery, we both agreed that while we liked the guys, there was no way

we could put our personal integrity at risk or allow the city to look bad. It would be a matter of when, not if, the media found out. I recalled an early conversation with Jamie. He said that if this thing works out, it should be a good thing for the city. "If it's meant to be," he said, "then it will work. If not, let's not force it." Now, I assumed the deal was dead and that the Railroaders would remain a footnote in history.

Over the next few days, we talked about whether to move forward or just let the whole project die. The team regrouped, and the project gradually started taking shape again. After letting the dust settle, Jamie went back to work on securing the right to purchase the property. While Jamie was securing the dirt, a new development group came on board to help us figure out the retail components and how to lay out the development. Greg Barron and Chuck Stark laid out a master plan. It was important to present a detailed plan to the voters so they could make an informed decision.

As the retail and entertainment components were coming together, it was clear that making the whole project work was going to require a major commitment from the city. Like most other cities with minor-league parks, we were going to have to build and own the stadium. Such a major undertaking was a decision neither a mayor nor a council could or should make alone. It needed the stamp of approval of the voters. It was, after all, their money and their future at stake. We began planning a campaign, the aim of which was to get the details of this complex public/private venture into the hands of the voters.

We ordered market studies to see if the project would work and if it made economic sense for the city. We needed to know if professional baseball could make it in Cleburne. While I was still uncertain about a few aspects of the project, I was quite certain that the market had changed since the last time our team took the field. We needed expert help on evaluating whether the project was truly viable, so we ordered a study from a Chicago firm that specializes in evaluating the market for professional sports venues.

Armed with visuals of the project, extensive studies by experts on the viability of professional baseball in Cleburne and an overall review of the market, the time was right to unveil the plans to the community. I called a press conference and invited the community to join us. First impressions are critical, and we wanted to set the tone for transparency. We needed to get the community up to speed on our six months of detailed planning and negotiating. The project would require a complicated vote in a specially called election.

Before the sun was up, I had already been interviewed by all the major networks about the project. We stood in the open field that, pending voter

Cleburne Station announcement. *Courtesy of City of Cleburne.*

approval, would mark the return of the Railroaders and the start of economic growth for the city. We were introducing the project that would soon be unveiled to the community. I had often told the media that Cleburne was north Texas's best-kept secret. The word would soon get out that Cleburne was the place to live.

With the council and economic team ready to go, we walked into Cleburne's largest conference room. It was filled to capacity. Residents joined the cameramen and reporters to hear the announcement. The air in the room was electric with anticipation. I made my way to the podium and welcomed the crowd. The lights dimmed, and music played as the audience watched a computerized video of what the development might look like when completed. During the portion of the film that featured the stadium itself, music from the classic baseball movie *The Natural* was cued. It was a surreal moment.

After the film, I verbally walked the audience and media through the details of the project. We talked about the stadium, the retail venture and what the impact of both would mean for Cleburne and the surrounding area. I introduced the development team, then fielded questions from the media and residents. Time seemed to fly and stand still at the same time. At the conclusion, Cleburne's own Sonny Burgess held up a Railroader

Architect's rendering of the new baseball stadium, known as the Depot. *Courtesy of Populous Architects.*

baseball hat and a conductor hat. People smiled as he told the crowd that he could wear both hats, since he played baseball and worked at the railroad shops. It was clear that this was a special moment in the history of Cleburne. Appropriately, Sonny led the crowd in singing "Take Me Out to the Ballgame" as the development team donned hats and threw foam baseballs into the crowd. We then enjoyed hot dogs and apple pie. Overall, it was a positive kickoff. However, getting the details out to the community over the next few weeks was critical.

The city was allowed to present the facts to the citizens, but law prohibited it from using public funds to promote the project. We urged the business community make the case for us. We put together a committee made up of business leaders. The group included some of Cleburne's finest leaders: Albert Archer, Bob Walker, Brenda Opela, Chuck Bailey, Jonathan Lee, Todd Regan, Cathy Marchel and Joel Victory. This group agreed to raise money to get the message out. They made countless telephone calls and worked to rally the community behind the project. We knew there would be opposition, but we also knew the community was ready for positive growth and opportunity. Now it was a matter of educating people on the specifics of the project, igniting enthusiasm about its potential and encouraging them to show up at the polls and vote.

As North Texas watched, we began the grueling process of explaining a complex project to the community and making the case for bringing professional baseball back. To spark interest, I took presentations to town hall meetings and civic luncheons. We instituted phone banks and mass mailings. I even attended a church pickup game of 42 dominoes. We brought

business and community leaders together to raise money and to reach out to the public to garner support. All but one of our living former mayors endorsed the project. From the first day, Cathy Marchel, the chamber president, was there helping get the community on board. Bankers and businesses stepped up and supported the election. I even met with some of the city's most outspoken opponents. While there was not much in the way of an organized opposition, there were some vicious personal attacks. Not to be distracted, we stayed focused on addressing concerns and getting the facts into the hands of the voters.

During a chamber quarterly luncheon, we introduced Texas red-dirt phenomenon Randy Rogers as one of the team's owners. Randy grew up in Cleburne and had since traded a baseball bat for a guitar. While we will never know what Randy might have accomplished if he had stayed with the sport, the world sounds sweeter with his music. Although Randy draws large crowds across the country, he never forgot his hometown. Having Randy Rogers in the owners' group was indeed music to Cleburne's ears.

As Election Day drew closer, the buzz across town became louder. I was grilled daily about the details. Our campaign leaders continued to work the telephones and gain support throughout the community. It was important for the community to unite.

Election Day dawned with an excitement in the air that only a free nation experiences. There was also a sense of history unfolding. November 3, 2015, was destined to be one of those watershed moments in Cleburne's history. Some 130 years earlier, Cleburne landed the railroad shops that would set the course for a century and propel the community toward growth and prosperity. Bringing back the Railroaders and landing the retail project could do the same thing for the next generation. After the sun set on November 3, we would know what course the residents had chosen.

As the day progressed, the lines at the polls grew. A watch party was planned. As the polls closed, a crowd was ready to watch the returns. Then there was a problem: Hundreds of citizens were still in line waiting to vote. Never in Cleburne's history, including during presidential elections, had an election resulted in such a large turnout. It would be a long night of waiting.

The day produced a record turnout of 3,351 voters and a record 72 percent support for the project. Some residents had waited two and a half hours to vote. The community had rallied together to overwhelmingly say "yes" to the project known as Cleburne Station! A major part of that project would involve resurrecting the Railroaders from the pages of history. Professional baseball would return to Cleburne!

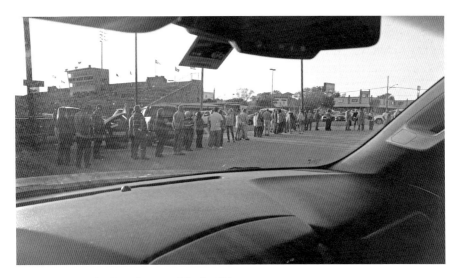

Election Day voting line. *Courtesy of Patrice Richter.*

The celebration would not last long; the meetings to move from vision to reality started at nine o'clock the next morning. There was retail to be recruited, contracts to draft, a team to organize and a stadium to build in record speed. The plan was to throw out the first pitch in the spring of 2017. Meeting that deadline would require a significant amount of hard work in a short amount of time.

Within a few weeks of the election, we were able to select the construction company and architects to design and build the stadium. Populous Architects had designed some of the most beautiful stadiums in America. It asked me to attend the winter baseball meetings so we could see stadium equipment and tour the Nashville minor-league park it had designed and opened a year earlier. There were many details to work out, and it was easier to walk through a stadium firsthand to see how the details could impact the final product.

In early 2016, Robbie Fenyes was introduced as the president of the Railroaders. He conducted local contests in which residents competed for creation of the team's logo and mascot. Daryn Eudalay, president of New Era, started plans for the retail and dining, and we all worked on plans to create a special development. The project was a true collaboration among the city, the chamber of commerce, the school district and private partners.

On February 20, 2016, ground was broken for the stadium. City crews plowed under a portion of the turnip field where home plate would soon be located, and they created a small baseball diamond for the occasion. A

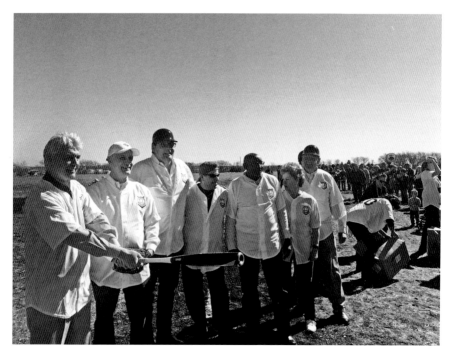

From left to right: Congressman Roger Williams, Mayor Scott Cain, Donnie Nelson, Robbie Fenyes and council members John Warren, Gayle White and Dale Sturgeon. *Courtesy of Cleburne Times Review.*

crowd of around six hundred showed up for the event. Firemen cooked hot dogs, the high school band played the national anthem and cheerleaders got the crowd pumped up. After a few brief speeches, members of the city council turned the dirt. They then donned Railroader jerseys. The announcer introduced the starting lineup. "At first base, Councilman John Warren, the Eagle! At second base, mayor pro tem, Dr. Sweettooth Bob Kelly! At shortstop, councilwoman Speedy Gayle White! At third base, the music man, Councilman Dale Sturgeon! And on the mound, Mayor Scott Cain! Behind the plate is Railroader president Robbie Fenyes, and calling the game today, Dallas Maverick's General Manager Donnie Nelson."

My wife had begged me to practice pitching before the event. I should have listened. I threw out the ceremonial first pitch. A voice from the crowd shouted that I should stick to mayoring. The crowd laughed. Then Donnie yelled, "Play ball!" The announcer introduced the first professional batter to step up to the plate in almost a century. "Former professional baseball player, member of the Atlanta Braves organization and current congressman,

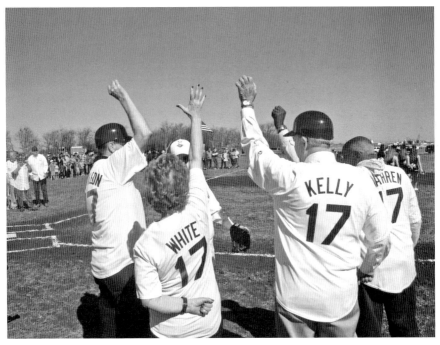

Above: Members of the city council take the field for the first pitch at the groundbreaking ceremony. *Courtesy of the* Cleburne Times Review.

Right: Mayor Scott Cain pitches to former Atlanta Braves minor-league player and congressman Roger Williams, while Donnie Nelson calls the pitch. *Courtesy of the* Cleburne Times Review.

Roger Williams!" I threw a pitch that slowly and miraculously floated into the strike zone. Donnie yelled, "Ball!" We argued a bit, and he came out to the mound and kicked dust at my feet. We were all having more fun than Little League kids. After a few more attempts on my part to find the plate, Congressman Williams proclaimed that I was the worst pitcher he had ever faced. With that, he took the ball from the catcher, threw it up and got the first professional base hit Cleburne had seen in almost a century.

Many members of Tris Speaker's family were present that day. Jim Swan, the great-nephew of Speaker, had heard about the Railroaders' return on

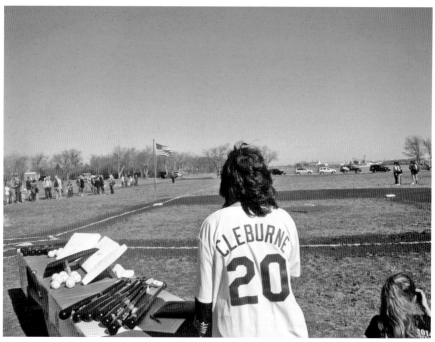

the radio. Not long after, he moved to Cleburne. As I was pitching to a former major-league baseball player, the family of the greatest center fielder of all time was watching. It was an emotional moment that only baseball could create.

While the final pages remain to be written on the story of how the Railroaders were resurrected from the tomb of history, Cleburne's future is bright, and it is once again baseball and railroads that will define the town's future. Across the city, fathers and sons still play catch, Little League and sandlot players still dream of the World Series, church league softball continues to unite and, now, the town and its neighbors will have their own professional team to support.

It's a great day in Cleburne.

Opposite, top: The groundbreaking celebration with kids. *Courtesy of the* Cleburne Times Review.

Opposite, bottom: Chamber president Cathy Marchel was instrumental in bringing the Railroaders back. She was present from the first meeting to the stadium's construction. *Courtesy of the* Cleburne Times Review.

APPENDIX

CLEBURNE'S PROFESSIONAL BASEBALL RECORDS

Year	League	Record	Manager	Titles
1906	Texas	77-49	Ben Shelton	pennant, league champion
1911	Tex/Okla	61-50	Dad Ritter	pennant, league champion
1912	South/Central	51-28	Dad Ritter	pennant
1921	Tex/Okla	51-75	Pete Dillon	
1922	Tex/Okla	36-58	Lindy Hiett	

1906 CLEBURNE RAILROADERS TEAM ROSTER

Rick Adams	Charlie Moran
Roy Akin	Art Pennel
Wingo Anderson	Dee Poindexter
Carl Arbogast	William Powell
Dode Chriss	Dude Ransom
Frank Coyle	Ben Shelton
Walt Dickerson	Tris Speaker
Cal Earthman	George Whiteman
Gus Fisher	Ed Wicker
? Gibson	Harry Womak
Charles Jones	Robert Wright
Bill Kellogg	Robert Yeager
Cal Lewis	

1911 CLEBURNE RAILROADERS TEAM ROSTER

? Adams	? Harrell	Dee Poindexter
Ed Appleton	? Hart	? Reed
? Barnett	Lindy Hiett	? Reynolds
? Boggs	Tol Hiett	Albert Ritter
? Carson	? Hooper	? Sherman
? Colquitt	? Hopkins	? Spear
? Cooper	? Johnson	? Spencer
? Corson	? Judson	? Stewart
? Crawford	? Jutzie	? Stribble
? Crosier	? King	? Tanner
? Deardorf	? Lawson	Lex Terry
Jim Fannin	? Lewis	? Thiell
? Fritts	? McClaim	? Thisle
Charlie Gibson	? McWhirter	D. White
? Griffin	? Moore	Foley White
? Harper	? Oram	

1921 CLEBURNE GENERALS TEAM ROSTER

? Abbott	? Kerr
Dusty Boggess	Gary Lacy
? Corder	? Powell
B. Darnaby	? Shaw
R. Darnaby	? Sheffield
William Ferguson	? Tabor
? Fruth	? Warden
Joe Gaines	? West
? Harbin	? Wilson
W. Hopper	Buster Wisrock
Roy Johnson	

1922 CLEBURNE SCOUTS TEAM ROSTER

Jimmy Amspiger	Gary Lacy
C. Atkins	Ralph Lind
R. Blackburn	Dee Payne
H. Craig	Jack Puddy
William Darnaby	J. Robbins
W. Ferguson	Elmer Shaffer
Joe Gaines	Curt Smith
Lindy Hiett	Guy Tankersley
Tol Hiett	G. Threlkeld
L. Hines	T. Wilemon
W. Hopper	Guy Williams
Roy Johnson	Buster Wisrock

NOTES

FIRST INNING

1. There are many dates put forward for the birth of professional baseball. Some scholars attribute the national tour of the Washington Nationals in 1867 as the beginning of modern major-league baseball. Eric Miklich, "1867 Major League Baseball Born This Year Washington Nationals Tour," accessed August 23, 2016, http://www.19cbaseball.com/tours-1867-washington-nationals-tour.html; "1867 Major League Baseball Born This Year," accessed September 26, 2016, http://www.baseball-reference.com/leagues/MLB/1867-births.shtml.
2. Jeff Guinn, *When Panthers Roared: The Fort Worth Cats and Minor League Baseball* (Forth Worth: Texas Christian University Press, 1999), 26.
3. Dudly Gordon, "History of Cleburne" (thesis, University of Texas, 1929); Earnest Guinn, "A History of Cleburne, Texas, a Master's Thesis" (thesis, University of Texas, 1950).
4. Mollie Gallop Bradbury Mims, *The History of Johnson County* (Virginia Beach, VA: Donning Company Publishers, 1985), 118.
5. Ibid., 119.
6. Gordon, "History of Cleburne."
7. Patrick Mondout, "1867 Baseball Season," accessed August 23, 2016, http://www.baseballchronology.com/baseball/years/1867.

8. Clay Coppedge, *Texas Baseball: A Lone Star Diamond History from Town Teams to the Big Leagues* (Charleston, SC: The History Press, 2012), 21.

9. Rueben "Rick" Adams and Tris Speaker each played for the Washington Senators. D. Wiley Whitten Jr., *Champions of Naught Six: The Cleburne Railroaders* (Raleigh, NC: Lulu, 2010), 171.

Second Inning

10. Whitten, *Champions of Naught Six*, 7.

11. Ibid., 57.

12. *Cleburne Morning Review*, January 4, 1906.

13. Richard Bak, "How Sunday Baseball Came to Detroit," Detroit Athletic, February 26, 2012, https://www.detroitathletic.com/blog/2012/02/26/how-sunday-baseball-came-to-detroit.

14. The team's support from the surrounding towns cannot be overstated. While the team's home was Cleburne, many of the surrounding cities claimed the team as their own. Thus, the Railroaders were a regional team claimed by fans from Grandview, Godley, Venus, Glen Rose, Rio Vista and many other towns.

15. *Cleburne Morning Review*, March 20, 1906.

16. Whitten, *Champions of Naught Six*, 196.

17. *Cleburne Morning Review*, April 16, 1906.

18. The nine players were Rueben "Rick" Adams, Wingo Charley Anderson, Dode Criss, Walter R. Dickson, William "Bill" Kellogg, Ryo Mitchell, Charles Bethal "Charley" Moran, Tris Speaker and George Whiteman. Whitten, *Champions of Naught Six*, 171.

19. Ibid., 170.

20. Ibid., 182.

21. *Cleburne Morning Review*, April 28, 1906.

22. Ibid., May 1, 1906.

23. Ibid., May 14, 1906.

24. Ibid., May 18, 1906.

25. *Cleburne Morning Review*, May 19, 1906.

26. Jim Swan (great-nephew of Tris Speaker), interviewed by Scott Cain, January 2016.

27. Whitten, "Champions of Naught Six."

28. Speaker still holds the major-league records for doubles (792), double plays turned as center fielder (107) and as outfielder (143) and assists as

center fielder (322) and as outfielder (449). Don Jensen, "Tris Speaker," Society for American Baseball Research, 2006, http://sabr.org/bioproj/person/6d9f34bd; Baseball-Reference.com, accessed September 26, 2016, http://www.baseball-reference.com/players/s/speaktr01.shtml.

29. Jim Swan, interviewed by Scott Cain, 2016.

30. *Cleburne Morning Review*, May 23, 1906.

31. Ibid., June 26, 1906.

THIRD INNING

32. *Cleburne Morning Review*, July 24, 1906.

33. Whitten, *Champions of Naught Six*, 151.

34. *Handbook of Texas Online*, "Willmot Mitchell Odell," accessed July 13, 2016, http://www.tshaonline.org/handbook/online/articles/fod01.

35. *Cleburne Morning Review*, August 8, 1906.

36. Ibid.

37. Richard F. Selcer, "Hell's Half Acre, Fort Worth," *Handbook of Texas Online*, accessed August 15, 2016, http://www.tshaonline.org/handbook/online/articles/hph01.

38. Whitten, *Champions of Naught Six*, 132.

39. Dickson amassed a 26-12 record with three no-hitters and pitched both games in three double-headers. To say that Dickson was crucial to the 1906 championship would be an understatement. Whitten, *Champions of Naught Six*, 186.

40. *Cleburne Morning Review*, September 3, 1906.

41. The inscription on the trophy reads, "Trophy presented by J.E. Mitchell Co. Fort Worth, Texas to Pennant Winners, North Texas Baseball League, season 1906." On the reverse side, in a different style of engraving, it reads, "Won by Cleburne."

42. Whitten, *Champions of Naught Six*, 158.

FOURTH INNING

43. Gordon, "History of Cleburne"; Guinn, "A History of Cleburne, Texas."

44. *Cleburne Morning Review*, May 21, 1911.

45. Ibid., February 5, 1911.
46. Ibid., March 8, 1911.
47. Ibid., April 30, 1911.
48. *Fort Worth Star-Telegram*, May 1, 1911.
49. *Cleburne Morning Review*, May 6, 1911.
50. Ibid., May 7, 1911.
51. Ibid., May 11, 1911.
52. Ibid. May 16, 1911.
53. Ibid., May 21, 1911.
54. Ibid., May 28, 1911.
55. Ibid., June 2, 1911.
56. Ibid., June 3, 1911.
57. *Fort Worth Star-Telegram*, June 25, 1911.
58. *Cleburne Morning Review*, June 28, 1911.
59. Ibid., July 5, 1911.
60. *Ardmore Morning Star*, July 19, 1911.
61. *Cleburne Morning Review*, August 2, 1911.
62. Ibid., August 7, 1911.
63. Ibid.
64. Ibid., August 11, 1911.
65. While team names were not that important, the tongue-in-cheek nickname "Cake Eaters" took hold and remained with the team for some time.
66. *Cleburne Morning Review*, August 18, 1911.
67. The regular season records for the league's teams were as follows: Cleburne 34-20 (.630), Durant 30-23 (.556), Bonham 30-23 (.526), Wichita Falls 21-24 (.467) and Ardmore 24-28 (.462). *Cleburne Morning Review*, August 23, 1911.
68. Ibid., August 31, 1911.
69. Ibid., September 9, 1911.

FIFTH INNING

70. *Cleburne Morning Review*, May 4, 1912.
71. Ibid., May 10, 1912.
72. Ibid., September 28, 1911.
73. Bill Rives, "The Sports Scene" (column), *Dallas Morning News*, January 10, 1951.

74. *Jonesboro Daily Tribune*, June 8, 1910.
75. Ibid.
76. *Fort Worth Star-Telegram*, March 25, 1911.
77. Ibid., February 8, 1911.
78. *Cleburne Morning Review*, December 5, 1912.
79. *Miami Herald*, June 5, 1912.
80. *Dallas Morning News*, June 5, 1912.
81. *Cleburne Morning Review*, June 7, 2012.
82. *Cleburne Morning News*, July 10, 1912.

SIXTH INNING

83. Gordon, "The History of Cleburne."
84. Juel Reuter, "Superstitions and Rituals in Baseball," The Bleacher Report, April 27, 2011, http://bleacherreport.com/articles/677898-mlb-power-rankings-the-50-strangest-superstitionsrituals-in-baseball-history/page/39.
85. *Cleburne Morning Review*, June 9, 1921.
86. Ibid., June 11, 1921.
87. Ibid.
88. Ibid., July 21, 1921.

SEVENTH INNING

89. *Cleburne Morning Review*, March 17, 1922.
90. Ibid., April 29, 1922.
91. Pranks and fun are part of the Lions culture. Members are known to throw rolls during luncheon meetings. But, with all the fun comes serious community services from the members.
92. *Cleburne Morning Review*, May 5, 1922.
93. Ibid., May 25, 1922.
94. Ibid., May 27, 1922.
95. Ibid., June 1, 1922.
96. Ibid., June 7, 1922.
97. Ibid., June 9, 1922.
98. Ibid., July 25, 1922.

EIGHTH INNING

99. History.com, "Jackie Robinson Breaks Major League Color Barrier," accessed March 31, 2016, http://www.history.com/this-day-in-history/jackie-robinson-breaks-major-league-color-barrier.

100. Elizabeth Campbell, "A Joyful Reunion: Oldest Graduates of Cleburne's All-black High School Reminisce," *Fort Worth Star-Telegram*, March 6, 2014, http://www.star-telegram.com/news/local/education/article3848847.html.

101. Historynet.com, "Negro League: Facts & Information About the Negro Leagues, African-American Professional Baseball Leagues in Black History," 2016, http://www.historynet.com/negro-league.

102. Mark Pressword, "Black Professional Baseball in Texas," Biography.com, 2016, http://www.biography.com/people/rube-foster-9299621; http://texasalmanac.com/topics/history/black-professional-baseball-texas.

103. *Dallas Morning News*, November 10, 1899.

104. Senola Howard, undated letter addressed to the Layland Museum in Cleburne (transcription of oral history).

105. *San Antonio Evening News*, May 31, 1920.

106. *Cleburne Morning Review*, July 15, 1922.

107. John Warren, interviewed by Scott Cain, December 2, 2015.

108. Warren, interviewed by Cain, December 2, 2015.

109. The known players with the Eagles were Arthur "Art" Rogers Sr. (catcher), Sylvester Carter (pitcher), Jabe Brazzell (pitcher), Oscar Fuller (outfield), Curtis "Sonny" Jay (outfielder), T.L. Lee (catcher), Shug Mitchell (pitcher), C.D. Liggins (third base), Felton Liggins (pitcher), George Smith (pitcher), Harry Wright (outfield), Billy Jo Earl (shortstop), Elsworth Waites (outfield), Robert Brown (outfield), Clyde Richard (pitcher), Artis Fuller (first base), Arvell Fuller (first base), Tom Grimes (pitcher), Arthur "Satan" Bouldin (manager), Ernest King (outfielder), Ted Gee (catcher), Billy Jackson (outfielder), Richard "Rich" Gee (catcher), Paul Akins (outfielder), Verlee "Nap" Maxwell (second base), Jordan Demmons (catcher), Willie Anderson (catcher), Gus Johnson (outfielder), Elam Holbert (outfielder), Walter Holbert (outfielder), Robert Casmer (catcher), Willie Leroy Johnson (outfielder) and Tom Gee (catcher). John Warren, interviewed by Scott Cain, December 2, 2015.

110. During the recounting of this story, John Warren smiled and started to laugh. By the end of the story, he was laughing so hard, tears were streaming down his face. Often in life, obstacles will either strengthen or

break a man. This event in Warren's life strengthened him; he chose to make lemonade out of the lemons. John Warren, interviewed by Scott Cain, December 2, 2015.

Ninth Inning

111. Joe Matthews, "Baseball: In 1955, The Little League Ejected the Found Who Wouldn't Play Ball. Now Five Years After His Death, the Corporate Entity Seeks to Reawaken the Sporting Spirit of His Game," *Baltimore Sun*, August 23, 1997.

112. Pete Smith, "The Origin of Cleburne Little League," *Cleburne Times Review*, March 22, 1984.

113. Ibid., May 26, 1953.

114. Garey Wylie, interviewed by Scott Cain, April 28, 2016.

115. Roger Harmon, interviewed by Scott Cain, April 29, 2016.

116. Wylie, interviewed by Cain, April 28, 2016.

117. Grady Easdon, interviewed by Scott Cain, May 20, 2016.

118. *Cleburne Times Review*, July 6, 2010.

119. David Lurila, Fangraphs.com (blog), November 19, 2014, http://www.fangraphs.com/blogs/qa-dave-owen-detroit-tigers-director-of-player-development.

120. *San Diego Tribute*, August 20, 2015.

121. Rich Marazzi and Len Fiorito, *Baseball Players of the 1950s: A Biographical Dictionary of All 1,560 Major Leaguers* (Jefferson, NC: McFarland & Company, Inc., 2004), 112.

122. Kristie Ackert, "NY Mets Pitcher Dillon Gee Able to Put Blood Clot Scare in Perspective During Brother's Battle with Leukemia," *New York Daily News*, April 3, 2013.

INDEX

INDEX

ABOUT THE AUTHOR

S cott Cain grew up in Cleburne, where he today maintains a law practice and serves as mayor. Scott frequently speaks across Texas on topics ranging from history and current events to business practices. He is also a lifelong baseball fan.